The Daughter of Gaia

Rebirth of the Divine Feminine

by Marko Pogačnik

edited by Tony Mitton

FINDHORN
Press

First published in English by Findhorn Press 2001

ISBN 1-899171-04-5

British Library Cataloguing-in-Publication Data.
A catalogue record for this book is available from
the British Library.

Edited by Tony Mitton
Cover design by Thierry Bogliolo
Set in Garamond ITC by Pam Bochel

Printed and bound by WS Bookwell, Finland

Published by
Findhorn Press
The Park, Findhorn
Forres IV36 3TY
Scotland, UK

tel 01309 690582
fax 01309 690036
e-mail: info@findhornpress.com
findhornpress.com

Contents

The Goddess Now

Yesterday I received a mysterious cylinder in my daily post. Renate, a friend of mine from Bavaria, had sent me a reproduction of a Russian Black Virgin icon. It was a 16th century Madonna of Mercy painted by the Novgorod School. Previously the reproduction had hung above the bed where Renate's mother lay dying during the turbulent year 2000. Now I was to have it—wrote Renate in the accompanying letter—so that I could feel the gentleness of the Black Virgin, as opposed to what I had been saying, during the previous few months while often feeling ill, that I was enduring a phase of change ruled by the *merciless* Black Goddess.

I had been persistently sick, but not seriously enough to cancel my workshops that were scheduled to follow one after another, month after month in different countries. It was quite a challenge for me to stand in front of large groups and teach the knowledge of life while feeling sick. Rather than excuse myself, I would explain that a phase of extended creativity, such as I have experienced as an earth healer and artist during the past few years, would sooner or later be followed by a phase of change. To put it in other language, a language that reaches the level of the soul, the creative phase must inevitably be succeeded by the phase of the Black Goddess.

The language that I use to express myself is the language of the Goddess. This language was known to innumerable cultures before the Bronze Ages when we began our obsession with the male gods. It is a cyclic language that honors the three distinct phases of any life process, be they personal, artistic, or social-economic. During the first, *white*, phase, under the rule of the Virgin Goddess, one is encouraged to search for inspirations and

visions, and to forge plans. I call this the phase of Wholeness. Only by experiencing the touch of the universal whole can we embody the full potential of the inspiration.

The second phase follows when the seeds sown during the white phase of the Virgin start to germinate, and the creative impulses expand to manifest the abundance of life. Works are created, relationships established, mountains moved...

Traditionally, the second phase of the Goddess, her **red** phase, is called the phase of the Mother. On the one hand one can accept such a label, because being a mother means giving birth to children. It is a primeval creative symbol. On the other hand, such a label may cause us to forget an important characteristic of the creative phase of the Goddess: this is the aspect of partnership. Only through creative interaction between yin and yang, between feminine and masculine, between the Goddess and God aspects of life, can creation evolve. Because of this, I prefer to use the expression 'the Creative Phase of the Goddess'.

The Threefold Goddess Principle

Symbolic Color	Traditional Name	Three Phases of the Goddess and their Meaning
White	Virgin Goddess	The Phase of Wholeness: Experiencing the holistic essence of a being or a phenomenon
Red	Mother Goddess	The Creative Phase: Based on the creative interaction between the opposite poles
Black	Black Goddess	The Phase of Transformation: Moving from death or decay towards resurrection

Following this quick initiation into the language of the Divine Feminine, we arrive at the third phase of Her presence, known as the **black** phase. To avoid the threatening connotations of the color black, I prefer to call it the phase of Transformation. The Black Goddess is the mistress of change and transmutation, of death and resurrection. Her rule begins when a process is brought to the limit of its meaningful expansion, and mere continuation would bring no blessings to the creator nor the creation. In that instant the Goddess of Transformation appears on the scene and finds means to undermine the decadent superfluity. She knows how to destroy it in such a way that, no matter how painful the break-down appears to be, the seeds for a new creative cycle can germinate.

Looking at the icon of the Black Virgin from the Novgorod school more closely, I realized that she is indeed holding a seed of the future in her hands: it is the Christ Child. She is holding him firmly to her chest with both her hands. But the child too has snuggled himself close to the Virgin, and is clutching at her robe with both of his hands. Cheek to cheek they touch each other, and they seem to be one.

In that moment I realized that the mouths of both Virgin and Christ Child are slightly open. And something more: they are so close to each other that their lips nearly touch. Suddenly, I felt that there must be a stream of breath flowing from mouth to mouth. I moved my hand into that sensitive area of the painting so that my fingers could test the quality of the exchange that I intuited. And they did indeed feel a solid stream of energy flowing from mouth to mouth. Even though I was using a reproduction of the painting to test the stream, the resonance with the icon's original message was so strong that, regardless of its condition, my fingers could follow a mingling of water and fire ether moving back and forth between the two mouths.

While I was wondering what all of this might mean, another inspiration hit me. I felt the urge to open my mouth slightly and form a double arch with my lips. This made a channel, through which I found myself breathing very slowly and consciously. While breathing in, I realized that I am drawing in an extremely sweet presence and distributing it throughout my inner space. And

while breathing out, I felt myself to be the Christ Child, renewing his relationship with the Mother.

The Virgin Goddess holding the Christ Child in her lap— usually called Madonna, **Mater Domini**, the Mother of God—is one of the most inspiring images ever created by our western culture. With its roots in the image of dark-skinned Isis, the ancient Egyptian Goddess holding her Son Horus in her lap, it is imprinted into the collective memory of humanity, reaching far beyond the boundaries of the Christian world.

I believe that what gives the image of the Madonna its immense power is an inner knowing that people share subconsciously. It is the knowing that there is stored within each human being an as yet unknown, sacred dimension that gives each one of us the right to experience ourselves as the Christ Child, sitting in the lap of the Virgin.

This kind of thought may be familiar to you. But did you ever truly consider what is meant by our 'sitting in the lap of the Virgin'? It simply means that the landscape and environment that we perceive all around us, and any—*any*—event that affects our life or weaves itself into its web, represents the lap of the Goddess. It is into the lap of the Virgin that we were laid, like an embryo into a womb, to evolve and expand on our divine essence.

Unfortunately, instead of remembering the archetype that is hidden behind the billions of images of the Madonna displayed on walls, windscreens and altars, people prefer to persist in their belief that the Virgin is holding another child in her hands, and not them! No matter how noble that child may appear in the paintings and sculptures, perhaps crowned with jewels or adorned with a bright aura, we should remember that the biblical reports all convey that the Christ Child was born in a poor stable, the son of a carpenter. This is a clear sign that tells us that this Child finds its reference point within the true essence of any human being, and not only in its relationship to a Chosen one— which latter belief has been forced on our culture during the later centuries of the Christian dispensation.[1]

1 I have elaborated on this precise point in my book *Christ Power and the Earth Goddess,* Findhorn Press 1999.

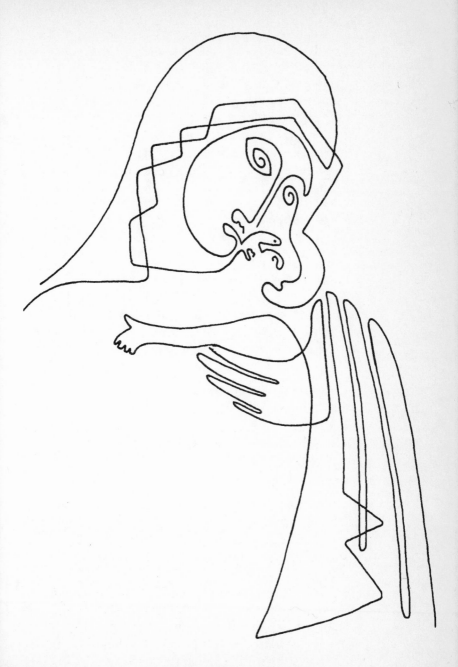

Russian Black Virgin icon
16th Century

One may say that this is a question of belief. Yet I would say that archetypal images do not need a belief system to be recognized as true. They simply are. They are the food of life. Instead of quarreling over their true meaning, one should muster up one's courage and experience their essence. Shall we try? May I ask you to put the book aside for a moment; and then to be here now and close your eyes. But before you close them, in order to facilitate the experience, let me give you some instructions on how to implement the exercise that I have been inspired to share with you.

Breath exchange between the Virgin and yourself

Imagine that you are sitting within the emotional field of the Virgin:

- *The landscape that you can see through the window (or perhaps you see the night sky clothed with stars or clouds), together with all the features of your room, indeed all that is around you, represent the body of the Virgin Goddess. Do not cling to the forms, but to the essence of whatever is around you.*
- *Open your mouth slightly so that by making a circle of your lips you form a channel.*
- *Start to breathe consciously through that channel, letting your breath flow extremely slowly and silently.*
- *Imagine that while breathing out, your breath is being spread throughout the universe.*
- *Imagine that while breathing in, you are taking in the quality of the Virgin's presence which is all around you.*
- *Then slowly breathe out again...*

Continue doing this for a while, and listen carefully how it feels to be the Christ Child sitting in the lap of the Goddess.

Welcome back to the book! I would much enjoy sharing our mutual experience of the exercise, but the fact is that it is much easier for me to tell you my story than it is for you to tell me yours. So please listen to what I experienced three weeks later when,

with a group of students, I visited the sanctuary of the Black Virgin in Altötting, Bavaria.

Nowadays, the sanctuary is perhaps the most frequented place of pilgrimage in all of Germany. People come in crowds to venerate the Black Virgin holding the Christ Child in her lap. It is a medieval wooden sculpture no more that 12 inches high, positioned in a niche within a small rounded Romanesque rotunda painted completely in black. The original chapel was later complemented by an unpretentious church surrounded by a vestibule where innumerable thanksgiving tablets are displayed, donated by those who have experienced miraculous healing after invoking the help of the Virgin of Altötting.

Legend tells that during the early Middle Ages a child drowned in the nearby river. It was some time before the victim could be found and brought lifeless from the water. But the mother was brave and had faith. Pressing the child to her breast, she ran to the chapel of the Black Virgin to ask for her help. Instantly the child was miraculously restored to life.

When I entered the sanctuary I went directly to the black space comprising the round chapel where the image of the Virgin resides, nowadays overladen with silver and jewels. In effect, I acted just as had the mother with the dead child. With great reverence I knelt down in the middle of the chapel, and in a gesture of prayer raised my hands up to the level of my heart. A long silence followed.

Then I curved my lips to form a channel, and imagining and firmly believing that I am within the Virgin—the Goddess being as vast as the cosmos—I started to exchange my breath with her breath. Suddenly I found myself within an enormous eye full of grace. It was watching me at the same time that I was watching it. Its gaze was composed of purest water and filled with a noble kind of compassion.

I felt the inspiration to bend my hands forward and open them as one opens a book, but without moving them away from my heart. In the next moment I noticed that, in slow motion, within the universal eye of the Virgin a crystal clear tear was forming. When it reached its full size, it dropped. For an instant I

was overwhelmed with the power of its beauty and didn't know how to react. Then I realized that, in anticipation, my hands had already taken the form of a channel. In that same moment the tear dropped into the channel of my hands and began to glide towards my heart. I opened my heart even wider so as to receive it properly, but to my surprise it did not enter my inner space but instead slid along the surface of my body into the earth.

Obviously, the blessing was not meant for me personally. Not that I was disappointed, but obviously I had been taught a lesson about the true role of the Virgin's compassion. The message that I felt within the Goddess' tear as it slid down to the ground spoke of her mercy, embracing the dirty stream of destructive, or even malicious and cruel, deeds and emotions set in motion by human beings worldwide. I realized that humanity would have instantly collapsed under the weight of its self-destructive behavior if that burden had not been continually diluted by the field of mercy spreading constantly from the heart of the Virgin Goddess.

When I stepped out of the chapel and viewed it from a distance, I saw a cylindrical wall composed of etheric light, around which were moving innumerable elemental beings and nature spirits, all working hard to strengthen its stability. Watching their busy endeavor for a while with my inner eye, I realized that the material with which they are constantly rebuilding the giant pillar of white light is distilled from the emotional power of devotion and its attendant feelings, which the pilgrims release as they walk ceremonially around the chapel or pray in its sanctuary.

When I asked my inner voice why the beings of nature should invest so much energy in supporting the cylindrical space, I received the knowledge that this giant 'pillar' is in fact a channel. It is through this 'pillar' that the power of blessing and mercy released by the pilgrims through their ongoing adoration of the Virgin is channeled into the energy field of humanity. Its purpose is to constantly neutralize the self-destructive tendencies and actions erupting at each moment within those parts of humanity's body that have become chaotic. This is how we still survive on Earth—even if we are not conscious of the gift that makes our survival possible.

A few weeks later, inspired by the busy actions of the elemental beings at Altötting, I realized that each one of us could help spread the merciful blessing of the Goddess worldwide. We can personally become a channel through which powers and qualities can be released that are capable of dissolving the forces pulling humanity, and nature with it, into the abyss of death. Such action on our part would provide welcome support for the self-healing process initiated three years ago by the soul of the Earth. By this I mean the so-called Earth Changes that are currently affecting our planet in an unprecedented way. As I explained in my last book, **Earth Changes, Human Destiny**, the fundamental frequency of the earth body has been changed: its power-fields have been reinforced and the emotional field has been cleansed. The consciousness of the earth has transcended the limitations that were previously holding it locked within the physical body of earth and it has spread far out into the universe. A new Earth is in the process of birth[2].

The first opportunity to use the healing channel surfaced as I was leaving the birthday party held in honor of my granddaughter Tara, a beautiful young lady of 11 years. In spite of the cheerful atmosphere, I felt a dull cramp that was slowly and overpoweringly invading my chest and heart space. I tried to ignore it, thinking that this was not the proper time to work on my inner problems.

Afterwards, I awoke in the middle of the night and realized that the cramp was still there. Now I was ready to concede that I was dealing with a message expressed through the language of my body. I felt that I had better listen and avoid the need for the Goddess to invent some more severe way to deliver her message. Life always finds a way to say what it has to say. We can of course persistently ignore its messages. But by going that route, we run the risk of being overthrown at an unexpected moment by some 'trumpet blast'.

What I am talking about here is the hologrammic language in which the Goddess talks to birds, rivers, forests, and to human

2 For more precise details, see my book *Earth Changes, Human Destiny: Coping and Attuning with the Help of the Revelation of St. John*, Findhorn Press, 2000.

beings too. It is composed of innumerable impulses that pop up amidst our everyday life situations, calling for our attention and the subsequent action or correction of the ongoing processes. It is a flexible language that can make use of most unusual ways of expressing itself. Its messages can be articulated through the medium of dreams, bodily reactions, sudden inspirations, as well as the banal situations that life brings with it, such as mishaps, bright moments of joy, illnesses of all kinds, or signs that often pass unnoticed. To become sensitive to one's life and independent of the often misplaced advice of others, one should become alert, listening and learning what the spirit of life— poetically I call it the Goddess—is personally telling you. You need to remember that she may talk to you at any moment and that she uses a most elaborate language composed of everyday life. This is her hologrammic language, and it is easy to overlook or ignore her message.

While I was lying awake in the middle of the night—it was not easy to digest the abundant food from the birthday party—I remembered how in the past I had often ignored the messages that tried to express themselves through my bodily reactions, and how painful had been the consequences. So I succeeded in convincing myself that I should stop ignoring the cramp and look for the cause of whatever was holding my breath as if closed in a rigid cage.

I started to breathe consciously while I looked inwardly to perceive the context of my bodily reactions. Quite suddenly, I noticed a transparent being approaching me from behind. To be approached from the back usually means that one is confronting the spirit of an ancestor, a soul from the world of the deceased or—as in the present case—one of the past-life aspects of a human being presently alive. As the spirit came closer, I noticed that, instead of a human head, it was bearing the repulsive head of a wolf. At the same time my intuition identified it with one of the men who had attended that evening's birthday party. Suffering from the pain of severe spinal problems, he had had to use crutches to move around.

Thus far I had recognized three elements that, if put together, could yield the intended message: the crippled man that I had met the day before, the wolf-masked head from a past

life memory, and the cramp that was interfering with my breathing. To come to a deeper knowing of a situation's meaning, I often use a method that was taught me while working with nature and exploring natural environments. In my imagination I let different elements of a place or a landscape merge one into the other, while I myself work on perceiving the forthcoming synthesis. I become one with it so that I can 'see' the issue from the inside. In this way I often get insights whose complexity surprises me.

In the present case, I put together the above-mentioned three elements derived from the hologrammic language of the moment. Instantly, there appeared the image of a big pyramid-shaped fire whose flames spiraled higher and higher. I understood that a real fire was not intended, but rather a fiery state of upsurging emotions, in which the two of us—the man with the filthy wolf's mask and myself—were competing for greater power and dominance in our clan or kingdom. It was disgusting to view it from the perspective of the present day.

Then a sudden knowing surfaced—I cannot explain from where—in effect a kind of intuition. I knew that in his striving for power my opponent was using the instruments of black magic. But I seemed to be versed in psychic protection. As a result his projections recoiled on him, so that he could never more be rid of the repulsive animal head that he had tried to project on me. The health problems with which he was struggling in this life seemed to originate in the, now invisible, distortion of his head.

What to do in such a situation? First of all, I sincerely forgave him and asked for the blessing of universal forgiveness. Yet I felt that such engagement on my part was too passive. It remained on the spiritual level and my decision was not sufficiently grounded in the emotional dimension of the heart. Then I remembered the tear of mercy from the eye of the Black Virgin. As I had in the chapel at Altötting, I exchanged a few breaths between myself as the Christ Child and the all-embracing presence of the Virgin. Next, I opened a V-shaped channel with my hands in front of my heart chakra. In the very next moment, the crystal clear sphere of the Virgin's tear dropped into my hands. It was so full of the fluid quality of grace that I feared that it would overflow. Instead, I

carefully directed the channel towards the imagined presence of the person involved, and by twitching my hands a bit I caused the tear to roll in the direction of my former enemy. I could perceive him as totally bathed in its cleansing and liberating vibration. What a relief!

It was mid-December 2000 when severe clashes were occurring between the Palestinians and the Israelis. The previous day, a call had arrived from the Global Peace Work Institute in Tamera, Portugal, to support the search for a possible resolution to the conflict. How could one single person, sitting at home more than a thousand miles away, be of effective help? Now I knew. I performed the same procedure as I had during the previous night's struggle with the past-life memory and asked for the tear of mercy. But this time I directed it towards the land of conflict. I was surprised how thirsty the land was there, sucking up the channeled grace.

I would be happy for you to pluck up your courage and go into the experience for yourself. The business of explaining and convincing on the mental level would use up too much of this book's precious space. Opening up to the immediate experience could also give the Virgin the opportunity to answer your call in the most appropriate way for you personally. Besides, to be honest, I know that to write a book truly dedicated to the Goddess means that I must leave behind the masculine tool of overpowering intelligence and find a kind of expression that is in harmony with her way of being. And her way of being is equivalent to the way of experience.

If this makes you feel stressed or nervous, and unready to glide fully into the experience, I propose that you take a few deep breaths and relax. Without moving from your chair, you can do a hologrammic exercise to center yourself in the peace of the present moment.

Hologrammic exercise to experience the present moment

Stretch your hands out in front of you and hold the palms open and upright in line with your shoulders. This is a symbol of the duality of past and future, which is the space in which we

usually live. Then start to move your hands towards you. As you bring them close to your chest, turn them around so that finally the tips of the middle fingers touch each other. The triangle thus formed should point towards the center of your heart chakra. Hold it like this for a moment. Then continue the movement by turning the hands downwards and apart again. In this way you will find yourself once again in the position of duality where you started. Hold it like this for a moment. Then repeat the gesture a few times till you feel centered and ready to move into the exercise of experiencing the Tear of Mercy.

The Tear of Mercy exercise

- *Start by deciding where you would like to direct the Tear of Mercy. Is it towards a person in distress, nature beings in a place suffering from ecological destruction, or perhaps the political situation of a country in turmoil.*

- *Hold your hands in front of your chest in the position of prayer. Also hold your goal in your mind and feelings. Next, exchange a few breaths with the Virgin who is present all around you—we did just such an exercise together not long ago.*

- *Open your hands as a book opens. By doing this, a channel has been formed, and now ask the Virgin to shed a tear into this channel.*

- *See and feel the tear bounce for a while in the channel of your hands. Twitch the channel a bit, so that in your imagination you direct the tear to glide to its preconceived goal. Keep a firm heart connection with the chosen person or place to accompany the gift of grace on its way there. Continue for a while to be present there through the vibration of your opened heart.*
- *Choose another goal for your service to the Virgin and do the whole procedure again.*
- *Give thanks.*

I hope you do not feel that I am intruding on your private space if now and then I invite your collaboration. Feel free each time to accept or simply skip it. My proposals for your cooperation originate in an inspiration that I should create this book as an instrument through which the impulses of the Divine Feminine can work in the here and now. You should know that the Virgin does not appreciate our dealing with her as a distant image attached to any historical tradition whatever. She wants us to be open to her presence now within the actual organism of life.

Also, I believe that the time is now ripe for us to start co-creating with her, be it personally or on the level of society. This in turn could open unprecedented potentials for personal growth and planetary transformation. But neither of the traditional ways which we are accustomed to use, neither the emotional practice

of devotion nor the mental instruments of different spiritual practices, are sufficient to get the co-creative process moving. I believe that only the freedom of the loving heart coupled with the creative imagination can bridge the worlds that seem to divide us, and make possible a new phase in the relationship between human beings and the Sacred Feminine.

This is why I have started to write this book right now. A few months ago during my yearly retreat to the Adriatic island, I pondered where my creativity might take me during the coming year. It was then the 4th of September, 2000. My idea was to work on a project best characterized by the sentence: "To avoid the threatened ecological break-down, the planet is radically re-organizing itself." I was pleased with the idea of writing some more on the actual geomantic and ecological situation of the Earth, though my feminine self protested.

It took me some time to overcome my stubborn ego. When I was finally ready to listen to the reason for that protest, I felt, far behind my back, a kind of a hilarious yet peaceful movement. It seemed as if something extremely interesting, definitively feminine in quality, wished to express itself. It carried the sense that in my future work I could offer it a form through which it could voice itself, provided I could develop the kind of sensitivity that it demands. Of course my masculine self immediately wanted to know what I was dealing with.

So I was seduced into devoting more and more of my efforts to finding the answer. No way! Despair and disappointment started to take over. Suddenly I realized that out in the sea a group of dolphins was approaching the island, joyfully playing and jumping out of water only to disappear again. I immediately plunged myself into the cosmic atmosphere that dolphins usually carry around them, focusing again on my question. Their presence acted as a mirror in which I could recognize a new, as yet unexperienced aspect of the Goddess. She wants to surface through my consciousness and perhaps find expression through my writing.[3]

3 On the subject of dolphins collaborating to decode the quality of an ambience, see my book *Healing the Heart of the Earth*, page 142, Findhorn Press 1998.

The idea that the feminine aspect of Divinity is not an unchangeable principle was quite familiar to me. As I mentioned at the very beginning of this Chapter, the presence of the Goddess is a cyclical one. We talked about the natural succession of the white, red and the black phases of the Threefold Goddess. The Phase of Wholeness is followed by the Phase of Creation, and the maternal Phase of Creation by the Phase of Transformation. But this time the inspiration was telling me that even the principle of the Threefold Goddess is not eternal. It may suggest, in any one moment, the old needs to be succeeded by a new epoch of the Goddess.

It was no accident that three months later I discovered a very rare medieval image that depicted the transition from an old epoch of the Goddess to a new one. It is located only a few steps from the sanctuary of the Black Virgin in Altötting, which I mentioned above as the place where I was initiated into the power of mercy. It sometimes sounds incredible, yet the unforeseen potentials of the hologrammic language are packed into each moment of time and each fractal of space. The capacity to store limitless amounts of information within the fabric of the living environment is simply a function of the earth's consciousness. This is why I use the image of a hologram to give a name to the language of life. It means that each situation to which we turn our attention is like a fractal of the whole and has stored within its wholeness all the information that we need in that moment. What is expected of us is that we recognize the message and find a key to its understanding.

Stirred by the waves of pilgrims visiting the Black Virgin of Altötting, the medieval church authorities decided to build a grand cathedral-like building in the late Gothic style beside the modest sanctuary. Later, in the 17th century, the Gothic images became too dull and austere for the taste of the ruling class. They were made to yield their space to the more superficial dynamics of the baroque. As a result—not just in Altötting but everywhere in Europe—the medieval figures disappeared from the altars. Yet it happens that some of them have been preserved in some outlying corner of the buildings. It seems that people were especially hesitant to destroy the ancient images of the Virgin.

Often a substitute space would be found for them, where they could be displayed for people's continued veneration.

This may have been how the unique Gothic sculpture of the Virgin with the Christ Child from Altötting was placed beside the western entrance to the grand sanctuary, an entrance that is not used by the public any more. There she stands on a sickle moon whose shape portrays the strangely wrinkled face of an old woman. It would have been easy for me to explain away that crone's face as depicting the being of the moon, if I did not remember a face with exactly the same quality. This was the face shown me by the Earth Mother while I was preparing one of my early workshops on elemental beings in Kinsau, Bavaria. Interestingly, I was invited there by the *Sophia* Foundation, which has its seat in the small village.

I was exploring the surroundings of the village looking for places where I could lead the participants to experience different kinds of nature spirits and elemental beings when I discovered that the local environment is a sacred nature temple. Unfortunately, its exceptional qualities have vanished from human awareness long ago.

Along the River Lech, deep down in its canyon, there is the dominion of the elemental beings of water. Further, I found that the consciousness of the air element is focused on one of the surrounding hills. One could imagine it as a circle of fairies moving in dancing rhythm high up in the atmosphere. They are free, yet connected to the top of that hill through a kind of a light pillar, and represent the consciousness of the surrounding landscape.[4]

The center of those beings who ensoul the element of fire is marked by the Basilica of St. Michael, built during the Middle Ages in the nearby town of Altstadt. Luckily the sanctuary has preserved all its architectonic and sculptural beauty, expressed through the language of the Romanesque style. It is not by chance that the builders invoked the presence of St. Michael there, so that his spear may counterbalance the 'dangerous' powers of the

4 For more detailed information on elemental beings, see my book *Nature Spirits & Elemental Beings*, Findhorn Press 1997.

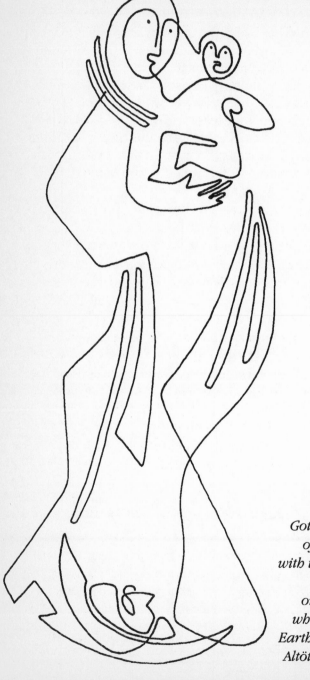

*Gothic sculpture
of the Virgin
with the Christ Child
standing
on the Moon
which bears the
Earth Mother's face,
Altötting, Bavaria.*

fire beings who have been residing in the place since time immemorial. To mark the intent, there is a carving of Michael above the main portal, featuring his famous fight with the fiery dragon.

Finally I found the area dedicated to the beings of the earth element. What once must have been a sacred grove is nowadays incarnated as a simple wood situated on an overhang above the River Lech. The entrance to the wood is guarded by a giant beech tree whose broad network of roots spread visibly along the slope. I felt inspired to enter the kingdom behind its root system with my full consciousness, and there found awaiting me the face of the Earth Mother.

At first I was shocked to meet 'in person' a figure that belongs to the mythic world, and to experience its almost tangible presence. Then a vibration of grace hit me and dissolved all my preconceptions. I gazed into a broad mask-like face composed of tiny clods of earth pulsating in the dark brown color typical of the Black Virgin icons of the Middle Ages.

I felt the impulse to step into the mask-like face and was amazed how vivid the images of the elemental beings became after I started to look upon them through the eyes of the Earth Mother. Afterwards, I began to use the image of the Mother's face-mask as a doorway, in order to perceive through its opening the invisible world of elemental beings and nature spirits who—to put it in a symbolic way—are her children.

You can test the method for yourself when you next go for a walk in a forest or visit a place imbued with the intelligence of nature.

To see nature through the face of the Earth Mother

- *Choose a place where you can feel the presence of the powers of nature.*
- *With eyes open, imagine in front of you the broad face of Mother Earth, composed of tiny pieces of wood, chunks of earth, interlacing roots or mosses... Use anything useful that you notice in the ambience of the exercise as material for your imagination.*

The face of the Earth Mother,
my vision from Kinsau, Bavaria.

- *Be sure that the image you are building is imbued with your love for the Mother.*
- *Do not let yourself hesitate too much, and build the image swiftly so as not to lose its emotional and magnetic momentum.*
- *Then, in the very next moment, let your consciousness slide into the face of the Mother to become one with it. Forget the image and be free to perceive the qualities, powers or beings that reside beyond the visible face of nature.*
- *When you return to your everyday awareness, give thanks for the insights you have gained.*

After I had used this method as a communication tool for a year or two, I forgot about it. The face of the Mother became overlaid by other methods of perception that I later discovered and taught. But three months before my visit to the Black Virgin sanctuary at Altötting, it reappeared with enormous strength, almost as a command. It was the end of August, 2000.

At that time I was at work decoding a landscape temple in the environs of a place quite close to Altötting. This place, stewarded by the Earthchildren Montesori School, is called Eberharting. By 'landscape temple', I mean a composition of particular places that together make up the sacred dimension of a given landscape. I will deal with this theme in more depth later. At this time it is only important to mention that, according to the signs I found, the landscape temple of Eberharting has its roots in the Goddess principle as it developed during the Neolithic Age. Its foundations are associated with the figure of the Triple Goddess as briefly sketched at the beginning of this Chapter. This means that the landscape temple is basically composed of three sacred places, of which one is dedicated to the Virgin as the embodiment of Wholeness, another to the maternal principle of Creation and the third to the Black Goddess of Transformation.

While doing geomantic research on the three places, I came upon a spot at the side of a creek that gave me a sense that it was calling urgently for my attention. Unfortunately, I decided that I

did not have time for the place just then. As I continued to walk past it, I felt that I was gradually becoming lame from the inside of me. The sensation that I was in the process of petrifaction became so overwhelming that I started to panic. I knew that the only way to regain my sanity was to be honest with myself and trust my intuition.

I had to admit to myself that I had been called to the place but had not allowed myself to listen to the call. So I returned to the spot by the creek, and the frightening sensation of being gradually turned into stone disappeared. I asked forgiveness for my conscious ignorance, and tuned into the place. In that same instant there appeared the broad, somewhat repulsive, earth-like face of the Mother that I knew from the communication in Kinsau.

Looking at her face which was as beautiful as it was terrible, I was deeply touched by her presence and filled with joy. But I couldn't help myself asking her a most stupid question—stupid because it was not in tune with the sacred character of the moment. I asked her if she could give me some information about the landscape temple that I was about to investigate.

Her answer was a strange laughter that made the whole ambience tremble, myself included. In between laughs, she exclaimed: "My daughters!"

I fell to my knees and gave thanks. Now I had an important key in my hand. The Goddess is not a static principle, attached to eternity. As the earth changes and humanity runs through its different phases of development, she too is changing. One could speak of the different generations of the Goddess. What she was as the Mother Earth in the most remote times was later transformed into the Threefold Goddess of the Neolithic era, afterwards becoming the Mother of different religions: the Buddhist Tara or Chinese Quan Yin or Christian Mary. These are her 'daughters and granddaughters'.

Yet her life goes on. I mentioned my sense of a new phase of her presence, a 'new generation' that is right now in the process of preparation. I could sense it mirrored in the play of dolphins out in the sea. Later the inspiration became clearer, and I started

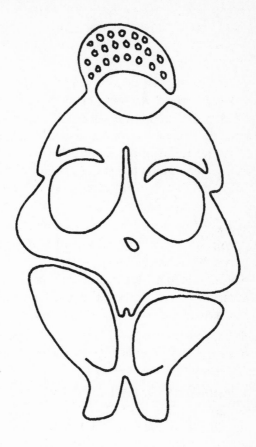

*Mother Earth figurine from the Paleolithic Age,
called "The Venus of Willendorf."
Note the stars on her head and
the roots to anchor her in the earth!*

to use the expression 'the Daughter of Gaia' to give an appropriate name to the Goddess in her process of rebirth.

Let us now return to the cathedral-like church structure in Altötting and take another look at the figure of the Virgin Mary standing over the old Mother of the Moon. Here we are facing two generations of the Goddess. Below, one sees the mysterious face of the Mother Earth, the Paleolithic Goddess also known as the Venus of Willendorf. Her cycles of fertility and transformation follow the cycles of the moon. It is no accident that the medieval sculpture depicts her within the moon's sickle. Note too that her eyes are closed while those of the Virgin Mary are wide open. She represents that period of human evolution when we followed the rhythms of life's wheel in an instinctive way. The eyes of our conscious freedom, the freedom of choice, were not opened till, as a culture, we experienced the touch of the Christ initiation. Only after that, holding the Christ Child in her hands, can the Virgin gaze with open eyes at the universe.

Looking at the sculpture yet again, we may recognize that a dangerous polarity exists between the two generations of the Goddess. One pole is condensed at the bottom of the figure around the symbol of the moon and the old crone, while the other is situated high up around the head of the Virgin and the solar principle of the divine Child. There are some 20th century images of the Virgin where the tension between the indigenous, earth-connected pole and the Christianized mentality of the head has in fact broken up in hostility. In such cases the face of Mother Earth may appear as a snake, while the Virgin is smashing its head with her right foot. The sense that the ancient Mother Goddess and the young Virgin Mother belong together seems to have been definitely lost; and with it we have lost the sense of the partnership between the two poles of our being, the nature-imbued and the spiritual—which are the poles not only of ourselves but of the universe as well.

How I was seduced to plunge myself as a Man into the Goddess Experience

It is a strange fact that an intimate relationship with the Goddess has been initiated three times in my life, each at the beginning of a decade: 1980, 1990 and 2000! The first of the three cycles began with a confusing mixture of dreams and health problems. My masculine self was not ready yet to accept the Goddess consciousness and rebelled against it. I didn't even really understand what was going on. As a result, the unacknowledged inspiration was soon lost in my various efforts to develop forms of alternative ecology and raise them to public awareness. A decade later the cycle began again with a grand fire of inner inspiration and enthusiasm, which however did not last very long. Later I will tell you more about why it dwindled.

This time, at the threshold of the third millennium, the situation is different. First of all, after two decades of struggling with the concept of the partnership of God and Goddess, my masculine ego has accepted the fact that it has to share its throne with a woman. Even though I am a man, I honestly try to be aware of the feminine aspect within myself and within the environment. My efforts may have been too mental and therefore not sufficiently in tune with the emotional dimension of the Goddess' presence. But there is also a good side to it. In the meantime I have collected a good deal of knowledge of the Divine Feminine, combined with a deep experience of the Goddess' presence in the landscape, and within the landscape temples of different cultures and epochs.

And yet, this time too, after two decades of preparation, my re-entry into the force field of the Goddess' immediate presence was terrifyingly dramatic. I even had to go through a near-death experience, followed by a painful three-month process of cleansing and attuning—does this happen just because I am a man?

There is a secret involved, which I am beginning only gradually to understand. It tells me that the human being, as an incarnated body, was formed by the Earth as a fractal of its wholeness. Relating this to the language of the Bible, we should look at the myth of Eve being created from Adam's rib. I suggest that this story was twisted through the influence of the patriarchate. I believe that the original version told that Adam, as a representative of the human race, was created as a fractal of Eve, who represents the Earth's wholeness.

The plants, animals and elemental beings are expressions of different aspects of the Earth Cosmos, but this is not true of the human being who is a kind of incarnation of the planet's totality. The qualities of Earth's plants, animals and elemental beings, even of her power points and the emotional layers of the landscape, are all to be found in miniature within the micro-universe of each human being.

One can hypothesize that, to further intensify the process of incarnating the quality of spirit within matter, the Earth has adopted us humans as a vehicle for her ongoing evolution. It is as if at one point Gaia—the Goddess of the Earth—could find no better way for her further development than to invite us to come down from the fringe of the universe to her surface, so that she could transfer her totality onto the microcosm of the human being. It is as if, through the creative interaction with the angelic dimension that each individual human being brings into the powerfield of the Earth, Gaia is able to weave her future.

This is why, in the course of my writing, I am bringing my personal stories to public awareness, which could be considered a way of magnifying one's ego. The inspiration that tells me to write in this way says, on the contrary, that when an evolutionary movement gets stuck and bogged down generally, that is the moment when the Earth initiates billions of transformative

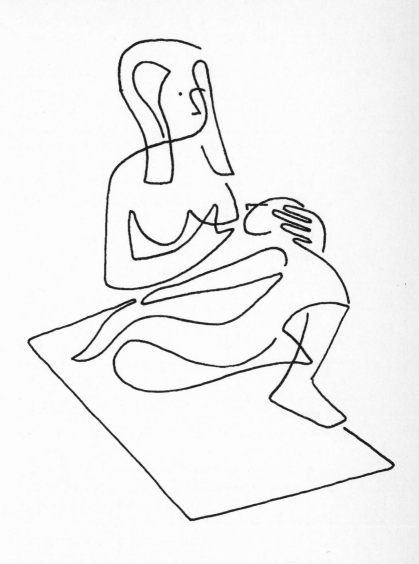

The Egyptian Virgin Goddess Isis
nursing her divine Son

processes within individual human beings. Because of the perfect resonance between the individual human being and the Earth as the whole, the synergy of numberless personal efforts towards change will inevitably cause a break-through to also occur on the level of the planet as a whole.

Such indeed is our present situation. On the one hand, the accumulation of ecological problems is threatening to suppress the life rhythms of the Earth. On the other, human civilization is trying to exert total control over the planet and therefore is unwilling to submit to the fundamental transformation that could avert the approaching disaster. So what should we do?

This is the time when, to dissolve the blockage in the gentlest way possible, the Virgin tries to touch the intimate hearts of millions of people upon the Earth simultaneously, inspiring them to move into the same transformative process on the personal level that, as a cultural collective, they refuse even to hear about. In this lies the hope for our future. Transmuted from the inside through countless, and most diverse, personal efforts, the general blockage could collapse in an instant and free the way forward.

This means that working on oneself and one's personal transformative processes is, due to the special resonance between the individual and the Earth as the whole, equivalent to saving the life of the planet. By revealing my experiences in this kind of 'earth healing work' and talking publicly about its purpose, I try to inspire my fellow human beings to do their part in a more conscious and therefore more effective way.

Hence, I have always suggested that one should carefully watch one's dreams. It is through the medium of dreams that the inner self—the soul—sends messages to one's consciousness, if more usual ways are blocked through the twisted opinions of the ego. During sleep the outer self or ego is forced to remain quiescent because the emotional and mental powerfields are not at its disposal. Instead, they are free to bathe in the wholeness of the cosmos and the ego has no tools at hand to suppress the voice of the soul. As a result the message spoken in the holographic language of successive pictures can be successfully conveyed to one's subconscious awareness—always providing

that one learns to save it in one's memory before the frightened ego can dilute it at the moment of re-awakening.

It was through the medium of a dream that the first inkling of the Goddess' presence reached me at the beginning of the 1980s. On February 1st, 1981, while staying with my dear friend Austin in Geneva, Switzerland, I received a dream that decisively shaped the following two decades of my personal life and creativity. Each time that a new phase in my development started to take shape I would be led back to that dream and find there moral support, and in consequence discover a new layer of its meaning. My experience shows that among one's daily dreams there do indeed on rare occasions appear dreams with long-term validity and a depth that surprises one again and again.[1]

The first sequence of the three-part dream shows me walking with my friend beside a large lake, watching ducks and swans bouncing up and down on the choppy waves. Suddenly I notice that the sky is getting heavy and utterly dark, as if made of syrup. While the last rays of the sun are still striking the crests of the waves with a remote, silvery light, a gust of wind stirs up the surface of the lake, conveying the notion that a powerful and far-reaching change is approaching.

During the second sequence I am led beneath the earth's surface into a cave illuminated by bright yellow sunlight from an opening above. The ambience is filled with the joyful babbling of an extremely lively water source located in the cave. I am enjoying the place, but in the next instant I am shocked to notice a boy lying unconscious on the ground. The ice cold water of the spring is running over his body's left side so that he is close to freezing to death. Yet there is nothing threatening about the atmosphere of the cave. On contrary, the space is filled with enormous life power and a sense of the sacredness of the spring.

I run to the boy immediately. Lifting him up, I press him compassionately to my chest and shout, "Where are the parents?" I realize that he needs help urgently.

1 In my book written in German, *Die Landschaft der Göttin* (Landscape of the Goddess), page 44, you can find an interpretation of the dream involved that is older by ten years.

The dream's first sequence can be understood as revealing a grand cycle of change that is approaching both on the personal and the planetary level. The following sequence reveals human civilization as a weak link that may prove fatal for us in the future when Gaia initiates her expected cycles of change. These will lead the earthly cosmos into a state of power and beauty beyond all imagination. One of course welcomes such a prospect, yet there is still an ultimate danger that modern human beings, who have almost lost their connection with the original powers of earth and nature, will simply break down under the pressures of the life power of the planet and its restored universal connectedness.

It was not until 17 years later, when the Earth changes had indeed started to unfold, that I properly understood the sequence of the dream related above. I had become aware of innumerable etheric sources of archetypal powers that the earth is opening everywhere on her surface in the course of her self-healing process. Step by step, our environment is being charged with extremely powerful energies that were previously stored within the planetary body and only rarely imparted to the life on its surface. Mythology knows them as the 'dragon powers'. Once distributed upon the surface of the earth, they may bring about an unprecedented increase in the power and beauty of life on the planet.[2]

Contrariwise, the modern human being—represented in the dream by the half-frozen boy—is hemmed in by his rational consciousness, holding tight to the mental level that separates him from the heights of heaven and the depths of the earth. The consciousness in which we presently abide represents only a minute portion of what we really are. This narrow state of being leaves us too weak to bear the escalating life powers of the earth. We run the risk of being beaten down by what should be a blessing.

I understood intuitively what was needed to avoid this tragic scenario. There is an urgent need to find ways to open human

2 For details see my book *Earth Changes, Human Destiny,* Chapter 4, Findhorn Press, 2000.

consciousness to geomantic knowledge,[3] and through it to the deeper dimensions of the Earth, i.e., to the etheric, emotional and spiritual levels. In this way people can have the opportunity to become better acquainted with the true nature of life on this planet and be more rooted in the multidimensionality of the Earth Cosmos. Only if we are connected to our inner self and to the powers of nature within and without, will we human beings be able to accompany the spiral of Earth's ascension to the new level of her evolution.

Inspired by the message of the dream, I developed different methods of *holistic ecology,* among them a kind of acupuncture of the landscape that I call lithopuncture. However, the most important goal of such an initiative may not be to care for the balance and health of specific environments. Primarily I see it as a means of conveying to my fellow human beings the practical idea that each ambience has invisible dimensions that we can perceive and work with. These have nothing to do with esoterics if such are conceived as an abstract yearning for the worlds beyond reality. Rather they have to do with the living environment and with life itself in its wholeness, beyond the narrow physical corset that people project onto it. Ultimately it raises the question, whether we as the human race will be able to continue to enjoy the hospitality of the planet earth or will be wiped away from its surface at the very moment when the Earth Mother—physically manifesting the spectrum of her invisible layers—becomes our most desirable habitat.

There was a third sequence to the dream I had had in Geneva, but one which as yet I couldn't really understand. In summary, my friend and I were hidden in a dark shelter, observing the activity going on in an adjacent, brightly illuminated hall. We saw a group of people walking up and down while performing a particular gesture in front of their bodies. It was not possible to discern precisely what the gesture was, because it was masked by little devotional objects with which that the participants were juggling. Finally they all left the hall, but one young lady suddenly turned

3 In the western tradition, the knowledge of the multidimensionality of the Earth and landscape is called geomancy.

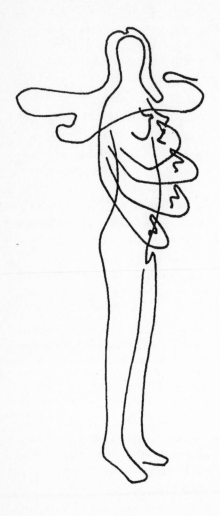

The Virgin Goddess from my dream in Geneva,
performing the gesture of redemption.

around and came running back to the entrance of our hiding place. Surprised, we crept even further back into the darkness.

The maiden stopped in front of our dark hiding place, but still remained fully illuminated by the lights of the hall. In the most natural way, she pulled her dress up over her shoulders to appear in front of us naked in all her beauty. Then, clearly and deliberately, she drew for us the gesture that we couldn't discern beforehand while observing the whole group. With her forefinger she went from the depth of her velvet belly up to the central point between her beautiful breasts. In the next instant she let her tunic fall down again and ran after the rest of the group.

As I mentioned before, my masculine self was not ready at that time to accept the reality of the Goddess, even as a concept. So I interpreted the maiden's gesture as the soul calling on the human being's outer self to work on redeeming the earthly nature within, which has been utterly suppressed during the last few millennia as human attitudes have become patriarchal. The earth-connected aspect of the human being, our quasi-feminine dimension, has been forced down into the subconscious space of the womb, while reason, rising high up in the head, has taken command over our life's decisions. I conceived the message to be that the woman within—as nature, as earthly dimension—needs to be raised again to the level of the heart to unite with the upper, spiritual level.

Such an interpretation makes sense, yet seen in the mirror of the Goddess' revelation, which at that time I did not comprehend, it is too shallow. Now, twenty years later, when seeking a more appropriate interpretation, I didn't overlook the tripartite composition of the dream. In this context the message of the third sequence shows an entirely different face.

The first part of the dream, which has the approaching storm, stands for the Black Goddess who enters the scene when an evolutionary cycle has come to an end and its potentials are being invested only to artificially prolong its duration. There is no doubt that our civilization has reached that dangerous point and is ripe for change and rebirth on a new level of development. Through the agency of innumerable local and planetary crisis

situations that are popping up worldwide, it is sliding into the lap of the Goddess of Transmutation.

The second part of the dream, featuring the limitless life source and consequent abundance of life's expressions, refers to the Goddess' Creative phase. The image shows that even though the blessings of the Mother are flowing freely, their manifestation and dispensation are blocked because human beings are holding tight to the limited capability of a rationally formulated world view. This in turn does not allow the generative aspect of the Goddess to express itself fully according to the demands of the cosmic moment. There is a resulting danger that its blocked potentials twist into their opposite and become destructive.

The third part of the dream speaks in the name of the Virgin Goddess. She finally offers us the key that we need to overcome the danger, by breaking down the restrictive blockage of our mind and instead tuning into the ongoing transformative process. We are to understand that key as the gesture connecting the womb of the Virgin to her heart.

But the key isn't all that simple to grasp. Does it mean that the sexual dimension of the human being has to be fused with our spiritual layers? This is certainly one aspect of its meaning. The Goddess' gesture did indeed run upwards from the sexual zone of her body.

The sexual dimension within women and men does undoubtedly represent one of the means through which the powers of nature work within our being. First of all one thinks of the miracle of childbirth, i.e., the capability of manifesting a lofty spirit as a visible and touchable being. Yet I believe that the act of communion between human beings, through the medium of sexual polarization on the one hand and intercourse on the other, is equally important. Love, touch, play, joy and oneness as experienced in a sexual relationship belong to the basic qualities of life.

Let us take the sculpture of the Virgin Mary in the great church at Altötting as a model through which to further explore the message of the Virgin's gesture. Let us imagine that the wrinkled face of the old Gaia who is coupled with the Moon at the

base of the sculpture represents the earthly counterpart of the Virgin's cosmic aspect. These are the powers of nature that slumber within the Moon's sickle and symbolize the menstrual cycle. By this I mean that the tripartite life-giving process has its counterpart in the phases of the Moon: the waxing Moon's fertility impulse is followed by the creative phase of the full Moon, which then descends into the phase of change and surfaces as the menstrual bleeding and is governed by the black Moon. Referring to the Virgin's gesture from my dream in Geneva, the face of the old Gaia corresponds to the point below the belly where the gesture started.

The site of the heart chakra where the gesture ended is represented by the Christ Child, whom, in the medieval sculpture, Mary is holding at the level of her heart.

The Christ Child stands for the cosmic impulse that, at a certain point in human evolution, entered our world through the mediation of the Virgin. Its intention was to initiate a new phase in the development of the planet as well as human beings. Translated into a logical statement, the symbolic language narrating how the Virgin became pregnant with the universal God means that the impulse was invoked from beyond the boundaries of the Earth's wholeness.

It was because the impulse of the Child had a cosmic origin that the feminine complement of the Christ was originally identified as Sophia, a bright beam of universal wisdom penetrating the dark, slumbering ambience of the earth sphere. Only later, in the early Middle Ages, was the authority transferred to Mary, the mother of Jesus. Her head became adorned with a wreath of stars to signify her cosmic role.

The sculpture in the church at Altötting presents the Virgin in similar fashion. She stands upright, holding the divine Child in her hands, and floats high above the sexual, earthly and emotional levels of the old Gaia. We should not overlook the tendency to split the 'higher' levels of spiritual quality from the 'lower' ones that are thought to belong to our baser instincts and the dark past of human evolution. They are often identified with the sinful Eve whom the Virgin Mary is to redeem.

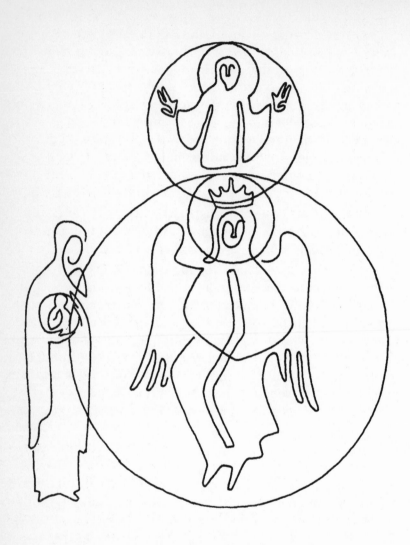

*An 18th Russian century icon shows Sophia in the center,
with Christ as her masculine counterpart above.*

*The Virgin Mary and the baby Jesus
at the side of the picture represent
the embodiment of Sophia and Christ*

During the Christian era there has been a growing tendency to split the cosmic aspects represented by Sophia from the earthly qualities symbolized by Gaia. In turn this has led our civilization, and each one of us who partake in its 'gifts', into a most tragic duality. On one side of our being we have developed a high-tech, head-centered culture manifesting in religious devotion and war, which takes us to roam somewhere high up on the mental levels. On the other side, we mate, make children, struggle for food and enjoy the rejuvenating breezes of nature. And yet we are the same people who ruthlessly cut down virgin forests, pollute the elements of every healthy environment and seek to manipulate the very genes of life.

In my dream in Geneva, the Virgin's gesture cuts right across the abyss between Gaia and Sophia, between earth and heaven, and initiates a bridge between the duality-oriented poles of our being.

Hold on! All the spiritual traditions which aspire towards wholeness have taught that heaven and earth belong together. Do I really have to make the effort to write, and you to read, another book that conveys the same message as innumerable previous ones? What new quality is to be found here that truly needs to be read throughout the world at least a thousand times, to become properly imprinted into the memory of the human race so that it can influence the course of its evolution?

I do indeed believe that there is a deeper layer of meaning to the message of the Virgin from Geneva. It has to do with the almost incomprehensible deed involving 'the overturning of space', which I have been experiencing since the present Earth Changes started in 1998. To characterize it in the simplest possible way, one can say that what we are accustomed to know as existing above may now be said to be positioned underneath, and vice versa. Of course, there are aspects that were not touched by the change, but in my experience there are facets of reality that now appear to be turned around in a most surprising way.

Within the new constellation that is now appearing, we may not experience the spiritual dimension as descending only from the higher realms. Relating this phenomenon to the constitution of the human body, the spiritual impulse may appear to be rising

upwards from the chalice of the hips. Did not a simple mother's womb become the birthplace of the Divine, according to the story told of Christ? Earth has indeed a unique ability to mirror heaven while clothing it in the forms of matter.

On the other hand, it is no longer my experience that the consciousness and the powers of the Earth are locked exclusively within the planetary body, i.e., beneath our feet. Instead, I can feel them nowadays moving freely high up into the atmosphere. Mirrored by the stars and planets, the impulses of Gaia descend as cosmic impulses back towards the Earth's surface.

Prior to August 2000, I supposed that the so-called 'overturning of space' could be a temporary effect of the present Earth Changes. But then, struck by a surprising experience, I was led to change my way of looking upon the heaven-and-earth polarity. At that time, I was studying diverse geomantic phenomena in the landscape at Eberharting, southern Bavaria, with the above-mentioned group of students. To conclude the week's study with a test, the individual students were each to enter a small forest that we had labeled 'the magic forest' because of the rich variety of nature spirits abiding there. It so happened that, in a landscape where nearly every square meter has been turned into farmland, this particular forest had become the last refuge of elemental beings and nature spirits.

So as not to disturb the students at their task I remained outside the forest. However, wishing to learn something new, I called on one of my invisible helpers, the giant fish called Faronika,[4] to show me a place where I might do so. The fish swam through the ethers towards a spot in the adjoining meadow and began to circle around it. A dry branch lay there and I had the impulse to remove it, so as to indicate by a physical action that I wished to enter the inner dimensions of the place. Once the branch was removed, a circular hole like a deep well opened in its stead. Before climbing down, I thought it proper to attune to the non-time of the present moment and I performed the exercise described in the previous Chapter to transcend the limitations of past and future.

4 About the Slovenian myth of Faronika and my related experience, see my book *Nature Spirits & Elemental Beings,* page 20, Findhorn Press 1997.

Fish Faronika
from Slovenian mythology stands for
the Mother Earth archetype.

In answer, a beautiful lotus-like flower appeared above the mouth of the well. I sat on the flower and, as if on an elevator, was taken down to the bottom. There I stood deep within the earth, ignorant of what this was all about. In the next instant, the axis down which I had been brought seemed to turn over, and I found myself standing in the sky high above myself.

Though standing high above, I still didn't lose the connection with the 'me' sitting in the grass at the side of the imaginary well-like opening. The connection ran through the space in the back of my head, so I knew precisely how it feels to be outside one's accustomed framework of space and time. My primary emotion was utter surprise at how soft and even fluid the earth's crust appeared when looking at it from high up. It did not have the kind of firm density with which I was familiar from day-to-day experience. Had the earth indeed changed during the last few years? Is matter, in its process of etherization, becoming softer? Is our accustomed way of looking upon the environment the only obstacle that prevents us from realizing that something different is happening?

In contrast to the fluidity of the earth's body, I felt how firm and 'dense' the arch of the sky had become. I could actually lean on it. Though hanging with all my weight from the heavenly arch, I felt in no danger of falling into the void. As if suspended from a parachute, I felt absolutely stable and supported from above—which was quite contrary to my feeling that the earth beneath my feet would no longer carry me as once it had.

Interestingly, my only worry was how to publicize the fact that reality was about to turn head over heels. My reason argued that there was nothing going on here worthy of public notice; I was dealing only with a random experience of myself. But my intuition was saying very clearly that the insight I was receiving had to do with a reality in the process of evolving, one which will become the every-day reality of the near future.

I had had another remarkable dream in Berlin on September 24, 1998, on the eve of a lecture on the current Earth Changes, but it was not until I had absorbed the above experience that I could understand its message. It was the only one out of a series

of impressive dreams during the year 1998 that I did not include in my book **Earth Changes**, **Human Destiny:** I sensed that I was still lacking the key to its message. I felt guilty, as if I were hiding something important from my readers, but I was just not able to formulate the meaning of its imagery in words. So, while I was writing that book last winter, I just ignored the dream. Now I am happy to make it available to our current readers.

In the dream a huge number of people were floating in the air. Everybody seemed to be hanging from fine threads attached to floating devices of all kinds, mostly parachutes. It was a magnificent view of humanity enjoying a new state of being. Then I noticed that a particular vibration was approaching from the spiritual realms beyond the visible world. I could see its imprint in the structure of the clouds. The vibration caused all the fine threads from which people were hanging to interlace and knot themselves together. In consequence, the people all fell to the ground. What was quite amazing was the gentleness of that fall: nobody was harmed.

In front of a large audience in Berlin the next day, I asserted that the dream pointed to the difficulties we are creating for the planet by keeping our mental awareness 'hanging above the ground'. The ungrounded mass of people, focused exclusively on their mental awareness, represent a tremendous burden; the planet must carry billions of people without getting any of our support in exchange. To bring matters into balance, the Earth might imbue its ambiences with powers of a sort that would force us to reconnect with our earthly facet and become grounded again.

It is true that the above interpretation could represent one of the many layers within the multidimensional structure of the dream, but the above-mentioned experience from Eberharting, coupled with the gesture of the Virgin from Geneva, has opened a brand new perspective on the dream's message. It is saying that in the course of the ongoing overturning of space, people will find their primal source of stability in the airy space of the firmament where the earth consciousness is newly focused, and not on the ground as in the past. Simultaneously the force of the spirit will be working from the opposite direction, through the

earthly dimension of matter. What promising turmoil! It makes one quite dizzy.

As a practical being, once the new insights had settled down, I made decisive changes in the way I personally connect to heaven and earth. And since then I have also taught the new way of grounding when I work with groups. Are you ready to lay the book aside and see for yourself how it works?

The new exercise for connecting to the heaven and earth within

- *Go with your awareness up towards the firmament. Feel the stars and the planets and the impulse layer of the earth consciousness arching above your head.*

- *Project fine threads of light from your shoulders towards that arch and anchor them there firmly.*

- *Create the feeling that you are hanging from the firmament joyfully and with all your weight. Imagine you're not even touching the earth with your feet.*

- *Now start connecting with the earth beneath. Create fine roots of light that penetrate the ground to anchor you in the depths of the earth.*

- *Make sure that there is a perfect balance between the proportion of your weight that is carried by heaven and that carried by the earth. Center yourself in the heart and from there hold the balance between heaven and earth upright within you.*
- *Use this way to enter into your daily rhythm, and do not press the earth with your feet more than is necessary.*[5]

I believe that the gesture that the Goddess showed me in Geneva could properly be understood as this kind of quantum leap. She drew a line with her finger from the bottom of her belly towards the heart center. Three months after the enlightening experience at Eberharting, I was personally challenged by a 'quantum leap' that in turn enabled me to come even closer to a proper understanding of the Virgin's message. At that time I was in Mondsee, Austria, leading a workshop on how to do spiritual work on oneself in the context of the Earth Changes. During a break, a participant took me aside to make me aware of a dull cloud of emotions around my sexual chakra. It was not the first time during the past three months that women had discreetly expressed their concern about what was going on at the base of my belly.

During that same three-month time-span I had been plagued by health problems in my throat area. I was forever coughing and sneezing without any real cause. That morning on December 3, 2000, in Mondsee, I awoke with a clear understanding that my health problems at the base and top of my torso had to do with the above-mentioned overturning of space—this time not within the environment but within the human body.

The sexual and throat chakras do indeed represent a pair of opposites. Their functions are distinctly diverse, and yet have a common purpose. The sexual organs enable us to create on the material level, while the potentials of the throat allow us to be

5 This exercise should not be used as an excuse for a person's failing to ground themselves properly due to their overpowering mental attachment.

creative in a spiritual way. Just as we create babies below, we give birth to the power of the creative Word above.

Now I knew that my health problems at either end of my trunk had to do with the hidden exchange of some of their functions between the two polarized centers. What had been below might now exist above, and vice-versa. I realized that the Virgin's gesture at Geneva was intended to reveal this essential change, and at the same time present the key to embodying the quality behind the change. But how to use the key?

Drawing on my inspiration, I began with a four-beat breathing rhythm coupled with the use of colors. One should breathe in from cosmic space through the throat chakra. By means of the outbreath the cosmic power should be pushed down to the bottom of the belly. The subsequent inbreath should pull the breath up again—but how high should it go? And how should the sequence end?

While I was struggling with these questions, my fish friend Faronika appeared in answer to my call for help. She pushed her way freely through my body to get herself aligned with its axis at the level of the sex. Then she let herself be carried upwards by the stream of my inbreath—but no further than the level of the heart. There Faronika made my heart shine with crystal white light while I was exhaling.

Would you like to try the exercise? It is the outcome of the almost twenty years that I have spent struggling to put the message of the Virgin at Geneva into action as she intended. It is my belief that she revealed the key to overcoming the difficulties we will face when the Earth Changes start to affect the earth's subtle axis and we need to attune ourselves to the new spatial order.

Breathing exercise for attuning to the overturning of space

- *INBREATH 1: Breathe **crystal white** light from cosmic space into your throat center. Hold it there, concentrated, for a moment.*

- *OUTBREATH 1: While you are breathing out, send the concentrated light down towards your sexual chakra on the*

*wings of the outbreath. Let the breath flow down in a broad, vivid stream that is golden yellow in color. The **golden yellow** color vibrates with the quality of cosmic wisdom.*

- *INBREATH 2: Rest for a moment at the bottom of your belly. Then, while you are breathing in again, guide a stream of green light from your sex chakra towards the heart chakra. The **green** color represents the qualities of love and healing.*

- *OUTBREATH 2: Rest for a moment in your heart, and then release the energy with its gathered momentum in the form of subtle blue light, shining out from your heart to all sides and in all directions simultaneously. Use the flow of the outbreath to distribute it as a blessing as far and as wide as possible. **Blue** is the color of the transformed Gaia, the earth wisdom.*

- *Start again from the beginning by breathing in the cosmic light and concentrating it in the throat chakra...Continue repeating the procedure as long as it feels right to do so.*

Next day, after I had written the exercise down, my inner voice urged me to make a clear statement that the current overturning of space does not merely imply that what was formerly positioned at the top is now down at the bottom. This would only mean that the former rigid polarization between opposites had been exchanged for another no less uncompromising duality. What is happening is in fact a new kind of dynamic involving an exchange between spirit and matter. To illustrate this, I was shown the image of a scepter that was constantly turning around in space, so that its upper and lower ends were involved in mutual interchange. It is through the rhythmic medium of breathing that we can rightly experience the wheel-like dance that the axis connecting earth and heaven is newly performing inside our being, and also outside it, in the environment of the universe.

The Unacknowledged Creatress of Culture

There is no argument that history as we know it was almost entirely created by men. An endless succession of great rulers, religious leaders, artists and generals from east and west and from all different cultural epochs have molded the currents of life into the cultural patterns and sequences that today we recognize as different streams of history. Coming out of the far past and leading on into the future, they often merge one with the other, become severely distorted and damaged, or even disappear to give way to new cultural initiatives. Who didn't learn at school the names of various kings or revolutionaries who brought their own culture to a phase of grandiose blossoming, or sucked down another's, destroying its temples and cities and killing thousands of people?

I was deeply moved when, following the second wave of the Goddess' revelation at the threshold of the '90s, I got to know the work of some feminine historians. Riane Eisler, Jutta Voss, Heide Göttner-Abendroth and Maria Gimbutas became my idols. I learned that there have been long, thousand-year periods of human history that have not been scarred by the deeds of the great masters of war and religious subjugation. The archaeological evidence indicates that the so-called Neolithic era, which lasted from between 8000 and 2500 before Christ, knew neither wars nor aristocratic rule and yet was a high culture with its distinctive artistic, religious and technological expression. According to the

historians, it was a matrifocal culture,[1] inspired by the religion of the Goddess and organized by women.

Further, it turns out that our Goddess-centered history should not be confined to periods like the Stone Age that lie way back in the past. The Minoan culture on the island of Crete was based on the principle of the Divine Feminine. It flourished till the end of the first millennium BC, which was a time when all the surrounding cultures on the shores of the Mediterranean were already deeply involved in the patterns of patriarchal societies. Even if one looks at the mythology of the conquerors and destroyers of Crete, i.e., the exclusively male-centered Greek culture, one realizes that their image of the world is also imbued with the hidden breath of the Goddess that has been smuggled into their myths through the back door of subconscious.

As an example, let me point to the myth of Demeter, the Greek Goddess of fertility, land and agriculture. Her cult has deeply influenced the whole history of ancient culture in the West. For a thousand years, up until the 4th century AD, the majority of the important creators of the historical material of that era, whether they were philosophers, politicians, artists or emperors, went to Eleusis in Greece, there to be initiated into the mysteries of the Goddess.

We don't know exactly what message they received there, because it was forbidden, under penalty of death, ever to talk about it. But we do know about the myth of Demeter on which the mysteries were based. It concerns the knowledge of the threefold cycle of the Goddess that is fundamental to understanding the deeper meaning of life—and is the same knowledge that was known to human beings during the millennia of the Neolithic evolution.

There are three figures involved in the myth: the Mother Goddess bearing the name of Demeter; her daughter Persephone

1 To give societies inspired by feminine values a name, I have discarded the usual expression 'matriarchal' because it may convey the idea that women were in a ruling position, similar to the position held by men in a patriarchal society. This would be a wrong association. The expression 'matrifocal' properly denotes societies focused on feminine qualities.

Bird Goddess,
one of the aspects of the Neolithic Virgin Goddess

who is associated with the world of the dead; and Kore, the maiden. Persephone was abducted by Hades, the god of the underworld, who bound her to the invisible realms of death. The mourning mother made the earth infertile to force the gods to accede to her wish to see her daughter again. Finally Zeus, the father God, had to recognize the power of the Goddess and propose a compromise. In the autumn Persephone had to disappear into the underworld to become the mistress of the dead. In the spring she was allowed to be born again to the visible world as Kore, the Virgin.

Kore represents the seed of wholeness, the Virgin aspect of the Goddess, her power to hold the universe together in oneness and joy. Demeter stands for the principle of abundance, the Creative Phase of the Goddess that expresses itself through the innumerable manifestations of life. Persephone embodies the third aspect of the Divine Feminine, denoting the phase of death and regeneration. It is the phase of change and transformation, the Black Goddess phase.

I was encouraged to take the next step toward recognizing the continuous presence of the Divine Feminine within our culture by looking in a new way at the mythology of the Christian era. In January, 1991, I dreamed of a sculpture featuring the Virgin Mary that was so overlaid with thick layers of paint that its details could hardly be discerned. I felt urged to go to work, scratching off layer after layer. Only then did I realize that the lower part of the sculpture belonged to that very well known classical sculpture of Aphrodite, which we call the Venus of Milo. It turned out that the angel above Mary's shoulder was originally positioned at Aphrodite's feet and was Eros, the spirit of love relationships.

It was the little church of Hrastovlje in the Slovenian part of Istria that offered me my first insight into the secret reincarnation of the Goddess within the Christian world. The sanctuary belongs to a poor village, and in consequence the finances were lacking in later epochs to rebuild it in keeping with more modern tastes. Its early medieval form has remained untouched. Even the high walls, with which it was surrounded when threatened by the Turkish invasions in the 16th century, are still there. Interestingly,

*The Neolithic threefold Goddess principle
translated into the Greek myth of Demeter
and its Christian counterpart.*

Greek Myth	Function	Christian counterpart as presented in Hrastovlje Church
Kore	The Seed of Wholeness (Spring Goddess)	Virgin Mary
Demeter	Manifestations of life's abundance (Summer-Autumn Goddess)	Eve with Adam
Persephone	Change and Regeneration (Winter Goddess)	Mother Death

my later geomantic analysis showed that it stands on one of the most important power-points of the landscape temple of Istria.[2]

At the end of 15th century Johannes of Kastav painted its interior with frescoes covering every inch of the sanctuary, including the walls, arches and pillars. Later the frescoes were painted over with a thick layer of chalk which has preserved them for our generation and the generations to come.

The Goddess' revelation had opened my eyes, and I could see immediately that each of the three naves of the sanctuary is secretly dedicated to one of the three aspects of the Divine Feminine. The left hand nave shows a large fresco of the Adoration of the Magi. The procession moves from the west towards the east. In the east the Virgin sits on a throne in a style equivalent to the ancient Kore. The throne is embellished with

2 For details, see my book *Landschaft der Göttin*, page 149.

gilded flowers to symbolize her role as the maiden of spring. Her throne is in the east, i.e. in the sign of the rising sun, and she holds the newborn Child in her hands. Spring, flowers, the rising sun, and the child born from the womb of a virgin are all traditional symbols of the Goddess of Wholeness, the Virgin.

Centrally placed in the arch of the middle nave is a remarkable image of Eve, archetypal mother of human race. In the scheme of the Hrastovlje sanctuary she represents the Goddess of Creation, the Demeter of the Christian epoch. Among the symbols of her role are two children suckling at her breasts, to represent the limitless abundance she bestows on her creation. In her hand she holds a spindle wound with thread to symbolize her role as the one who spins the destiny of all living beings. And she sits centrally in the structure she has made her home, her place emphasized by a tympanum that represents the axis around which creation evolves.

The so-called 'Dance of the Dead' is depicted along the wall of the western nave, offering us an admirable and unique revelation of the Goddess of Transformation. A procession led by eleven skeletons marches in ceremonial fashion towards the setting sun, that is, towards the west. There, the twelfth skeleton is sitting on a throne made of bare stone to represent the Black Goddess, the Goddess of Transformation. With her right hand she is pointing to an open grave, an invitation to human beings to courageously enter the process of change and transmutation. The eleven skeletons are leading the representatives of human society towards the open grave: first of all the pope, followed by the king and queen, then by a cardinal, a bishop, and the hierarchy of other social roles with a beggar bringing up the rear, and finally a baby stepping out of a cradle.

The cycle of the Triple Goddess is presented surprisingly clearly in the sanctuary of Hrastovlje from the Middle Ages. But would you believe that it has also manifested some five hundred years later, during the World Exhibition Expo2000 in Hanover, Germany—not randomly placed in some out of the way corner but right in the middle of the city's main sanctuary, the town church?

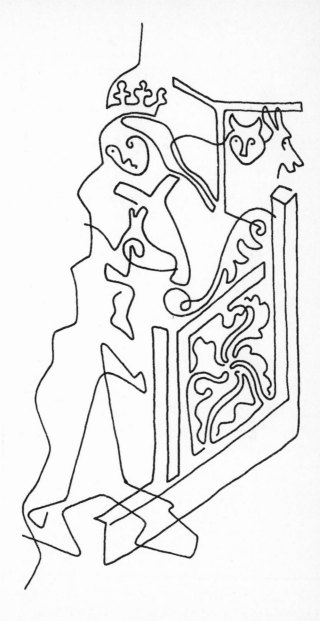

The Virgin from Hrastovlje church, Slovenia, 16th century.
The left-hand side of the fresco is destroyed.

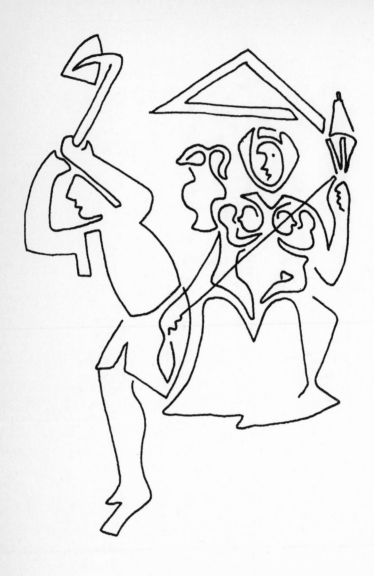

Eve and Adam
scene from Hrastovlje featuring
the Creative aspect of the Goddess

Mother Death leading a bishop to the grave.
Detail of the "Dance of the dead" fresco
from Hrastovlje church, Slovenia,
representing the Transformation aspect of the Goddess.

Hanover was originally built on an island between two rivers, the Leine and the Ihme. At the center of the first-named island there is a very special geomantic point. If one stands there, one has the notion of being able to reach not only high into cosmic space but also deep down into the womb of the earth. I believe that this incredibly intimate connection with the core of the earth may have been the reason why the spot was already chosen as a sacred place in ancient times, for today the town church, or more precisely, her mighty bell tower, stands on the sacred spot. The reverse pentagram which embellishes its summit occasions visitors some surprise, but knowing the place's geomantic situation, it is quite logical that the star should point down towards the earth and not upwards as is normal.

To accompany Expo2000, an exhibition of early 20th century sacred art from all over Germany was displayed within the town church. Innumerable sculptures stood within the sanctity of its marvelous Gothic space.

Among the saints sculpted in bronze and wood and placed directly in front of the main altar, I discovered to my surprise the bronze sculpture of a completely naked maiden. It portrays 'Asunta' by Georg Kolbe. I immediately recognized a resonance with the naked Virgin of my dream in Geneva. Like her, Asunta is also making a special gesture in front of her heart. She holds her left hand upright to form a vertical line. At its side her right hand is arched in a semi-circle. The vertical represents the masculine quality—yang. The rounded form of the circle stands for the feminine—yin. The first one stands for the axis connecting heaven and earth, the second for the rhythms of the all-penetrating life that are evolving around the axis.

Through her gesture Asunta reveals herself as the Virgin Goddess who embodies the wholeness of the universe by embracing its opposite poles in perfect harmony. Attuning to her presence through the above gesture can impart great joy:

"Asunta"
by Georg Kolbe,
representing the Virgin Goddess

The gesture of the Virgin

- *Hold your left hand vertically in front of your heart chakra.*
- *Position your right hand next to the palm of the left, rounding the fingers into a semi-circle.*

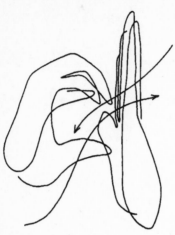

- *Breathe slowly and be aware that the presence of the Virgin is encoded within the breath. In your imagination guide your breath through the gap between the vertical and the semi-circle created by your hands. Be alert to perceive inwardly whatever tends to manifest.*

Having found Kore, I had the impulse to look round the exhibition for Demeter and Persephone. And indeed I did discover two more naked women among the sculptures displayed! It is so healing to experience the beauty of naked women exposed within a Christian church! The Goddess of Creation is represented by a proud woman portraying Pandora, a work by Edwin Scharf. In ancient Greek mythology, Pandora is the counterpart of the Mistress of the Holy Grail who is conceived as the cornucopia of abundance. According to the archetype, she possesses a box in which are stored all the good qualities of the world—a role typical of the Mother Goddess. Unfortunately, as a result of the myth's distortion by the patriarchal culture, Pandora's box became a synonym for all the forms of misfortune from which the world is suffering.

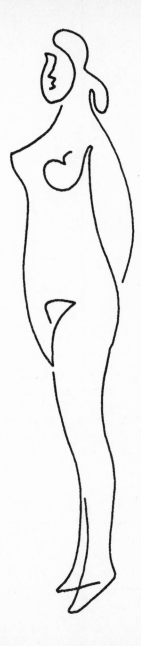

"Pandora" by Edwin Scharf,
representing the Creative aspect of the Goddess.

Kaethe Kolwitz sculpture of a woman overlaying her children, representing the Black Goddess aspect.

Positioned triangularly in relation to the other two sculptures, there is a Kaethe Kolwitz sculpture of a woman overlaying her children. She is smothering them with the weight of her body and she represents the role of Persephone. The sculpture has a very distinct touch of the underworld and the vibration of the Goddess of Transformation.

At this point I must clarify that there is a distinction, on the one hand between the manifold symbols that can be attributed to the Goddess, and on the other her immediate revelation through particular symbols. I am not talking here only of finding symbols of the Goddess distributed throughout the legacy of the successive cultures that have inhabited Europe. The examples I am presenting were shown to me as being among the hidden 'air holes' through which the suppressed impulse of the Divine Feminine could breathe within the different epochs. It was in this way that our civilization did not lose complete contact with the Goddess, though she was banished from public awareness. Suppressed by the long line of patriarchal cultures, for three millennia and more she has had to work from the subconscious space of the human race.

If the patriarchal cultures of the past and present were to succeed in exiling the Goddess' influence completely, history would become a repetitive succession of events leading nowhere. I make this assertion because it is she who fosters a history that is the history of our individual and collective growth, spiraling towards our emotional, mental and spiritual perfection. Seen from the feminine perspective of history, what is most important in our epoch-making initiatives and famous battles is in what each participant gained from the experience—no matter which side they were on.

History inspired by the Goddess is not history in a linear sense, but a complex cultural weaving. It knows neither past nor future but only the eternally present NOW. We are who we are in each moment. Each moment is new and can bring change. At one point during my second cycle of the Goddess' revelation, she made me to look at my wrist watch. There were no numbers and no pointers. Instead there was a tiny weaving of green and red threads, an image of the cultural fabric that she is patiently weaving day after day, age after age.

Of course, I do not want to exaggerate and suggest that the linear principle of time and history is of marginal importance. If our patriarchically structured society did not impose its one-sided will to control history totally according to its own viewpoint, the linear and the cyclic principles of time could both be seen to be equally important in the sense of achieving yin/yang balance. The linear principle is being exalted and pushed into the foreground while the feminine is devalued as something subjective and politically impotent. Herein lies the problem.

The second cycle of the Goddess' revelation began for me in 1990, with her pointing to precisely this problem. It started with a dream that carried a note of the greatest urgency. It sounded as if we have to deal here with a general blockage that needs to be brought to public awareness in a quite uncompromising manner.

The structure of the dream was almost identical with the composition of the Greek myth of Perseus decapitating the Gorgon Medusa. The story goes that the Goddess Athene had sent the hero Perseus to the island of Samos to slay Medusa. Medusa is considered to be one of the three Gorgons—Medusa, Steino and Euryale—who represent the pre-Hellenic Threefold Goddess in all her primeval power. She has a terrible boar-like face, with her tongue hanging out of her moon-like mouth. It has been said that the blood from her body's left side brings life, while that from the right side leads to death. Whoever looks into her eyes is immediately turned to stone.[3]

Athene, on the other hand, stands for the new generation of the Goddess who has been integrated, step by step, into the patriarchal pantheon. Within the new constellation of power, Greek goddesses had to share their roles with males—husbands, fathers or brothers. Athene for example, as a successor to the ancient Virgin Goddess, must be born out of the totality of the universe which she herself embodies. This is why she is called "Partenos," virgin-born, in Greek. As the myth progressively became imbued with patriarchal qualities, she came to be born out of her father's head.

3 You will remember the face of the Mother Earth, of which I wrote in the First
 Chapter in connection with my experience at Kinsau. It showed the same kind
 of savage beauty.

The pre-Hellenic Goddess Gorgon Medusa
with her child Pegasus,
to whom she gave birth
at the moment of her decapitation by Perseus.

Perseus represents the modern, logically oriented human being that the Greek culture has successfully launched into the orbit of our civilization. To enable him to decapitate the Gorgon Medusa without being turned to stone, Athene gave him a polished shield. This stands for the capacity of the rational mind, which human beings developed during the ascendancy of the patterns of the patriarchal cultures. Instead of looking into the eyes of immediate reality and running the risk of being turned to stone, he could watch the abstract image of the Goddess, mirrored in the shield of his mind, and kill her without being hurt himself.[4]

The story ends with Athene placing Medusa's head, surrounded by its celebrated wreath of snakes, on her own chest. Such a gesture may symbolize that the archetypal power of the Mother has become integrated within the new world-view, to become part of the daughter Goddess' grandeur. As a parallel, we may remember the Virgin with the Christ Child at Altötting: at her feet is the moon, and on it is the wrinkled face of Gaia! In both cases, in the ancient myth and the Christian sculpture, one can imagine that the symbols bear witness to the relatively harmonious succession of two different generations of the Goddess. Or do they convey the sense of a combat between two different worlds that do not understand each other?

This is precisely the point where the hidden problems lie, and it is the point addressed by my dream of April 25, 1990, which launched the second phase of my personal revelation of the Goddess.

In my dream the three actors in the above myth were represented by three people whom I know in life, and so am well acquainted with the qualities they embody. The role of Athene was taken by a slim, spiritual woman; the role of the Gorgon Medusa by an artist whose mind often used to wander in poetic hallucinations; and the role of Perseus was entrusted to a friend of mine whose manner of thinking tended to give absolute priority to logic and the intellectual kind of rationality.

4 For arriving at this understanding of the myth of Medusa, I owe my thanks to Jutta Voss and her excellent book *Schwarzmond-Tabu*.

The story told by the dream is that 'Athene' has convinced the rationalist guy that the emotionally shattered 'artist' has no purpose in the world's evolution. She has advised him to give the 'madman' successive doses of poison to erase him from history. The first dose of the deadly poison had already been given. In that moment, watching the dream from within my consciousness, I realized that the spiritual woman and the rational fellow are about to make an irreparable mistake that could cripple our future. Making the effort to break into my own dream, I took 'Perseus' by the arm, led him aside and explained to him that the 'madman' may be of no use, but by poisoning him, he himself, the rationalist, was taking the path of the murderer. I was totally penetrated by the intuition that I must act at once to halt the process of 'decapitating the Gorgon Medusa'.

The classical myth of Medusa's decapitation relates to the transition from the Neolithic to the Bronze Age, when barbarian nations from the east broke in and destroyed the flourishing Goddess-centered cultures of ancient Europe. In Greece, the tribes of Acheans, Ionians and Dorians fell in upon the land one after the other. They 'decapitated' the existing matrifocal society by killing the men, raping the women and destroying the traditional cultural patterns. In consequence, people's former, vivid relationship with the Triple Goddess was pushed below 'the level of the head', i.e. into the subconscious of the new cultural awareness. Symbolically, the act of decapitation means that certain knowledge is suppressed by erasing it from the level of daily awareness, pushing it down into the realms of the subconscious.

However, the dream is telling us that the mythical act of decapitating the Goddess did not only shake the course of history three thousand years ago in the savage conditions of the Bronze Age, but is continuing with the same degree of brutality in today's highly sophisticated civilization. It is just that we have become used to it. We believe that suppression of Goddess-awareness is part and parcel of the culture of which we are part, and do not even notice the consequent distress roaming below the surface of our daily awareness.

If the Goddess represents the Soul of Life, life in all its dimensions, life in its wholeness and life in its cyclical transformations, then it is not difficult to grasp that to live life and yet ignore its divine dimension means, in any long-term sense, to steer towards suicide. As long as we were trying to manipulate life through the medium of iron and coal, hammer and sickle, history was at times severe, but still a useful classroom for our further evolution. But now that we are starting to manipulate the archetypal powers of the atom and the sub-elemental consciousness of the genomes without first nourishing a pristine relationship with the Soul of Life—the Goddess—we have in our hands the first cup of that deadly poison. One could say that we are deliberately turning the Virgin's sacred tools that she uses to make life on the physical level possible into tools that deny our own life's source.

There is still the question why the archetypal Goddess in my dream should have been presented through the figure of a man. The reason for choosing a strange madman-artist to be the representative of the Goddess might be that he does not represent the Goddess as she is, but as she appears imprinted in the memory of a culture that has suppressed her true nature.[5] Look again at the face of Gorgon Medusa. The strange, threatening and confusing aesthetics of her appearance clearly differ from the classical canon of beauty cherished by the Greeks. Similarly, the wise, emotionally powerful and sexually potent presence of the Goddess differs from the mentally organized and rationally controlled framework and behavior patterns of modern society.

20th century art, with its limitless freedom of expression, its craziness and poetic power may be the only phenomenon in modern society that can be compared with the strange qualities of the life-birthing Goddess. Characteristically, modern art is also continually confronted with the threat of exile into galleries, theaters and entertainment halls, which would prevent it from

5 Compare the 'Dionysian frenzy' and the behavior of the Maenads who represented the patriarchal Greeks' projection of the impact of the Goddess on a human mind which is unprepared or in denial. The Maenads tore Orpheus to pieces.

influencing the current course of modern development, taken under the guidance of rationally oriented science. There are sufficient reasons for choosing a madman-artist to represent the tragic situation into which modern civilization has pushed the presence of the Goddess.

Natural catastrophes are another possible symbol of the tragic mode of expression that our highly rationalized society has thrust upon the Goddess. Such catastrophes are continually breaking through the framework of mental control that we try to impose on all aspects of nature's kingdom. Like people in general, I would flee from catastrophic situations, and yet I must admit that they are needed. It seems that only catastrophes can shake human self-pride to its foundations. Piercing through all the blockages, they are able to convey to our awareness the feeling that there is something more powerful than our all-controlling mind.

Let me make myself clear. I do not mean that the smaller and greater catastrophes that daily beat on the drum of our awareness are a proper expression of the Goddess' qualities in general. I do assert that in conditions where we use mind control to try to block the in-depth expression of the Soul of Life within our culture, the Goddess is forced to seek such an inappropriate form of revelation. Or would you rather that life ceased to exist? Do you believe that life could continue to flourish for ever, if over millennia its consciousness—the Goddess, the Divine Feminine—is forced to suffocate? Does she not have the right to make us aware that we are making a deadly mistake? Characteristically, scientists are promising that so-called 'gene manipulation' will make it possible to control nature even more perfectly in the future! The Soul of Life feels challenged to warn us yet again, so do not be surprised if the catastrophes get worse.

Let me clarify a further point. I do not believe that the rational mind and its most lucid expression, logical thought, are rubbish. On the contrary, I believe that they are precious gifts donated to human beings by the Soul of Life. They are the heralds of our freedom and the most powerful tools of our creativity. What I am trying to bring to our awareness is the tragic use to which we are currently putting these splendid gifts. Speaking for

our culture, too often we use the gift of our free rationality to subdue nature; or else to suppress the voice of the divine presence within our being and within the organism of the Earth. We could instead use those same gifts to co-create with the consciousness of nature. I believe that this would lead us into the experience of unprecedented health and joy.

No less interesting than the madman-artist of my dream is the figure of 'Athene'. She is the very spiritual woman who, in my dream, started the procedure to finally extinguish the Goddess-memory from the fabric of modern culture. She seemed to be a woman but she acted like a man. Indeed, she is a relative of Athene, born from the head of the father God.

I identify the masculinized woman with the spiritual preconceptions of the modern era. These hold tight to the concept of a monotheistic God as the supreme principle of the universe, without noticing that our culture is consequently missing something essential. And what is missing is in that exact area where the powers of God should *manifest*. What is missing is the wisdom that manifests those qualities that are most appealing within the image of God: love, peace, and mutual understanding in our daily life. Are they not missing because the feminine principle, whose cosmic role is to make those qualities a living reality, has been excluded from its true status as the equal counterpart of the masculine God?

To take an example from the Christian culture, one can frequently read accounts of how the feminine counterpart of the Divine is struggling to make the public aware of her presence. I am referring to the so-called appearances of the Virgin Mary. There were many of them recorded during the last century. The worshippers receive them with great enthusiasm, yet the inspiration soon tends to dwindle, suffocated by the rigid Christian patterns that the Virgin is forced to use as her mode of expression. If she did not, she would risk not being recognized as a relevant voice of the Divine. The last tragic example is her appearance as the 'Queen of Peace' at Medjugorje in Bosnia and Herzegovina, where she manifested herself in a country devastated by war, murder, and rape.

It is not that I do not believe in the Virgin Mary's appearances. On the contrary, I cherish them as the most obvious evidence that the Goddess is trying to contact the human race at the present time and speak to the minds and hearts of people worldwide. I can feel the exquisite vibration that radiates even from the kitsch-like images produced in her memory from Medjugorje, Lourdes, Fatima or Guadeloupe.

Unfortunately, we do not understand that the Virgin Mary's appearances are only one of the possible mediums through which the Divine Feminine is trying to reach humanity. She is being forced to use a particular path in hopes that it may ring a bell in the rational mind of a race addicted to physical reality. She has to appear 'from outside', almost on the physical level, to be recognized at all. But her message then gets blocked, because millions of people attach their devotion to the medium, instead of searching for the message.[6]

The other problem is that as faithful Christians we are in total control of the 'language' in which the Goddess talks to us. We expect her to use a pre-conceived theological vocabulary. In this way we preempt her freedom to reveal any alternative to our belief system. Under these conditions, how can she inspire us to go beyond the boundaries that we ourselves have projected onto her revelation?

To make available a tool which will help transmute the rigid patterns that forbid our culture's proper expression of life's sacred dimensions, the Goddess of Transformation has shown me a simple breathing exercise. Instead of feeling angry or powerless, one can apply it anywhere without the risk of people asking what one is doing:

Breathe-to-transform exercise

* *Hold in your awareness the pattern that you wish to transform or the blockage that you are experiencing right now.*

6 In a conversation with James Twyman at Medjugorje, the Virgin herself refers to this phenomenon; *The Secret of the Beloved Disciple*, p. 80, by James Twyman, Findhorn Press 2000.

- *While you are breathing in, take the problem into your heart with your breath.*
- *Imagine that during the pause between the inbreath and outbreath, the alchemy of the heart is working on transmuting the problem.*
- *While you are breathing out, cause the transmuted vibration to shine into space with the power of the heart.*
- *Continue the process for as long as possible, or as long as it is needed. You can reinforce your work by calling for help from your invisible helpers, or the Black Virgin herself. Also, you can use the color violet as the color of transmutation.*

The only society I know to have given space for the voice of the Goddess to express itself on the political level is the former Republic of Venice. The relative freedom of expression given to the Soul of Life lasted for about one thousand years in Venice, till the Republic was finally suppressed by Napoleon's military machine.

I say 'relative freedom', because even though Venice was in its time a world power with wide possessions in the Mediterranean and merchant routes as far afield as China, the authorities there had to adjust to the framework of the contemporary Christian culture. So the leaders of the Republic often had to invent false images to cover the true essence of their political rituals. The politicians themselves of course would never have admitted that they were performing rituals dedicated to the Triple Goddess. I am the one to have recognized the hidden patterns, thanks to my knowledge of the unique geomantic organism of the city of Venice, which cannot hide its relationship to the quality of the Divine Feminine.[7]

The hidden role of the Divine Feminine within the political life of Venice can best be observed in the three main festivals that were officially celebrated every year. In their meaning and ritual performance, they represent the maritime Republic's annual

7 For details, see my books on Venice, **A Hidden Pathway through Venice**, Rome 1986, and **Geheimnis Venedig** (The Secret of Venice), Munich, 1997.

reconnection with the three facets of the Goddess. Their purpose must have been the desire to secure a continuous blessing on the state and its population for their well-being and abundance.

According to my investigations, the political and religious festival performed with great solemnity in spring time was dedicated to the Virgin Goddess. Spring is the traditional time for her to initiate new impulses within the organism of life, giving birth to the new cycle of growth and development. On Easter Monday the Doge, head of the Republic, together with his court and officials, went in ceremonial procession to the convent of San Zacharia, there to be received by the Abbess and her nuns. Throughout the winter, the nuns had been working on a new ceremonial headdress, the so-called 'corno ducale' that the Doge wore as token of his authority during his period of service to the Republic. Each year in front of the convent of San Zaccaria, it was by the hands of a virgin—the Abbess—that the Doge was crowned with the new headdress. In the ancient Goddess-centered cultures, the annual enthronement of the sacred king was celebrated by the priestesses of the Goddess as the spring festival of initiation.

The Venetian Doge with his characteristic headdress

In the Goddess tradition, the second great festival in the cycle of the year was the summer ritual of the sacred marriage. This was a ritual to ensure a continual abundance of resources for the country and its population. In Venice it took the form of the Doge's annual marriage to the sea. At the threshold of summer, on Ascension Day in the Christian calendar, the Doge, accompanied by politicians and foreign diplomats, sailed out of the lagoon. Throwing a golden ring into the waves as a sign of the Republic's continuing abundance, he proclaimed himself married to the sea.

The third ritual, the one dedicated to the Goddess of Transformation, is embodied in the famous Venetian Carnival. Officially, it started on January 17th when the Doge and his court

attended the foolery of jugglers, acrobats and other performers in St. Mark's Square. Who knows if any of the people wearing all those fantastic masks were, or are, aware that they are taking part in an ancient ritual, and going beyond the limits of the physical world into the strange realms of death and regeneration?

To recapitulate, the history of culture, as seen though the eyes of the feminine principle, is not organized on the chronological lines of historical events running from the past towards the future. Rather, one can imagine it as a power-field that is constantly vibrating in present time. And yet there is a kind of evolution involved, based on the principle of cyclical transformation. In consequence, one can view the feminine-created culture as a succession of phases, each one of which represents a transformation of the previous one.

The oldest phase of human culture is the so-called Paleolithic Age which lasted for several hundred thousand years. This is a phase practiced by diverse societies of hunters and gatherers who live—even today!—in close relationship with the wilderness of nature. They represent not just the hunters of animals and gatherers of edible roots and fruit, but also the shamans who are perfect communicators with the spirits of animals, elemental beings, and the spirits of the ancestors.

The second phase of Goddess culture was the one that started around 8000 years before Christ with the invention of agriculture and such handicrafts as weaving, building, pottery-making, etc. Called Neolithic, it is an age of conscious Goddess worship, evidenced by countless figurines of the Triple Goddess found all over the world.

The third phase is the problematic one that started with the destruction of the matrifocal world and the upsurge of aristocratic and patriarchal societies struggling for power and dominance. Even though the goddesses were put under the rule of male gods during the Bronze and Iron Ages and though the linear way of male thinking prevailed, I refuse to exclude these eras from the succession of Goddess-created cultures. The act of abnegation should be considered as a possible avenue of cultural evolution.

Even though the patriarchal phase was characterized by the suppression of feminine qualities on all levels, it has opened up new approaches. The act of detaching from nature's powers, for example, has enabled human beings to develop the qualities of self-dependence, spiritual autonomy and freedom of thought.

During the period of dominance by patriarchal ideology, a fourth cultural phase has revealed itself, marked by the upsurge of great religions and spiritual philosophies such as Buddhism, Taoism, Christianity and Islam. The Goddess now re-appears as the feminine counterpart of the male bearers of cosmic revelation. Be it as Tara, Quan Yin or the Virgin Mary, she is contributing her part to helping human beings recognize their true identity and reconnect with their cosmic source.

Our brief exploration of culture—which is the Goddess-aspect of history—has shown that if we stay true to the feminine principle of the ever present NOW, we cannot separate the different phases of our evolving culture as if they followed each other linearly. Several examples show how the phases, though they did indeed start one after the other, also run simultaneously, i.e., they exist parallel to one another.

For example, the Goddess of the Paleolithic Age is known as the Great Mother. She appears during the Bronze Age as the decapitated Gorgon Medusa, contributing her powers to the status of Athene. The images of the Christian era show her as an earthly counterpart to the Virgin who stands for the cosmic impulse of the Christ. Remember the face of the crone in the moon at Mary's feet, and the snake too! And even today I find myself meeting her in the form of the broad, wrinkled face of Mother Earth, to facilitate my perception of the invisible dimensions of nature.

We have also followed the transformations of the Goddess of the Neolithic Age as she branched out into her three basic principles. As the Virgin she stands for the principle of wholeness, as the Goddess of Creation for the quality of life's abundance, and as the Black Goddess for the principle of change and transformation. Through a succession of examples I have tried to show that her trinity is present from age to age, right up to the

present day. We discovered her clothed in the ancient myth of Demeter and transformed into the Christian images painted in the church at Hrastovlje. We were able to recognize her threefold presence within the political structure of the Venetian Republic and even in the art displayed at the World Exhibition 2000 in Hanover, which closed its doors only a few months ago.

On the other hand, our investigations show that our dealings with the permanently pulsating presence of the Goddess, manifesting throughout her different evolutionary phases, are not only cause for bliss and harmony. On the contrary, we have often found ourselves faced with dramatic issues of opposition, suppression and transformation. Human history does not find the Goddess as the Creatress of Culture an easy partner to mate with!

The Divine Feminine at the Foundation of the Human Self

This Chapter addresses the intimate presence of the Goddess within the human being. Here, the relevant question is not whether the person concerned is a woman or a man. The question is whether one is giving the sacred dimension of life enough space to fully express itself within one's etheric, emotional, mental and spiritual facets, regardless of whether one is currently manifesting in a feminine or masculine body.

Being born as a woman does not automatically mean that one has a personal sensitivity towards the all-pervading Divine Feminine, or that it is developed and manifested within one's relationships, be they with one's fellow human beings or with nature. Also, holding the Goddess image sacred does not necessarily mean that the sacred feminine is cherished in one's heart and practiced according to its essence

At the very time when my enthusiasm for the Goddess was at its highest, I was confronted with the real truth of my relationship with the Divine Feminine within me. The realization came in a dream on November 11, 1990. The scene started with a group of us, collaborators all, marching briskly through a large forest. A little later I became aware that I was not keeping up with the group. Instead I found myself on a side-path, walking with a woman whom I inwardly tried to keep as far away from me as possible.

I even pretended that I didn't know who she was and that it was only by chance that I was walking by her side. Nevertheless, I noticed that she was pushing a bicycle which lacked its front

wheel. I also knew that in the depths of her soul she was freezing; and that she was silently asking me to give up marching with my collaborators, and instead follow her onto another path that would run in a direction exactly opposite to the one on which the group was traveling.

I don't think much commentary is needed. Instead of making at least a minimum effort to get in tune with the immediate presence of the Goddess within me, I was roaming around Europe promoting a kind of 'Theology of the Goddess'. I held myself out as an expert, explaining her signs and symbols within the different landscape temples and sacred places. Without my being aware of it, I was myself implementing the model of which I had been warned in my dream. I was decapitating the Gorgon Medusa.

Note that to march linearly in a definite direction represents the active, yang, or masculine way of engagement, which searches for expression in the world of form. How can it bring any blessings to our life or culture if we neglect the foundation that should nourish it and imbue it with life-power? The front wheel that was missing from the bicycle pushed by the woman at my side symbolized the absence of this inner foundation, which is the fully rounded and centered force-field of the Goddess within us.

Even more indicative of how alienated was my relationship with the Goddess within were the contradictions in my emotional behavior that were revealed through the dream:

- While I was striving for the rights of the Goddess in the outer world, I was afraid of knowing her as my inner truth. In fact, I pretended not to know the woman at my side.

- While my spiritual aspirations were engaged in the fiery upsurge of ideas concerning the sacred feminine, the living Goddess within me was freezing for lack of my love. My heart's fire that could have warmed her was evaporating in the ideological character of my actions.

- I was not ready to listen to the silent voice of my inner self—the Soul of Life within me—who was asking me to take my personal evolution on a different path, one which would lead me to a point of pristine joy and integrity.

Neolithic Virgin Goddess
showing the symbols of connecting heaven and earth,
Vinca Culture, Balkans, 5th millennium BC.

Whom do I mean by the 'Goddess within'? To dispense with confusing glamour, I usually speak of the human being's 'inner self'. Another appropriate expression would be the 'soul dimension', seen as part of the holistic spectrum of the human self.

If one imagines the human self as a tripartite composition reaching from the physical part of the spectrum on one side to the divine aspect on the other, the soul dimension has its place in the middle, to mediate between the both extremes.

When a human being incarnates in the earthly world that manifests through matter, we desperately need to have at our side a consciousness aspect through which we can perceive and act in this materialized world. Usually this aspect is called the 'outer self' or 'ego'. Ego has eyes to see, ears to hear, nose to smell and hands to touch, work, embrace and make love.

Some spiritual teachings blame the ego for seducing humans into an attachment to the 'illusion of the physical world'. I vigorously oppose that type of projection. Just as the divine aspect of the human being relates to our participation in the infinitive dimension of eternity, so the ego relates to the framework of our incarnation within the dimensions of time and space. There is nothing wrong in this. It only becomes wrong if the true role of the outer self is misunderstood, and the resulting inner disproportion allots more responsibility to the ego than it can healthily bear. The inflated ego can be destructive of one's inner development, but no more so than the glamorous projections of the so-called 'higher self' and its divine origin, such as are fostered by some spiritual movements.

The cosmic role of the soul is to mediate between the two extremes. On the one side the soul, through its spiritual status, is able to contact the divine core, the 'higher self,'[1] of the human being. On the other side the soul, in following the human being as an invisible companion through the cycles of incarnation, has worked out all the possibilities of contacting the outer self, i.e., the ego. Were the soul's basic role of mediating between the

1 I do not like the expression 'higher self' because I think it no more important than the so-called 'lower self' (the ego). To avoid imposing any hierarchical pattern on the reader, I use the expression 'divine self' for the first and 'outer self' for the second

heaven and earth within us to be suppressed, there could be no communication between the ego and the divine self, and the human being would ultimately be lost in the infinite particularity of matter. This is what ancient traditions refer to as 'the second death'.

If the concept of 'the first death' denotes an individual's natural departure from the framework of physical incarnation, 'the second death' refers to a dangerous life situation where the soul is suppressed to the point of total black-out. The soul can no longer mediate between the two extremes of one's human consciousness, i.e., between the outer self and the divine self. Human beings then run the danger of becoming spiritually handicapped monsters.

I believe that my 1990 version of the Gorgon Medusa's decapitation myth is warning us of this ultimate danger. More and more in the modern era, people are giving their attention to the surface of material reality. It helps little that they may be religiously orientated and believe that a God resides within the infinitive spaces of eternity. It doesn't help because we are lacking the mediating link which makes it possible for the powers of spirit to be translated onto the level of time and space where the outer self is held prisoner.

Ten years previously I had already understood the dangers of the approaching situation and had written about them in my book *Landscape of the Goddess* which I mentioned above. I recognized the Goddess as the universal Soul of Life, mediating between the lofty realms of eternity and the manifested life in the dense dimension of matter. I also understood that the soul, abiding invisibly within the microcosm of the human being, represents a fractal of the universal Goddess. But at that time my personal world was still missing the link between the two dimensions of the Goddess' consciousness. To put it in the simplest way, it was easier for me, highly charged as I was with the male-centered deviations indicated in the above dream, to develop a lively interest in the manifestations of the Goddess around me than to change my inner world and become what I believed in.

I postponed making the needed changes and ten years later had to start from the beginning again. A succession of illnesses during the latter half of 2000 brought home the need for a new attempt to foster my relationship with the Goddess within. These illnesses, which I mentioned at the beginning of this book when I referred to the Black Virgin taking charge of my life, left me feeling insecure and afraid. After my personal sense of self had been sufficiently broken down to make space for something new to coalesce within me, I was given a dream that highlighted the task before me. It was received on August 12, 2000, during my stay at the Findhorn Foundation, Scotland.

In the dream I was brought face to face with first one woman, then with another, who were both playing an important role in my life. The first woman was a down-to-earth gardener, the second a very spiritual intellectual. In the dream I met the first woman while she was engaged in repairing sewer pipes that were leaking somewhere deep underground. I was surprised to learn that she was proposing simply to pour a load of concrete into the pipes and hope that it would fill and repair the hole, whose precise location and extent were unknown. How strange, I thought, that such a practical woman is basing her actions on hope and expectation.

Afterwards I met the spiritual woman who insisted on telling me about some highly interesting projects on which she was working. They all had to do with different methods of ecological healing in natural and urban environments. Suddenly I realized that in some instances her thoughts were running off track and becoming suspiciously fantastic. Is it possible, I thought, that she has become psychically insane since the last time I met her?

No deep insight is needed to see that both women represented the two separated poles of the sacred feminine within me. Together they revealed the tragic results of the separation governing my soul level, which was rooted in my idea of the dual nature of human being. I often talked about this when explaining that we are beings of nature on the one hand and angelic beings on the other.

Accordingly, I was striving to nourish both sides in my

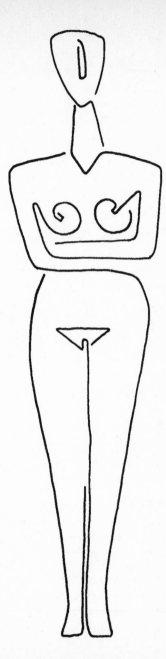

*Neolithic Goddess of Transformation
called "The stiff white nude", Cyclades, Greece.*

personal life. On the one side I was working to deepen my sensitivity to the imprints of nature within my body, and also to the personal elemental being that is—in the name of nature—caring for the well-being of my body's power-fields.[2] On the other side I was persistently engaged in meditation, listening to the voice of my personal relationship with my guardian angel and seeking to be in tune with the impulses of the spiritual world. I was certain that my way of working on myself involved no fundamental error.

The above dream arrived to help me understand how it came about that the stability of my inner world, in which I took such pride, had crumbled in no more than a month. I realized that I did indeed take good care of both the basic dimensions of my being, but I was neglecting the intermediate realm of the soul, the all-connecting principle of the Divine Feminine which vibrates within the human being as a fractal of the universal Goddess.

The situation taught me that even if one develops the highest degree of positive engagement and service on both physical and spiritual levels, things can still go wrong. Let us say that a person takes good care to follow a healthy mode of life, including eating organic food, jogging, living in eco-sensitive housing, etc.; and the same person is active in meditation groups or spiritual movements, perfecting their inner world. Things can still go wrong because the person is missing out on the crazy, emotional, feminine, illogical vibration of the Goddess within. The power-field of her presence may reveal no obvious existential purpose, but it is surprisingly capable of achieving the synergy of all opposites within the complicated totality of the human being. Since modern humans strive towards mental clarity to give themselves a sense of structure and spiritual purpose, it is hard for them to accept the completely opposite nature of the Goddess' impulse.

She has to enhance the power-field of our emotional world, whose watery quality is capable of reaching all the pores of our being, in order to connect all the various aspects of our being in

2 For more on personal elemental beings, see my book *Nature Spirits & Elemental Beings,* Chapter 7, Findhorn Press 1997.

one whole. To take emotional powers seriously may appear very threatening to the spiritually spoiled ego because emotional qualities have such indefinite and vague dynamics; not to speak of the alchemical processes that the soul uses to establish an intercourse between the different levels! Their unpredictability causes the outer self to be especially suspicious of their dance within us.

The stories of the two women in the above dream show the distortions that inevitably surface when the interconnecting and crazy dance of the sacred feminine within is ignored, blocked or suppressed. Procedures and pursuits that have a clear structure and follow infallible logic may unexpectedly lead to catastrophic results. Brilliant ideas and projects that should prove eminently sensible may suddenly end in intellectual chatter and impotence.

This time I made no pretense of not understanding the message, as I had ten years before. I immediately decided to retire for a period of introspection and was luckily able to get the following week free. Three days after receiving the alarming dream, I was ready to work on the schizophrenic condition of my feminine self. The place of my retreat happened to be in the south of my country of Slovenia, on the river Kolpa. It is a beautiful countryside called Bela Krajina, which, translated, means "the White Land."

Since the "White Land" lies at the foot of a plateau formed of thick layers of chalk, it is an easy matter to locate deep caves through which streams of underground water gush out during heavy rains. I found one with the strange-sounding name of "Mare's Cave" and chose it as the archetypal entrance to the underworld. I decided to go through the cave to enter into the world of the soul in search of the lost unity of my inner self. Of course, one does not have to find a real cave, but can simply imagine the entrance to a dark tunnel and use one's imagination as the starting point for the quest. But it felt more real—and more romantic too—to perform the ritual in front of a natural cave.

To create a ritual frame for my quest, I was inspired by the Greek myth of Orpheus, the divine musician. He descended into the underworld to find his beloved Eurydice who had died.

Through the power of his music he obtained permission to search for her in the underworld and bring her again to the surface of daily life. But this was granted only on condition that he did not look back to see whether she was following him until they had reached the sun-lit levels of creation. Unfortunately, Orpheus fell victim to his doubts during the ascent and turned around. In consequence Eurydice had to disappear into the underworld for ever.

I believe that the myth depicts the modern human being's tragic relationship to its 'Inner Goddess', the soul. The outer self is represented by Orpheus, and the invisible soul, i.e., the inner self, by Eurydice.[3] Since the ego is unable to feel the presence of the inner self pulsating 'behind its back'—beyond the physical world—it tries to grasp it with the eyes of mind and logic. But because it is impossible to perceive an invisible presence through the tools of one's rational mind, one is misled into the conviction that the soul does not exist at all.

Orpheus' tragic motion to turn around in the attempt to silence his doubts suggests what lies behind our modern ignorance of the human soul's immediate existence. Instead of applying the 'cold' medium of our mentality to communicate with the inner self vibrating on the non-physical level, we need to use the emotional sensitivity of the heart. We need to awaken within ourselves the very quality which the mentally oriented human being has dismissed from awareness. The resulting dominance of the mind over the powers of emotions has caused the inner self— the Goddess within—gradually to withdraw into the nebulous depths of subconscious, represented in the myth by the image of the underworld.

My version of the 'Search-for-Eurydice' ritual is designed to enable one to contact the inner self, and—above all—to recognize the blockages that prevent one's soul's ascent out of the dim fog of the subconscious:

3 In Greek the syllable 'eu', as in the name Eurydice, denotes something all-encompassing which here corresponds to the role of the inner self. As another example, the Greek goddess of the universal wholeness is called Eurynome.

Ritual for descending into the underworld

- *Imagine that you are kneeling in front of the entrance to a deep cave. State clearly why you wish to descend into the 'underworld'. Ask for guidance and illumination, and especially for the faith you need not to repeat Orpheus' mistake. You can ask your power animal, your spiritual guides or other invisible helpers to guide you.*

- *Imagine that a stream of silvery light starts to rise from your solar plexus. Composed of innumerable tiny stars, this is the etheric path upon which you will be walking into the realms of the subconscious and which will infallibly show you the way back.*

- *Imagine yourself as a little figure standing upon that path and ask for permission and blessing to enter 'the underworld'.*

- *Start to walk consciously into the dark space of the cave, following the light path bubbling out of your solar plexus. Be alert to feel where you are being led and to perceive and do whatever is needed. If you get the feeling that you are becoming lost, stop for a moment and ask for clarity and guidance. Never break up the ritual, even if you feel that you can't go on at this time. In such a case, excuse yourself and return back to the outer self along the same path as you came.*

- *After you have perceived what you needed to realize and have done what you needed to do, return home along the same path, pulling the stream of light back into your solar plexus. Give thanks and go about fulfilling whatever you have promised yourself.*

The morning after my return from my first journey to the underworld, I felt that the Goddess had returned to within the firmament of my being. I could feel her as a beloved partner, moving within me and wearing the same skin. As regards myself, it definitively feels that it is a woman with whom I am sharing my intimate space. It may be that I perceive the inner self as feminine because I am a man. You should check for yourself what the inner partner feels like.

During the weeks following I did more work on the redemption of my relationship with the inner self through the ritual described above. I found out for example that certain traumatic events during my early childhood had imprinted my memory with the idea of being separated from my inner self. This sensation reproduced itself through various events in my later life, thus alienating my relationship with the soul. I felt great relief after the causes of this alienation had been recognized and transmuted.

On other occasions I was led into those layers of the subconscious where the unredeemed memories from the past lives are stored. I had for example to deal with repugnant experiences from the late period of a matrifocal society of which I was a member. As an enthusiast for the Goddess' culture, I was surprised to learn how stifling it feels to be chained by the traditions devoted to the Triple Goddess and her constantly repeating cycles. Suffocated by the repetitive rituals that had lost their creative potential, at that time I developed strong feelings of resentment towards the Divine Feminine. As a result my present relationship with the Goddess within, with my soul, was also overshadowed by a certain feeling of rejection.

To be fair, I must also mention imprints from the era of patriarchal rule which were even more distressing, and profoundly disruptive of the link to my soul. Through a dream received on September 9, 2000, I was made aware of an acute problem bedeviling my relationship with the soul. The language of the dream was simple. A horde of riders fell upon my tribe and we were swallowed up. Somebody approached my dead body and heaped layers and layers of different dresses upon it. It was not difficult for me to understand the message: the tragic events that occurred when patriarchal tribes took over from the matrifocal societies of Neolithic Europe are still glowing like fiery embers, hidden under the many layers of memory belonging to my subsequent lives. The stored-up feelings of powerlessness and grief are poisoning my present relationship with the inner self.

To remove the poison from ancient memory, I decided to perform the ritual that I described above. After I had attuned and asked the animal kingdom for assistance, a black panther

appeared. I asked him to take me to the source of the trauma in my dream. With long bounds he ran ahead of me into the dark space of the cave. Following after him, I arrived in a realm associated with the Balkans and the wars fought there a few years ago. The panther stopped there and I opened myself to see how it felt. Instantly I was overwhelmed by a sensation of profound despair and felt lost in waves of horror.[4]

To help me, the panther brandished his great paw and broke the iron lattice that kept me imprisoned behind the bars of despair. It felt as if a rigid grid had been pierced and shattered somewhere within my head. Out of the opening flew tons of disgusting dung mixed with bones and skulls. I reacted, horror-struck, and lost all sense of groundedness. I felt paralyzed, as if I existed only in the upper part of my body, unable to move. I pleaded for mercy but there was nobody to hear me.

Only through the medium of my eyes, now brimming with emotion, could I ask my companion for help. Swiftly, the panther dug a hole and made me roll into it. I did not understand what he wanted, but soon, as I lay in the hole, I noticed a kind of golden light emanating from the depths of the earth and filling me with the sensation of grace and love. After being cleansed in the transmuting light of the archetypal powers of the earth, I felt free to return home, expressing gratitude to the black panther for saving me in that difficult moment.

I was later shown a method that I would like to offer as a helping tool to avoid getting hopelessly lost in similar situations, and instead be able to successfully transmute such old personal stuff. In this case 'transmuting' means to liberate one's energy, emotions or consciousness from the prison of old memories, traumas or other rigid patterns. As long as these powers are imprisoned or frozen, they represent a burden blocking one's development. Once liberated, they can be recycled for personal or universal use in the here and now.

4 Knowing that European matrifocal societies first appeared in the Balkans and spread from there throughout the continent, I gained a new insight into the origin of the recent Balkan wars. They reflect the unredeemed memories of the disaster that occurred when tribes organized on the patriarchal model overwhelmed the core of the Goddess-centered culture.

A *four-beat breathing rhythm to stimulate transmutation*

- *Hold the situation that needs to be transmuted in your awareness. Ask for help in your customary manner.*

- *INBREATH 1: Breathe in the pure light of the cosmos through your back and bring it into the center of your heart chakra. Pause for a moment there.*

- *OUTBREATH 1: Breathe the power collected in your heart into the situation that requires transmutation. While breathing out, color your breath violet and visualize the situation you are working with as being bathed in violet. Violet is the color of the cosmic transmutation flame.*

- *INBREATH 2: During the second in-breath, collect the power that you have previously dispersed and turn it into the color white. White is the color of perfection. Gather the power colored white within your heart center. Pause there for a moment.*

Cosmogram that I created for the 'Vid' Clinics, at Kromberk, Slovenia. It shows the human being balancing between the powers of the soul (the snake) and the intelligence of his consciousness (the eye).
The triangle outlines the huge face of the Goddess.

- *OUTBREATH 2: Breathe the energy you have gathered out through your back and into the cosmos for regeneration.*
- *Now start from the beginning again. Repeat for as long as needed. Finally give thanks.*

My persistent efforts to renew my relationship with the inner partner resulted in several inspiring moments of communion with the Goddess within. Bit by bit I got to understand how the human soul expresses itself in one's life as a fractal of the Divine Feminine.

The so-called *white* aspect, which is the aspect of the Virgin, is responsible for inspirations and impulses that penetrate the stream of one's life in the moment when there is a need to discover new directions or to expect the birth of new ideas. Because it is in resonance with the universal wholeness, the Virgin aspect of one's soul can inspire and enhance development from within the organism of one's own totality.

The aspect of the Goddess of Creation manifests within the human being to stimulate a broad spectrum of personal relationships, creative ventures, and fields of entertainment. She is the so-called *red* Goddess and stands for the abundance of creation, expressed in all its possible facets through one's personal life.

One's will to hold onto the essence of one's spiritual development, beyond the pressures of personal desires and beyond any other temporary goals or illusions, is represented within one's microcosm by the *black* aspect of the Goddess. The moment we forget who we are and what is the true reason for our being here and now, the transformation aspect of the soul tends to intervene in our lives. If there is need for change or a need to put the brakes on some strand of development, she warns us through all kinds of signs and accidents—including our retrieval from the scenario of physical life. But in dealing with such cases, don't yield to the glamour of believing that there are strange forces working from outside! One is actually dealing with the

transforming powers of one's own soul working from the inner wisdom.[5]

This was the point that my relationship with the Goddess within had reached when I started on my workshop tour through Scandinavia at the end of September, 2000. Traveling from west to east, I gave lectures and workshops in Norway, Sweden and Finland. A new dimension of the inner self revealed itself to me on this tour, each country contributing its own part to the inspiration.

The first facet of the revelation surfaced on the shores of lake Bjosa north of Oslo, Norway. I was leading a workshop for biodynamic farmers there and was looking for a place where the group could experience the qualities of a sacred place. This is how I found a majestic medieval church standing on the lake shore, close to the place called Stange. It is positioned over a strong source of the earth's archetypal life-forces.

To conclude the workshop I brought the group to the place, and we sat silently around the source in the center of the church in order to perceive its qualities. Suddenly my inner vision opened and I saw a gigantic crown adorned with innumerable jewels in the middle of the space. Its beauty was breath-taking. Then, to my horror, I noticed that the crown had caught fire from within. It took only a few moments for the flames to engulf it.

Gazing into the empty space, I hoped that there would be some successor to its vanished beauty. The pause that followed lasted too long. Then I saw a tiny bird being born out of the void and flying straight up to the heavens.

One's first association is with the mythical bird, the Phoenix, whose outworn beauty was consumed by fire. Immediately afterwards, the bird would ascend from its own ashes, renewed and more beautiful than ever. My vision had a similar structure, so the myth could be used as an interpretive key. But what condition

5 Dr. Rudolf Steiner presents the three aspects of the soul as the mental, the emotional and the will aspects. As regards bodily functions, he sees the first working through the nervous system, the second through the rhythmic organs of lungs and heart and the third through the transforming processes of metabolism.

or dimension of reality is represented by the majestic crown that it should become the object of transmutation?

My rational mind proposed that the crown would be the right symbol for the power of the earthly world. But I didn't believe this could be true because I knew that its incredible perfection could not represent the temporal nature of any ego-centric power. Instead, I followed my intuition which suggested that the crown, ready for transformation, represents the spiritual dimension of the human being—perhaps even of the universe.

If I am right, a unique process is preparing through which the spiritual dimension is to descend deeper into the world of matter. This step in the evolution of the universe demands that the path of death and resurrection be taken to ensure that the incredible breadth of the spirit can glide within us and be embodied in the relative simplicity of the material form. In respect of the human being, the result of such an alchemical transmutation would be a strange synthesis of the elemental and spiritual aspects of the soul. This was symbolized in my vision by the tiny bird ascending towards the heavens. It showed me that what beforehand was above is now present within its fragile body.

Another appropriate association is with the saying of Jesus the Christ concerning the cornerstone of the 'kingdom of heaven'. The latter could be understood as a synonym for the spiritual world which is to become embodied in the Earth during the present phase of evolution. He asserted that "the stone which the builders rejected has become the cornerstone." The crown that caught fire in my vision stands for the 'kingdom of heaven', and the little bird that flew out of the void represents the stone that was considered useless. I believe that Jesus' saying and my vision both refer to the same mysterious process that is presently causing a continuous earthquake of change within the inner self.[6]

6 In Chapter 13 of my book *Christ Power and the Earth Goddess*, Findhorn Press 1999, I explore another association with the same theme: the story of Cinderella who was raised from the ashes to become the royal bride. She symbolically represents the earthly aspects of the human self which become integrated into the spiritual core of our personal wholeness.

The second part of the Scandinavian tour brought me to Jaerna, Sweden, where I had to go through the so-called 'nigredo phase'. In the language of alchemy it denotes the 'black phase' where one has to descend to the bottom of one's being. Only after an individual has faced his or her own shadows and experienced a moment of death that gives liberation from all illusion, are they capable of ascending towards the synthesis of their wholeness.

In Jaerna my first action was to search for places that I could use for my teachings on the perception of elemental beings. Thus it happened that I visited the peninsula called Solvik. There, on the seashore, I came across a place where I sensed the existence of an entrance to the underworld. I knew that the place was calling for my attention, yet decided to ignore it and continue with my search. I was not aware at that moment that my inner self was moving to answer the call, while I—representing the ego— was pushing my body to continue towards my immediate objective. The result of this temporary split, even though it lasted only for a moment, was quite distasteful.

I felt greatly fatigued, went home, fell asleep and awoke sick. Even though I had slept for only a short time I had had a remarkable dream. I saw myself swimming in the open sea, wholly concentrated on the direction in which I was going. Suddenly I realized that a boat was approaching from my right side, crossing my course at right angles. Four men were standing on the sickle-shaped boat, totally immersed in their rowing. I was sure they did not see me. And yet, at the precise moment that they cut across my course, they unanimously exclaimed a strange word that sounded like "*DANDREDO.*" In that same moment I looked up and realized that the sky ahead of me had become utterly dark, almost black.

During the following night I felt sick, and harbored the dreadful notion that death was all around me. The language of the dream told me that the sickle of death had cut the thread of my life-path. And yet there I was, still alive, doubting if the experience was true at all. I asked one of my spiritual helpers, the giant fish Faronika mentioned above, to give me some idea of what was true and what might be fantasy. Faronika appeared instantly and began

to swim towards the sickle-shaped boat containing the four ruthless rowers. The closer the fish came, the stiffer it became. Finally it bumped against the boat and fell apart as if it were made of cardboard, and only its white bones were left.

Even though sick and shattered by the experience of a moment of death, I had to continue with the workshop next morning. People had come from far away and I could not disappoint them. It also turned out that the process, kicked into action by my rather close meeting with the Black Virgin's most feared facet, was intended to be a lengthy one. During the next three months I was confronted almost daily with past-life memories, traumas and deviations from the path, which I must work on to transmute and liberate.

The third act of my 'Scandinavian revelation' took place in Helsinki, Finland. Early in the morning I was awakened by the touch of an inspiration. While still lying in bed, I felt the urge to concentrate on the spot between my knees. I often use that chakra, positioned 'at the end of one's tail', to contact elemental beings and nature spirits. One can imagine that the chakra concerned would be pulsating at the end of 'our tail' if the latter had not atrophied into the short coccyx. In effect, it belongs to the system of yin-chakras that, organized in four circles, imbue our bodily power-field with the qualities of the Four Elements. The chakra concerned belongs to the Element Earth.[7]

To perceive elemental beings I focus my consciousness down there 'at the end of the tail', and from there move into communication. This time I was urged—while lying on my back—to bend my knees so that my heels were positioned on either side of the 'tail's end'. In this position the chakra's usual capacity to contact elemental essence was transcended, and I found myself in the energy field of the so-called kundalini.

Traditionally, kundalini is imagined as a snake, coiled spirally upon itself and slumbering below the base of the spine. Within its coils are coded all the experiences and all the knowledge that the

7 Becoming aware of the yin-chakras is part of the awakening of the feminine dimension within. For details, see my book **Schule der Geomantie** (School of Geomancy), Chapter 1..2..D.

soul has built up from incarnation to incarnation, to carry with it as its spiritual heritage. This inner treasury provides all the knowledge needed to master even a seemingly insoluble task, and, when so confronted, the human being can use intuition to draw on it.

The treasury of kundalini is usually hidden from the eyes of the outer self, not just to prevent its dissipation for egocentric purposes but also to foster the autonomy of the human being. We must learn to decide and act in the appropriate way and in the right moment, without being dependent on knowledge derived from the past.[8]

This time I was given a glimpse of its spiritual power. But in the next moment I was urged to follow the light channel that leads upwards from the kundalini basin through the space between the thighs and up along the spine towards the head. Following the multidimensional 'dragon channel' upwards, I noticed that it passes through two nexus points where its power is concentrated and radiated outwards. The first one is positioned in the area of the sexual organs and the second one on the level of the heart. Following the spine, the light channel of the soul finally reaches the neck where it splits and terminates in two spirals. One of them turns to run into the 'empty' space behind the head, and the other runs into the space of the head itself.

Arriving in the realm of my head, I touched that sensitive point where the light channel of the soul transforms into the three facets which we mentioned above in relationship to the three Goddess aspects. The first is the Virgin aspect residing in the head. The head could indeed be recognized as the perfect seat for the principle of Wholeness. Its spherical form, comprising the totality of our intelligence, is similar to a micro-universe that is rounded in its wholeness, just like the Virgin Goddess. Looking at it from the inside or from the outside, one is overwhelmed by its perfection.

From there my attention was led downwards to my torso, which I recognized as the seat of the Goddess of Creation within

8 This is the reason why it can be dangerous to one's health to awaken kundalini for the sake of an ambition to attain enlightenment.

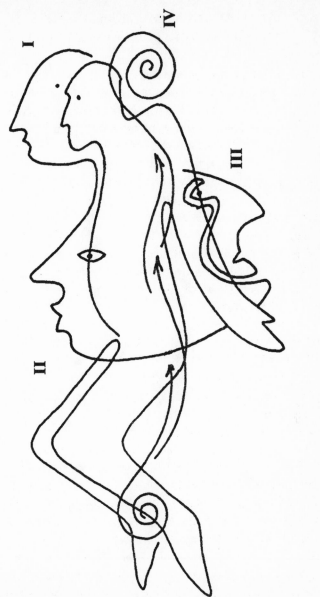

*My Helsinki experience of the soul body with the three Goddess aspects,
(I) Virgin, (II) Creation, (III) Transformation,
and the soul's light channel (IV).*

the human being. The creative aspect of the soul showed itself to me in the soft and rounded triangular form that is common in Neolithic representations of the Goddess. The base of the triangle was in the area of my sexual organs, its peak focused in my throat. The heart chakra represented its center.

The next moment my attention was drawn down to the triangle's base and led between my legs and around my buttocks to the realm of the back. I recognized this as the realm governed by the Goddess of Transformation. The invisible area behind one's back obviously corresponds to the archetypal quality of the underworld. There, our soul enjoys freedom from the constant attention devoted to the visible world of personal history and creativity. From its void are born the impulses that again and again rise up in us to change the course of our life.

To be able to work on revitalizing and balancing the three soul aspects within me, I was shown a set of three exercises that you can experience even while seated. You only need to lay the book aside. These exercises were revealed to me a few weeks later by a vast being from the elemental world whom I call the Beautiful Vida.

Breathing exercise to contact the three facets of the inner Goddess and cleanse the corresponding power fields

1. *Position both hands vertically at 90 degrees to the body, one in front of you next the genitals and the other at your back behind the buttocks. (See drawing.) Breathe into the space between both hands to strengthen the will-aspect of the soul. (This exercise is designed to touch the transformational facet of one's soul).*

2. *Cross your arms in front of your chest without touching it. The palms of your hands should be positioned over the two chakras that are in tune with the Water Element. You may feel them pulsating on either side of your chest below your shoulders, lateral to the nipples. (See drawing.) Breathe for a while into the space between your palms and the chakras to strengthen the soul's emotional field. Follow the impulse as it distributes itself concentrically throughout your emotional power-field. (This exercise touches the creative facet of the soul).*

3. *Close your eyes and place your hands in front of them
without touching your head. (See drawing.) Breathe into the
space between your palms and your eyes, and extend the
impulse backwards through your head, spreading it
throughout the horizontal plane of the mental power-field.
(The purpose of this exercise is to touch the holistic facet of the
soul).*

- *In all three exercises there are four phases to the breathing. If
you wish, you can color your breath in violet and white as
indicated above, where I propose similar breathing exercises
for purposes of transformation:*

 (1) Breathe in cosmic power.

 *(2) Breathe it out into the personal energy field, which is
 indicated by your hands.*

 (3) Breathe in, taking the power back from the energy field.

 *(4) Breathing out, you return the power to the cosmos. Then
 start again from the beginning and repeat a few times.*

After following the trails of the soul and completing the
journey through my body, I felt free to ask some questions.

First of all, I was interested in the difference between the
soul and the divine self of the human being. I know the divine self
as a spirit of pure white light that pulsates in eternity. It vibrates

with its own unique identity, but does not relate to any kind of form. Now, when I asked about the difference, the human soul appeared to me in the form that people commonly use when they want to depict angels.

Yet, even while I was admiring the soul-body's graceful, white silhouette, I was struck by its flat and disproportionately large feet. Responding to the attention they were getting, to my surprise they began to grow even bigger till I recognized them as a symbol of the soul's close connection with the path of incarnation. In contrast to the essence of the angelic self, the soul is accustomed to 'walk' on the trails of earth.

I also became aware that it often happens that people who are convinced that they are contacting angels are in effect relating to the powers of their own soul. I do not claim that one is less important than the other. But a failure to understand the difference between the angelic level and the level of the soul may result in one's ignoring the presence of one or the other.

Next I concentrated on another question. I was experiencing the threefold nature of the soul in my being as a man. Could it be that a woman would experience it in a different way? If so, it was beyond my imagination what that might be. So I called on my fish-friend Faronika for help. The fish arrived at once and began to dig into my belly with its mouth. I was scared because I had no idea what she was going to do. When she reached the point where the tubes of both ovaries meet—I was now pretending to be a woman—Faronika urged me to start exploring from that point to tune into the feminine soul experience.

Now that I knew the key to sliding into the feminine experience, I was curious to find out how it felt. I perceived no difference in respect of the constitution of the soul's light channel. What attracted my attention was a white spiral-like nebula forming above my stomach. Finally, it took the form of a labyrinth. I understood it to be a symbol that represents the autonomous creative space of a woman. I also noticed that the fractals of the Threefold Goddess are not so strictly associated with different parts of the body as is the case with a man. A woman must rather experience them as moving around freely through her whole body.

The constellation of the human self, showing the role of the soul (the snake!) mediating between its different facets. The field of consciousness represents the masculine counterpart of the soul, which represents a fractal of the Goddess. The parallelogram in the center symbolizes the personal soul link that may be broken if the modern human world continues 'to decapitate the Gorgon Medusa'.

In consequence I became interested in the potential problems that I carry with me from the incarnations when I lived as a woman. Indeed, while gazing at the feminine facet of my soul during my journey through my body, I noticed that it was not properly grounded. Why? Fish Faronika answered my question by pulling a coarse rope out of my belly. She was swallowing it as she pulled it out.

The process of pulling out and swallowing seemed endless. Only after a while did I become aware that the rope was imprinted with memory after memory of the pain caused by masculine control over the sexual and creative powers of women and 'our' forced subordination. Too often women were forced to restrict their creative power and intelligence to giving birth to children and satisfying the sexual appetites of men.

When I got up in the morning, I was deeply grateful for the revelations of the night. To celebrate the day, I decided to visit the Orthodox Ouspensky Cathedral, one of the most remarkable buildings in Helsinki. There I discovered that this way of 'traveling' within one's body and touching the four aspects of the soul can be used as a perfect instrument of perception. I tested it immediately. Looking through the eyes of the soul, I could perceive crowds of elemental beings striving to hold the building blocks of the cathedral in their proper place, constantly balancing them and attuning one to the other. Also I could see the broad cloak of a deva overshadowing the turmoil caused by the elemental beings, holding it within the embrace of harmony.

Do you wish to experience what it is like to travel through the worlds of your soul? Here is what I propose:

Guided meditation to experience the dimensions of one's soul

- *Lie down and ask for the experience. Bend your knees so that your heels are placed on the either side of the end of your imagined tail. Imagine that point as the source of a river that runs up along your spine towards your head.*

- *You are a beautifully colored duck being slowly carried on the waves of the river from its source towards your head.*

- *When you arrive at your neck, imagine that there is a waterfall where the river falls majestically down into a rounded, peaceful lake situated among high rocks.*

- *Arriving at the lake, you transform yourself into a swan. You bob peacefully on the ripples of the lake.*

- *Then you open your wings and fly high up to the top of the tallest rock, which is identical with the top of your forehead.*

- *There for a moment you transform yourself into an eagle and gaze upon the totality of the universe which extends all around you like a mandala.*

- *Below, in the area of your belly, you see a vast shallow lake full of inner life. You transform yourself back into the swan and fly down to land upon the surface of the lake.*

- *You notice a storm-cloud on your left and see bright flashes of lightning striking the surface of the water. They represent the masculine counterpart of the feminine quality of the lake.*

- *By now you have arrived at the sexual area where the waters of the lake make a thin waterfall. While pouring down through the narrow space between your legs, the waters become transformed into fiery magma.*

- *The magma is pouring down to fill the underground lake below your spine. It is a lake of fire, but without any suffocating heat. While falling with the magma, the swan transforms itself into a transparent spirit that is called the phoenix.*

- *Phoenix flies above the lake of glowing magma to reach an opening at the back of your heart. It ascends through the opening to come into the inner chamber of your heart.*

- *Rest for a moment in your heart and hold the resultant feeling. Then distribute that feeling throughout your whole body and within every cell. Be who you are and give thanks.*

Chapter Five

Lady of the Beasts, Mistress of the Animal Soul

It was not until the year 2000, after the Goddess had begun her third attempt to reach my consciousness, that I became aware of my ignorance of animals. During the previous years my priority had been given to the plant world and the nature spirits that work with plants. Trees were my special favorites when I was busy exploring places and landscapes. Only now did I realize that I felt at ease with them because plants always occupy a distinct place in the environment. They are relatively easy to relate to with the help of a few conceptual rules.

As opposed to plants, animals move around and, within a given ambience, they are relatively free from any preconceived patterns. Their presence relates more to the flexible field of the emotions than to some fixed structure that can be perceived mentally. Further, animals are free to follow the impulses of their soul, whereas plants are cared for and directed in their growth by nature spirits and elemental beings.

Freedom and the emotional nature of their relationship to their souls are two qualities that animals share with humans and are the reasons why people either adore animals or try ruthlessly to control them. On the one hand, their links to the soul show them to be relatives of the human being, and therefore they can get close to our hearts. On the other hand, human beings, who are generally trying to deny their relationship to their own souls, are either trying to enslave animals or are in process of driving them to extinction. We are obviously imbued with the subconscious hope that in so doing we will be able to kill the memory of our own souls.

Of course, there is a distinct difference between an animal's and a human being's relationship to the soul level. Human beings relate to a fully individualized soul that enlightens our personal life and its cyclic transformations, leading us from incarnation to incarnation. Animals relate to their group souls. The group soul means that there is one and the same spiritual being that is gathering experiences through all animals of the same kind.

To give an example, I will relate my encounter with a flock of boars in the zoological gardens at Berne, Switzerland. I took time to look at each animal separately with my inner eye and realized that each of them was holding one and the same soul presence within its aura. It showed itself to me as a beautiful maiden. The contrast between the muddy, ferocious looking animals and the fine weft of the soul was incredible.[1]

Unlike human beings, animals embrace a wide range of evolutionary stages, from a simple insect to complex mammals organized like humans. There is a corresponding difference in the relationship of the various species to the group soul.

In the case of the boars—representing the higher evolved mammals—I could perceive the presence of their group soul within the force-field of each separate animal. However, as another example, when looking at a flock of crows, I see a bright point moving with their flight and vibrating in the midst of them. If I concentrate on that point and look for the place to which the resonance bridge is taking me, I discover, way up in the heavens, a spiritual being that is gathering knowledge through the life experience of crows. On the crows' stage of animal evolution the group soul is obviously present only through resonance.

Exploring even simpler animal forms such as reptiles, I can perceive no basic difference between the way they experience the soul level and the way plants do. Just like a tree, they possess the soul quality, but it is not separate from Gaia who is the soul of the planet. It looks as if the soul of the Earth is present, through a strand of its being, within each plant.

1 It is not by chance that in the ancient traditions the boar appears so frequently as one of the symbols of the Goddess.

Animals on the 'lower' stages of development seem to relate similarly to the Earth soul, but in a subtly different fashion to plants. They experience its presence not from inside as plants do, but from 'outside'. For them, the Earth soul is a womb embracing and inspiring them towards further growth and development. And yet in some respects they experience themselves as guests of the Earth just as we do. Plants, on the contrary, are beings of the Earth in all possible aspects.

We should not conclude our short introduction to the soul relationships of animals without recognizing how they resonate with the Goddess principle. In contrast to human beings who can easily ignore their soul link and pretend that they are free of its all-pervading presence, animals can never be disconnected from their group souls. They are soul-enlightened beings. This is the reason why for many millennia different species of animals have been chosen as symbols of diverse facets of the Feminine Divinity.

As an example let us take the owl, a well known symbol of the goddess Athena. The owl is a perfect representation of all the three Goddess phases that Athena embodies in the Greek tradition. In her white phase she is the Goddess of Wisdom; in her red phase she endows humanity with the knowledge of handicrafts and arts; finally, in her black phase she is the Goddess of Warfare.[2] Though it sounds impossible, the owl can represent all three aspects of the Goddess even when they seem to contradict each other.

The owl became the symbol of the Goddess of Wisdom because its eyes are so perfected that its vision is excellent even at night. If seeing by day stands for the rational sort of knowledge, seeing by night symbolizes the quality of wisdom. Wisdom represents that aspect of knowledge that has to be retrieved from sources that lie beyond the realm of waking consciousness.

The owl's exquisite attitude towards care of its 'children' qualifies it to be the symbol of the creative power of the Goddess. To prevent owls that are newly hatched from dying for lack of food, the owl hatches only one egg at a time. Should one young

2 In Greek, the three corresponding names of Athena are: Athena Partenos, Athena Ergane, and Athena Glaukopis

The Lady of the Beasts, from a Greek vase painting, 7th century B.C.

owl die because of a general food shortage, circumstances may improve later on and the 'owl-children' that follow will be saved.

Finally, the owl is also a symbol of warfare. It feeds by killing small animals. The terrible cry of the owl at night is widely thought to announce the approach of death or the presence of the spirits of deceased.

It was no accident that animals helped begin my third cycle of the Goddess' revelation in the summer of the year 2000. Do you still remember my story of the dolphins in Chapter Two of this book? The sequel to that message was also conveyed to me through the help of an animal, a bird in fact.

After becoming interested in the possibility of using my writing to create a new image of the Feminine Divinity, I went that evening to meditate on the nearby hill. I knelt down and asked for the blessing and help I would need when working to express my inspiration in a proper form. In that moment a bird came flying past me at great speed. As it went over my head it gave a piercing cry.

I instantly realized that the bird might be carrying a message to answer my plea for help. I tuned in and with my inner eye I saw that the bird did indeed carry a white sheet of paper in its beak! At the same moment that I recognized its role as messenger, the bird dropped the sheet. Ceremoniously bouncing through the air, the white sheet of paper slowly descended to where I was kneeling. I stretched out my hands to offer it a safe landing place, anticipating that the fragile etheric sheet was carrying a message written for me.

It landed gently on my hands, but to my disappointment it was quite blank. I did not lose faith that a message must be intended, but obviously I was not able to read it. So I called the bird that had dropped it back for help. It returned instantly, but this time it had a tiny human head. Unfortunately, the moment I asked the bird what the message on the paper was, the sheet dissolved into dust. I was disappointed again, but the bird started to dance upon my arm and laughingly tell me that what I considered a misfortune was in effect a joyful message.

To prove it, the bird began to jump from stone to stone while pointing in a certain direction. Now I finally grasped that it was

the seemingly unsuccessful transfer of the message that was itself the real message. It made me aware that I had a wrong attitude, waiting for the Goddess to speak to me in some mentally conceived form. She speaks in the hologrammic language of life, imbued with emotion and the quality of imagination. To indicate the kind of communication that would be more in tune with the Goddess' intent, the bird led me to the entrance of a nearby cave. During the next few days some of my most important communications with the world of the soul did indeed come through that cave.

When communicating with animals, one should be clear about the different levels involved. Just as with human beings, one can speak of the physical, energetic, emotional and soul level of the animals. The mental level, the specialty of the human race, is of course absent.

Let us start with the energetic level. In my book *Nature Spirits & Elemental Beings* I write about the specific role that each species of animals performs within the etheric organism of the earth. This information was contained in messages from the angelic world received by my daughter and collaborator Ana Pogačnik. For instance, when a mole rubs its fur against the layers of earth, it causes a build-up of power. As it digs through its tunnels, it distributes this power within the power structures of the earth. Ants have tiny polarized power points on the bottom of their legs. When they walk—and they walk ceaselessly—they balance the force field of the ground. In flying, birds open up channels on the physical plane through which cosmic powers can come pouring in. One could go on and on with similar examples.[3]

The emotional level possessed by the higher animal species is what distinguishes the animal kingdom from the plant world which does not know that level of existence. If a person feels there is an emotional quality attached to a plant, it is a sign that they have contacted the elemental being that takes care of that plant, or simply enjoys its hospitality. The consciousness of

3 There are more examples in my book *Nature Spirits & Elemental Beings,* page 199, Findhorn Press 1997.

elemental beings vibrates with emotional quality, but this is not the case with the plants themselves.

Is there anyone who hasn't experienced the emotional quality permeating dogs, cats and horses? To contribute my own insight into the emotional level of the animal kingdom, I should like to share my experience of a herd of cows that I observed during the workshop for bio-dynamic farmers in Norway, which I have already mentioned.

When preparing for the workshop, I felt it would be important for the farmers to experience the emotional level of animals. Early in the morning prior to the commencement of the workshop, I went to the cow barn to see whether the situation there would allow me to perform an exercise. I was amazed by the emotional atmosphere pervading the shed. One could feel as it were a great rumor, with the cows giggling and chatting to each other. Their excitement must have had to do with the fact that they were just getting ready to go out to pasture.

I asked the farmer when the cows would be back in the barn, so that I could plan the workshop. He proposed two o'clock in the afternoon. Unfortunately the group was nearly one hour late. Nevertheless we were allowed to enter the barn, but were told we should hurry up because milking was due to start in a few minutes. When I entered this time, I was disappointed. In the contrast to the experience of the morning, absolute tranquillity and silence reigned. The workshop participants could also feel it readily. The cows were obviously focused on preparing themselves emotionally for the sacred ritual of milking. This is the time when they give of themselves to feed their human sisters and brothers.

I must emphasize that this event took place on a bio-dynamic farm where the soul quality of the animals is recognized and supported. When listening to the news about 'mad cow disease', one can only imagine the tragedy pervading conventional cow barns, which is precisely where the emotional and soul levels of the animals are severely suppressed. There is an obvious correspondence here with the oppression undergone by the other realms of the Goddess in context of the present culture.

The soul aspect of a wild boar,
from a Greek coin from Rhodes, 7th century B.C.

You may be curious about the kind of exercise that I proposed the farmers use while entering the cow barn, so that they could perceive the subtle level of the animals. In effect, I proposed two. The first one can be used in any situation, and will also serve to perceive the invisible dimensions of a place or to experience the presence of elemental beings. I learned it from my other daughter and collaborator Ajra Miska. The second exercise is designed only to contact the soul level of animals.

Exercise 1: for perceiving the invisible dimensions of a phenomenon

- *Be fully present and grounded. Concentrate on your heart center and push the blockages of past and future aside, so that you are present NOW. Be present in your heart, and go into the perception phase from that point of NOW.*

Exercise 2: for contacting the soul level of animals

Concentrate your awareness at the end of 'your tail' as explained in the previous chapter.

- *While holding your concentration down there, open the back of your head to perception.*
- *Give thanks to the animal kingdom for the secrets it may have shared with you.*

When I communicated with the bird with the tiny human head, I touched neither its etheric nor emotional aspect, but its soul aspect. This is a group soul which vibrates beyond the boundaries of space and time. It is not bound to the body of a given animal, but it is the physical, etheric and emotional levels of the animal that make contact with it possible. In the above example, the experience was initiated by the flight of a 'real' bird. Yet, through the attention I gave to its cry, I pulled the spirit of the group soul to which that bird was linked into my sphere of consciousness. The bird itself continued to fly in its chosen direction, while I started my communication with its group soul.

Communicating with animal souls is a fascinating venture. I have to acknowledge the exquisite abilities that animals displayed

while helping me in my personal cleansing cycle during the autumn of 2000. One of my worst problems, one which has held much of my creative power bound to the past, was the figure of a Celtic warrior that abode within my psychic world. Its rigid and introverted attitude prevented me from moving into more enlightened and dynamic forms of expression. I often tried to get rid of the warrior's armor that, against my wishes, was imprisoning my emotional presence and transmitting the notion that I was altogether a boring fellow.

One night during October 2000 I felt that the time had come to say farewell to the strange company of the dead warrior within me. But I didn't know how. I asked for an animal that could master the task to approach me. A black raven answered my call. This made me suspicious, but finally I mustered up all my faith and let him do his job. With his sharp-pointed beak he started to dig into my chest in the area of my physical heart. Before I could protest, he had pulled out a sort of string that was anchored fast within the tissues of my heart.

When I followed the string to its end, I discovered it to be fastened to the figure of the dead warrior. Luckily, this time a clear memory accompanied the image. It told of a past life situation when I was the leader of a Celtic tribe that was in danger of extermination by a far more powerful invading army. To gather the necessary strength to defend my homeland to the last drop of blood, I performed a ritual by which I anchored my physical power within the etheric powers of my heart. I was not ready to listen to the call of the Black Goddess and to accept the path of change that was inevitably opening in front of me and my people.

Of course, there was no chance of my being stronger than she, and I died in the battle. I got my lesson. Yet the tragedy, which must have affected my succeeding lives, and even the present one, was that after death I could never free myself from the magic bond. I had to carry the repulsive load of that dead warrior within my subconscious from life to life. Even though I tried, I couldn't free myself of his shadow till the raven helped me recognize the background to the problem and enabled me to work on dissolving that magic link. Without the help of the

merciless raven, I would not have known where to direct the powers of mercy and transmutation and become free.[4]

Animals have helped me at other times. While leading the above-mentioned earth healing workshop in Hanover, Germany in the summer of 2000, I received invaluable help from the group soul of a tiny animal. This time I was troubled by a problem in the overall quality of the city's environment. The disturbance must have surfaced only recently because I had not noticed its intruding vibration during previous years.

I discovered the problem when I attuned to some powerful centers of elemental beings located in the park surrounding the city's huge artificial lake, which is called Masch Lake. I found that the nature spirits were agitated because there was a kind of armor enclosing the ambience. It carried with it the threat of controlling the city with intent to subdue its power-field and divert it to a malign purpose. In the background I felt the sinister will of a dictator trying to exert control over the place, but I had no idea where to search for a practical clue to solve the problem that was upsetting the beings of nature.

In my despair, I opened for a moment to the silence within and asked if there was an animal that could help me. To my surprise a squirrel appeared. It led my consciousness underneath the lake to a point at its center where I saw a small chamber with an etheric device. Its purpose must have been to sustain the threatening armor that was rising over the city.

Only then did I remember that the lake was designed during the time of Nazi rule and excavated by the slave labor of those German people who resisted the Nazi regime. When I explained the problem to the group, an older participant explained that at that time there had been a rumor going round that the miserable 'slaves' had had to dig a narrow tunnel under the future lake. There had been no suggestion as to its purpose. Without the help of the tiny squirrel I would never have known that a geomantic

4 I am grateful to Sandra Ingerman whose discussion of shamanic practices inspired me to awaken to the animal kingdom. This took place during our collaboration on the Findhorn Foundation's *Conference on Angels* in the spring of 2000.

The Virgin Mary holding a unicorn
that symbolizes the human soul.
Medieval painting from Erfurt cathedral, Germany.
Note the gardener working below, who represents the outer self.

controlling device was located there in great secrecy, and I would have been deprived of any possibility of curing the situation.[5]

As the following example demonstrates, animals can often get results where all a human being's intelligence ends in failure, especially when the realms involved are those where emotions play a prime role. On a particular day I was feeling miserable and knew that I must work on the further clearing of shadows derived from my past. A turtle answered my call for help. At first I laughed, considering the stubborn crawler to be useless.

But I was amazed at the skill with which it was able to push apart the dense layers of memory, and like an armored tank proceed towards the location of the subconscious memory that was oppressing me. Led by the turtle, I found myself deep down at the bottom of the sea, where it showed me a dead body lying. Together we pulled it up to the surface of consciousness. Holding the body so that it lay in my lap, I still didn't know what it belonged to, or what I should do to free its death-frozen energies. Also, the turtle could not help me any more.

So once again I started to lament and ask for help. This time a black panther appeared, pulled the dead body out of my lap and started to tear it to pieces. Only then could the proper memory surface. It was connected to an ancient experience in a previous lifetime, when out of the blue I was torn apart and killed by a savage beast. At that time I was unable to understand the deeper purpose of the apparent accident. And that was why the dead man had stayed with me unredeemed till I had grown up enough to be confronted with the truth.

The truth is that I had fled from confrontation with the quality of change. I tend always to follow those imaginations and plans that promise eternal sustainability, forgetting that we incarnate in a world that follows a cycle of death and rebirth. The quality of change and the blessing of the Black Goddess are inevitable preconditions for the evolution of life on the level where we have been pursuing our development for ages past.

5 For another example of the Nazi's sinister manipulations through misuse of geomantic knowledge, see my book *Healing the Heart of the Earth*, page 61, Findhorn Press 1998.

While I was dealing with the sensitive processes described above, I was in a train traveling from Germany back to my homeland of Slovenia. At the time when I was conferring with the black panther, the train was passing Slovenia's most sacred landscape, which is centered around the lake of Bled. I consider that there, amidst the peaks of the Julian Alps, the archetype of my country is encoded. I used the opportunity to ask my helper whether it is true that the black panther is related to the essence of Slovenia. Some historians affirm that the figure of a black panther, horned and red clawed, was the ancient symbol of Slovenian autonomy a thousand years ago, before we lost our independence and came under German rule.

The panther with which I was conferring seemed to be in perfect accord with the idea. It instantly diluted itself so that it embraced the whole country, in demonstration of its role as Slovenia's protective power animal.

Communicating with animal group souls can also prove 'dangerous'. While I was leading a workshop in New Mexico, USA, with my daughter Ana in November, 2000, I discovered that there is a beautiful landscape temple of the Goddess that extends throughout the country. Early one morning, while still in bed, I tried to feel its quality as it pulsated all around me. I asked the Goddess to demonstrate the way in which she dances within this particular landscape. To satisfy my wish, she let a rattlesnake glide past me, undulating over the ground in its characteristic way.

At the same time I was struck by the idea that the snake could help me make progress on my work of clearing personal stuff. Without thinking overmuch, I exclaimed: "Hey you, would you come back and help me?" Not need to ask twice. The snake appeared at my side, reducing its size and folding its body so that it looked like a harmless being. Only later did I understand that it was trying to calm my fear of snakes. Then without warning, it started to glide into my nostril and clear its way towards my brain. I became frightened and forbade it to continue, commanding it to leave my body.

It obeyed instantly, but then I regretted missing a unique opportunity of learning the secret that the snake wanted to show

me by climbing into my head. In that moment of uncertainty, I was inspired by the cunning idea of using my imagination to produce a replica of my body. I then asked the snake to use the replica as a model and show me where the problem lay.

It crept into my replica's nostril, but didn't continue towards the brain as I had feared it would. Instead, the snake found some opening through which to slide down towards the throat. There, in the area between the throat and brain, it coiled itself into a tight knot, thus showing me the location of the problem and the symbol characterizing it.

Knowing now where the problem lay hidden, I addressed the snake's group soul and asked for its help in decoding the symbol of the knot behind the throat. It took my memory way back to a civilization created by an ancient American Indian culture. I recognized myself as having been one of the guardians of their secret knowledge. It was a turbulent time of change and my nation had become enslaved by a rough, wild tribe. They wanted us to betray our treasured knowledge. Yet we all held to our vow not to give away the secrets even if tortured and killed. Together with my fellowmen, we performed a cultural suicide and took our knowledge to the grave. The result of that unredeemed experience was a continuing blockage with which, even nowadays, I must always struggle when I am about to impart my knowledge in any large public forum.

There are innumerable ways in which animals can offer help to human beings. But my intuition tells me that there is an aspect to the animal presence that touches us even deeper than the communication with animal souls. It must have to do with the very essence of the human being.

Imagine ourselves as human beings immersed in nature's kingdom, living for at least a million years in a half-animal form. Our bodies were covered with beautiful fur and we lived in caves as hunters and gatherers. At the same time we were developing the first indications of culture, rough tools of stone and bone, which later blossomed in fantastic cave paintings and carvings. Through shamanic practices we were contacting the group souls of animals while seeking their protection and knowledge.

Our sister and brother animals were our elders on the planet. They had started to incarnate in the realm of matter billions of years before we did. At a time when our civilizations were built on the planet's more subtle levels, animals were already busy gathering the experience and knowledge necessary to incarnate and survive as intelligent beings within the conditions of matter.[6] By the time we were ready to start the phase of our own physical incarnation, they were already masters of a world that was alien to us, who were newcomers from the subtle dimensions of the planet. Animals were not only our first spiritual teachers on the earth. It was through their evolution that they developed a bodily form that we could adopt for our own use: the ape's body.

I got a hint how important is our link with the animal kingdom for human identity when I was writing this book and had got to the point where you are reading now. I saw various possibilities opening up, different ways to continue the chapter on animals. In my uncertainty I turned my attention to our house cat—its name is Mina—who was purring close to where I was meditating. I focused it on the question of how I should continue with my writing.

It was a strange image that the cat mirrored back in answer. It resembled the background of an orthodox Black Virgin icon. I mentioned such a one at the very beginning of this book. By 'background', I mean the painting's marginal area surrounding the central figure of the Virgin holding her Son. I got to see only that fringe area of the icon, while the central figure was missing.

The vision would perhaps have found no resonance within me but for a surprising event a few days before. My daughter Ana had had a very vivid dream that told of three new phenomena appearing in the meadow at the back of our house. All three were in a disgusting condition. After she had telephoned me about the

6 My intuition tells me that the eras we call Lemuria and Atlantis refer to the memory of the early human civilizations that were built on the etheric and emotional (astral) levels of the Earth, without directly touching the planet's physical dimension. In parallel to those civilizations, the conditions for our incarnation in material form were in the course of preparation, in cooperation with the animal kingdom.

dream, I felt the urge to go to the backyard of my house and work on perceiving what was going on there.

The houses in the south-western part of Slovenia are traditionally built so that their back is to the north and their doors and windows open to the south. There are no openings to the north because a strong wind called the 'burja' often comes down on us from the Alps that lie in that direction. So it happens that the back of our houses are like the back of a human being, who also has no organs of perception located at the back.

In consequence, it was clear that an appearance at the back of the house signified that the three phenomena belonged to those powers that abide in the otherworld. Either they belonged to the realm of the soul or they represented some qualities that had been suppressed in the subconscious of the human race.

When I arrived there, what I perceived first of all was the energetic and emotional smog that weighed on the three apparitions. They seemed to be suffocating under a thick layer of negativity. I supposed that they might be three nature spirits who were handicapped by some human abuses and had fled to our home for help. I immediately asked my invisible helpers for support and, implementing my earth healing tools, began a healing ritual. Then I left the backyard to give the apparitions a chance to order their powerfields.

After a few hours I returned to see the results of my work. To my surprise, one of the three phenomena showed itself as the spirit of the straw on which the Christ child lay after his birth in the cave at Bethlehem. The second could be identified as representing the twin spirits of the ox and donkey that stood beside the Christ's cradle. The third one turned out to be the spirit of the Three Magi who followed the comet to find the Christ's birth place. What an amazing company![7]

I felt that the three spirits had been cured of their problems, but had no idea what to do with them. I just supposed that after

7 I am aware that the birth in the cave at Bethlehem was of the baby Jesus who only later became the Christ. But I consider his birth scene as prophetic and thus anticipating the child's Christhood.

being freed from human projections they would go on their way. So I bade them farewell and went about my business.

But that evening, when I sat down to meditate on the possibilities for my future writing, I instantly felt that the three spirits were still there at the back of the house. The image I got was of three elderly men, shivering in the winter frost, with their luggage at the feet, waiting to be let into the warm house.

I felt compassion for them and immediately went out to transfer them via light channels to a stone circle that I had built years ago on the southern side of the house. My idea was to offer them a 'warm' place in the part of our land that, because it extends on the sunny side of the house, symbolizes conscious existence. After arriving there they formed a light pyramid within which the Virgin manifested her beautiful presence. I went no further with the strange process at that time.

While I was engaged in their transfer, an intuition surfaced that a common characteristic linked all three apparitions. The fact is that they accompanied the Christ's birth *from the fringe of the scene*. Taking into account the straw on which the Child lay, the animals standing beside the manger and the Three Magi approaching the cave from outside, one recognizes all the figures typical of the traditional birth scene at Bethlehem. Only missing is the event's central figure, the Virgin with the Christ child.[8]

The meaning of this curiosity was unclear to me until three weeks later when our house cat confronted me with a similar riddle. As I wrote above, the cat showed me the fringe area of a very usual Madonna icon, but without the central part that is normally occupied by the Virgin and her Son. In that instant, when I connected both situations one with the other, the knowledge hidden behind both imaginations appeared and showed me the joyful face of clarity.

8 You may have noticed that Joseph, the Virgin's husband, is also missing. In my vision he represents the consciousness aspect of the human being. It is part of my game to push consciousness aside a bit in favor of the soul aspect. It also reflects a somewhat critical attitude towards those spiritual movements that exaggerate the importance of mental consciousness and forget the emotional quality of the soul.

It is generally known that the configurations of stars and planets at the moment of birth show the guidelines for an individual's future life path. Similarly, one could imagine the scene of the Christ's birth at Bethlehem as an archetypal configuration which reveals the secret of the Child who was born there. But if we consider that the Christ incarnated primarily to initiate a further step in human evolution, the scene at his birth place should reflect the patterns that are characteristic of the human beings of the future. *But remember that what was future to that era when the Child was born is the present time of today!*

The straw on which the Christ baby lay represents the organic essence of plants, that which makes our bodies come alive. By this I am referring to the vital power that only plants, through their chlorophyll-filled leaves, can manifest. We perceive the plant essence within ourselves through the vitality and cycles of our body, for example the menstrual cycle. The spirit of the straw spread in the cave of Christ's birth represents the etheric or bio-dynamic aspect of our being.

The Three Magi approaching the cave symbolize the three facets of our soul. We have already labeled them in conformity with the three facets of the Goddess: the Wholeness, the Creation and the Transformation aspects of the soul. In the last chapter we mentioned that these three soul-facets represent the powers of will, emotions and mentality within the microcosm of our being. These three powers are symbolized by the gifts that the Magi brought the Child: gold, incense and myrrh.

A further aspect of our soul, the one that, when analyzing the soul body, we recognized as the light channel of the soul, is represented by the Star that the Three Magi were following to find where the divine Child lay. Within the constitution of the human soul the light channel has a guiding role similar to the Star of the Magi in the story. It represents a backbone or axis around which the other three aspects evolve. You will remember my experience in Helsinki when I had to follow the line of my backbone to experience the different aspects of my soul.

Then which facet of the human being is represented by the two animals, the donkey and the ox, that according to tradition

The scene of the Christ's birth relates to the different aspects of the human self.
The Star of the Magi stands for the light channel of the soul and the three Magi for its three Goddess-aspects.
The animals represent the personal elemental self, and the straw on which the Child lies represents the organic base of our body.
The Child itself symbolizes the divine self, born into the earthly reality.

stood beside the newborn Christ, warming the child with their breath?

They must symbolize something like the 'animal within the human being'. I call it the elemental self, explaining it as that aspect of ourselves which holds the human being embedded within the intelligence of nature. I first came to know it through my daughter Ajra Miska, a spiritual healer who works with the elemental self of her patients. Together we introduced the idea of the elemental self to the public in my book *Nature Spirits & Elemental Beings*.[9] Now, deepening my relationship with the animal kingdom, I got to know it from a new perspective.

The ancient cultures knew the secret that the intelligence of nature does not only abide in our environment but also has its seat within each individual human being. They spoke of a personal power animal. Yet they didn't mean just an animal spirit that would protect us from external threats, but the animal essence that is slumbering at the core of our being. It represents the qualities and powers that enable our individuality to express itself through the medium of matter and incarnated life, and their task is to manifest those conditions in our lives that enable us to live the life that we have decided upon.

Now look at the tragic situation that the whole animal kingdom is experiencing right now, sharing the bio-sphere of the planet with us. Look at the misery of the domesticated animals, manipulated like slaves to fulfill our ego-centric wishes. Look at the misery of the wild animals! Their living space is constantly under threat of diminution, up to the very point of extinction. All this is because animals are mirroring our miserable relationship with our own soul level. Or to put it more exactly, the present miserable situation of the animal kingdom mirrors our ignorance of that part of our soul that represents a fractal of nature's intelligence abiding within our being.

There are citizens' initiatives that provide opportunities to engage oneself in animal protection, if one decides to help relieve the pain of one's animal sisters and brothers. But if one wishes to

9 There is also a Chapter on the Elemental Self to be found in my book *Healing the Heart of the Earth,* Findhorn Press 1998.

make a basic change in this distressing situation, one should work as an individual on re-connecting with the elemental essence within. Only when the human being has personally re-established the link with the 'animal within' and renewed the relationship with the basis of their individual elemental, can there be a radical change in the situation, personally, in the environment, and in general.

The presence of the two animals at the birth of the new human identity—symbolized in our culture by the birth of the Christ—is a moral imperative urging us to search for a new bond with our human-animalistic heritage. It may be a good thing that the old bonds are in process of decay, giving us freedom to grow beyond the limitations of the past. But this does not mean that our ignorance is to be rewarded. Evolution is moving along a spiral. As each new level is achieved, it needs to re-establish the ancient bonds in a new way.

To make contact with the personal power animal, I was shown an exercise that differs from the traditional one I knew. In my case, the path of search does not lead outside to a place of revelation in nature, but to the proper place of communion with the elemental self within the body.

Ritual for getting to know one's personal power animal

- *Lie down on your back and ask the animal kingdom for help in making contact with your power animal. Remember that the world of nature is so powerful that it can renew itself in each moment. So don't stick to the past or future, but know that the power animal of yesterday may not be your power animal of tomorrow. Be open for the intelligence of nature to speak to you now.*

- *While lying, bend your knees so that your heels can be placed at either side of the end of your imagined tail. This is the proper position for staying connected to the elemental level of existence.*

- *Cross your hands under your buttocks so that where they cross will press on the coccyx bone. This is a position for connecting with the animal essence.*

- *Center your awareness in your heart center and perform the following short ritual there before moving into the experience: express your reverence for the animal kingdom and declare your purpose for contacting your power animal.*
- *Move your consciousness down the length of your spine to the point indicated by your crossed hands.*
- *Imagine a deep dark hole in the ground there. Your crossed hands represent the bottom of that hole.*
- *Walk around the hole, following its edge in an anti-clockwise direction.*

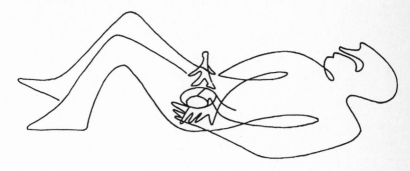

- *Keep walking around and slowly pick up speed. Watch continually for whatever is going on in the dark area of the hole. When you perceive powers starting to rise and move out, give your attention to whatever wants to manifest and forget about walking around.*
- *While you are walking around, you may get glimpses of various animals. Don't pay any attention to them because they represent your subconscious projections. You will recognize your true power animal because it will imbue all your inner space with its presence. One usually feels it as part of oneself before the animal allows you to get to know its characteristic forms.*

Return to your heart and give thanks. Relax for a moment with your feet stretched out and your hands lying alongside your body. Then stand up, and do not forget to play and collaborate with your power animal.

Animals are not only the helpers and teachers of their fellow-incarnated human beings. They have their own evolutionary path to follow and though it intersects at various points with the human path, its essence may lead them in some other direction, one which, for human beings, is not easy to grasp.

When the new wave of animal tragedy in Britain started with the outbreak of foot-and-mouth disease in March 2001, I decided to make the ritual for comforting the animal kingdom part of each workshop I led, performing it as often as possible.[10] During my workshop in Berlin in mid-March 2001 we performed the ritual twice, both times in the Tiergarten Park close to the zoological gardens.

In the ritual, each participant attunes to the soul level of the animal kingdom and then invites an animal to lie in her or his lap, to be cradled there in love and reverence. The first time we performed the ritual in Berlin a bear approached my lap, and the second time a sea lion. Surprisingly, both animals gave me the same message. While the group engaged in harmonious singing, 'cradling' the animal souls, the animal in my lap opened up and a figure, looking as if it were made of bronze, ascended out of its body. It was a tall, slim Goddess figure, representing the ancient Mistress of the Animal Soul

I enjoyed the blessed presence of the Mistress till she disappeared at the end of the ritual, leaving a small baby in my lap. The message I received in that moment revealed that the slim figure of the Goddess represented the animal soul principle in the way we have known it since the Neolithic period when people started to domesticate animals, and thus invite them to live in companionship with them.

As I mentioned earlier, it was the animals which were the first to develop the soul level, and with it the possibility for a cosmic spirit to embody itself within the conditions of matter without losing its creative dimensions. After human beings had lived with animals for hundreds of thousands of years, learning the

10 For instructions for the performance of the ritual, see my book *Earth Changes, Human Destiny,* Chapter 9, Findhorn Press 2000. Another version is given in Chapter Eight of the present book.

knowledge of the soul from them, we introduced a fantastic innovation. The individuation of the soul that human beings as *Homo Sapiens* introduced to the planetary evolution enables each separate being to relate to their personal archetype instead of, or being limited to, a general one related to the whole race. My intuition tells me that animals approached the human societies of that time and agreed to become domesticated in order to get close to human culture and to learn from human beings the secret of soul individuation.

This is the point in time historically referred to as Neolithic when the relationship between animals and humans reversed, and animals approached human beings to learn from us, as we had been learning from them during the previous ages. They agreed to become domesticated and give us food *if in return they were given the conditions in which they could learn from us the secret of soul individuation.*

But later on human beings started to misuse animals, ignoring the underlying reason for their domestication. This brings us to the present time when animals are massively exploited as our slaves. I consciously say 'slaves' because they are forced—often under the most disgusting conditions—to give us what we want from them without getting what they need in return. What they need is the knowledge of individuation.

In the meanwhile the present Earth Changes have initiated a new turning point on the evolutionary path of the animal kingdom. My vision of the ancient Mistress of the Animal Soul disappearing after having laid a baby in my lap reveals the decision of the animal kingdom's guides to use the impetus of the Changes to advance the animal kingdom to a new level of its evolution. I can't yet say what this new level is about, but it has definitely to do with the individuation issue.

Before, we were looking at our current animal catastrophe from the human point of view, asking ourselves what is its message for our world. However, seen from the angle of the oppressed animal kingdom, the catastrophe may only be a seeming one, because it provides whole masses of animals with the welcome opportunity of retreating from their modern slave

conditions by dying. On the other hand, I believe that by threatening human life through their diseases, animals will force our culture to recognize the right of animals to live in dignity, and to dedicate themselves primarily to the spiritual essence of their evolution, especially to the new issue evoked by the present wave of Earth Changes.

Behold: Landscape Temples Worldwide!

Let us now return to my Goddess revelation in 1990 and 1991. One of the practical results of my efforts to grasp the essence of the feminine principle was that I began to look on the landscape in a totally new way. Beforehand, a place had appeared to me as a sophisticated composition of power points and streams on the one hand, and biological environments plus geographical features on the other. Now I see the invisible and visible poles of the landscape as connected and impregnated by a soul principle that bears the mark of the Divine Feminine. It represents that level in the total landscape that provides lands, places and environments with their sacred dimension.

One can easily have a theoretical discussion on the topic of landscape temples, yet understanding the reality of a landscape temple as a soul organism in the landscape, invisible and untouchable, proved a tough nut for me to crack. My male-centered 'sensitivity' was not fine enough to perceive something that shows no physical or radiesthetic form but can be 'perceived' only through the medium of various soul qualities.

As a result of this deficiency on my part, I had first to go through the teaching cycle that the Goddess bestowed on me, mainly in the form of sleepless nights. After being suddenly awoken, one of her messengers—I believe a fractal of herself—would appear, slip into my bed and begin the lesson.

But before I was ready for this 'high school' of direct teaching, two key experiences were necessary. The first one reached me through a lascivious dream in which the Goddess appeared wholly naked in the courtyard of our house. It was early

morning when, with my five-year-old daughter, I came all unprepared out of the door. It was a shock to see the milky white beauty of the naked woman's body in the context of our normal courtyard scenery.

She silently urged me to approach her and caress her back with my left hand, starting upwards from the buttocks. At the same time my right hand was allowed to touch her pubic zone. While engaging in this 'indecent behavior', a whole palette of my hidden fears and traumas surfaced, all relating to how I experience the bodily facet of life.

Touching her silky bottom, for example, made me scared of coming into contact with her rectum, which showed me that my belief system considers the most sensitive aspects of the human body to be something taboo, or even something of a lower nature. Such beliefs prohibit me from allowing myself the kind of sensitivity that does not stay fixed on an abstract level but instead reaches down into the most immediate areas of our embodiment.

Further, in contacting the feminine sexual zones, I was made aware that I automatically identify the sensitivity of such intimate touching with the act of sexual intercourse between women and men. I did not consciously accept the power of the feminine as an autonomous spiritual power that manifests itself independently of the touch of a man. In this case his role is secondary. The primeval quality rests with the sensitive human body with its doors and organs—of which the sexual zones are a most important facet—through which the spiritual qualities of the soul can express themselves. I also noticed that, for the little girl who accompanied me, all my 'nasty' gestures were absolutely natural, while I felt highly embarrassed to have her watching me. Obviously, she stood for the powers of nature within me, for which the most usual language is the language of the body.

Later, I understood why I had had to deal with the blockages and traumas related to the bodily dimension of my being first of all. Until then I had been in the habit of conducting my communication with the divine realms on the spiritual level, mostly using the path of meditation. The Goddess, to the

contrary, speaks a language of manifestation, the language of life embodied. Her messages do not originate in any distant source 'outside' our being. They ascend from the deepest levels of the elemental soul within one's body towards its surface, to the point where they can be perceived and understood by one's consciousness. To nurse blockages relating to the most sensitive aspects of our bodies means we are blocking the Goddess' preferred paths for the teaching of her secrets: for example, the secret of the soul level as it manifests through the material features of the landscape.

This brings us to the second key experience, one which was bestowed on me the next morning, after the night enlightened by the above dream. At that time I was engaged in a lithopuncture project in the park of the castle at Cappenberg, Germany. When I sat down to meditate on the features of the landscape where I was working, I started to let my consciousness roam over the rounded hills and valleys that compose this landscape. Suddenly I realized that the separate hills and valleys of the park are not merely geographical forms but constitute the rounded and radiant body of a woman lying in the landscape.

My heart instantly recognized her as Gaia, the Goddess. How came it that I had never met her through the landscapes with which I am constantly working? In answer to the question she started to sink into the ground, and the next moment I saw only the features of the physical environment with which I was well acquainted. My disappointment didn't last too long because in the next instant she started to rise again to the surface. The geological landscape again underwent a process of 'translation' into the bodily features of the Goddess' appealing beauty, and the material forms tended to disappear.

One could not overlook the message of the vision. What we think of as plain physical forms, in which often we find no deeper enjoyment, are in effect elements of the living and breathing body of the Goddess, which permeates the landscape as its soul body. A landscape breathes in two phases, of which the geographical aspect is only one. As human beings, we have unfortunately lost the ability to see the ensouled level of the landscape and we believe that its geological face is the only reality of the places we

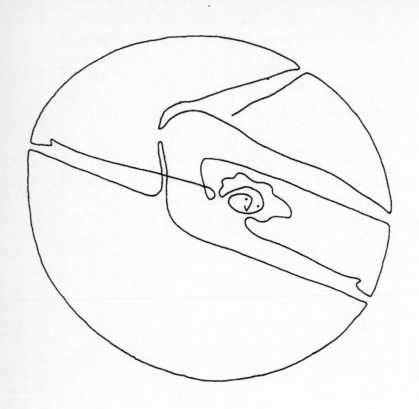

Gaia in the landscape.
Imagine a lake with a steep rock face
that has a cave in its side.
It is a place of Transformation.

inhabit. Instead, the Goddess urged me to open to the other face of the landscape, one that is equally as complete as the physical one. Often there even exists a surprising correspondence between a landscape as a geological body and the same landscape featuring the bodily forms of the Goddess.

These two preliminary experiences were followed by a tutorial sequence that I jokingly called the Goddess' 'high school'. Through a series of dreams intermingled with sublime bodily experiences during the following three months, I got to know different facets of the Goddess' presence. To my surprise, there were not just three facets of her to experience as I had previously thought, but at least 3 x 3, if not 3 x 3 x 3, making 27. The number could be also 3 x 27, which makes 81 Goddess' aspects in total. I found myself contemplating another dimension of the Divine Feminine, one that was not easy to grasp.

It started with an intuitive hint that there is a special numerical order in the way the Goddess extends her presence throughout different places, landscapes, countries, continents and finally throughout the planet as the whole. It was through the work of the archaeologist Maria Gimbutas and her book *The Language of the Goddess* that I was first led to uncover this secret. In her volume she presents a clear systematization of the symbols of the Goddess as they appear in the art of Neolithic Europe. She recognized that the symbols refer to three main groups, which she labeled as the 'Life-Giving' aspect of the Goddess, the 'Renewing and Eternal Earth' aspect and the aspect of 'Death and Regeneration'. What made me think there was more to it was the fact that each of these aspects can be subdivided into different facets.

My invisible teachers of the Goddess' secrets responded to my hunch by introducing into my immediate experience the symbols that I knew from archaeological evidence. They used either the language of dreams or the language of bodily expression. In the latter case, I would be awoken in the middle of the night to feel a special vibration extending around me and also within me. After a while, the vibrating quality would start to coalesce within me till I myself became an embodiment of the quality, not just on the emotional but also nearly on the bodily

level. In this way I was able to come face to face with and recognize the different facets of the Goddess, which ancient people knew and communicated with, but which to the modern mind are mere concepts derived from the study of archaeological finds.

The most exquisite was my experience of the creative aspect of the Life-Giving Goddess. She visited me during the night of April 19th, 1991, when I was still working at Cappenberg. The closer she approached me, more and more I became her. First, I could feel a gigantic vortex of magma spiraling just below her sexual organs. At its margins, the fiery life-power of the vortex was constantly crystallizing till a thin and precious layer of fertile soil began to form within her hips. This enabled all kinds of vegetation to grow within the sexual area of the Goddess. A real magical garden manifested there, symbolizing the world of plants. In the next instant I realized that her belly was composed of all the different species of animals crawling one upon the other, the simpler ones below and the more evolved above. The highest level was achieved by the whales and dolphins who even jumped over the barrier formed by the elevation of her breasts to touch the area of the head.

After the arrival there of the evolutionary impulse, I discovered that my head—remember that I was one with the Goddess—had been raised in a ceremonial way so that I could oversee the whole variability of the life processes occupying the body of the Life-Giving Goddess, which at that instant was also my own. I silently understood that the raising of the head should symbolize the role of the human being, which is one of consciously embracing and loving the whole of life, with the ability to care for the safe development of each tiniest part of it[1].

After my experiences of the different Goddess facets had culminated, I could see a clear pattern emerging. Just as the Goddess principle is composed of three aspects, each of those aspects again contains the same three facets of the feminine Divinity. Let me give an example from the Greek pantheon.

1 For a fuller description of the vision, which was much more detailed, see my book *Die Landschaft der Göttin*.

*The Life-Giving Goddess
(the Creative aspect of the Virgin)
as she revealed herself to me on April 19th, 1991.*

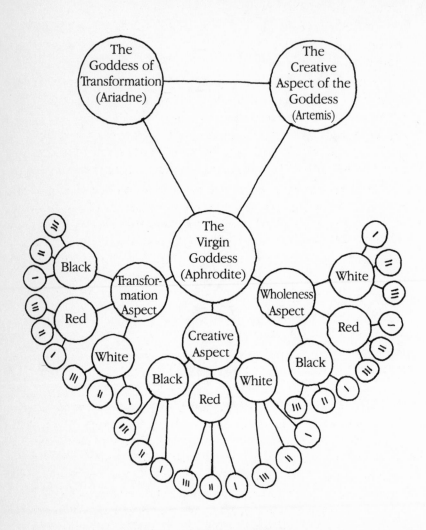

The infinite tri-partition of the Goddess,
shown in the example of Aphrodite,
the Greek Virgin Goddess.

Aphrodite, the well known 'Goddess of Love' represents the virgin aspect of the 'Life-Giving Goddess', that is to say the virgin aspect of the Virgin. As concerns the other two aspects of the Virgin Goddess, I have recognized the Creative facet in the features of Artemis and the Transformative aspect in the individuality of Ariadne.[2]

Even though Aphrodite is generally known as the Goddess of Love, the traditional myths bear witness that she was also venerated as a tripartite Goddess. Her title 'Aphrodite Urania' expresses her role as the Creatress of the Universe. Emerging out of the sea of eternity, she laid the archetypal egg from which all creation was born. This myth refers to her *white* phase.

Her second name 'Aphrodite Pandemos' refers to her role as the power of social love which connects members of a society or clan and stimulates the bonds of affection that each has for the other, and which in turn represents the spiritual and psychological basis of community. Here we are dealing with Aphrodite's creative or *red* phase. In her *black* phase she is known as 'Aphrodite Apostrophia', the Goddess of sexual love.

I was unsure whether I was right to interpret sexual love as revealing the transformational potential of the Virgin, so I asked the Goddess to unite with my body and clarify my understanding of it, beyond the rather hostile thought forms about 'earthly love' that my Christian education had impressed on my memory.

First of all the Goddess made it clear that the essence of sexual intercourse is not bound to the act of procreation, but rather represents an autonomous transformational process in which both partners participate during their union. Then she took me imaginatively through the proceedings of an act of sexual intercourse, so that I was simultaneously present within both partner's bodies. I soon realized that I was watching an alchemical process through which the fine soul organism of both partners was drawn to enter deep down into the tissue of their bodies. For the soul essence, this is like entering the womb of physical

2 It is my belief that as the Greek pantheon evolved, Ariadne lost her position among the Gods and Goddesses of Olympus and regressed to a mythological figure known to us as the guardian of the Cretan Labyrinth, which is a symbol of transformation.

*The Wholeness aspect of Aphrodite,
an antique clay figurine showing her emerging from a shell with two pearls in her hands.*

creation. In alchemy this phase of the process is called 'nigredo', the Black Phase. During the next step, the phase of uniting, the partners touch upon the creative powers of the Goddess—*a living fractal of herself*—focused within each woman's 'underworld'. Finally, buoyed by the love bonds created between the two partners, the archetypal power of regeneration surfaces to enrich their daily life. I no longer doubted that it is the transformational power manifesting within the act of sexual love that causes the Virgin to appear in her *black* phase.

After I had come to understand the principles through which the different Goddess aspects manifest and had been gradually sensitized to their immediate presence within me, it was time to find a practical example in the landscape where I could test the knowledge gained. The opportunity came through an invitation from the Orchard Gallery in Derry (Londonderry) in Northern Ireland. I was invited to develop a lithopuncture project there, on both sides of the border between Northern Ireland and the Republic of Ireland. The aim of the project was to use the medium of art to further the prospects of peace between the Protestant and Catholic populations. It is worth mentioning that at that time nobody was talking about the possibility of peace being anywhere in sight.

Arriving there in the spring of 1991, I realized that in fact the state border has cut in two a landscape that shows the obvious marks of a complete landscape temple. When I studied the landscape of Derry/Donegal during my first trip, I discovered the Virgin aspect of the landscape temple to be embodied by the Inch Island while the Creative aspect was focused on the Grianan Mountain, both presently part of the Republic of Ireland. The Transformational aspect is represented by a former island on the river Foyle—where nowadays the city of Derry stands—which on the contrary is part of the United Kingdom. In between lies a strictly controlled border, at that time guarded by heavily armed check-points.

My proposal to the Gallery was to reconnect the wholeness of the landscape temple by positioning stone needles at its dominant points, regardless of whether they lay on one side of the border or the other. Then the blocked communication could

flow again between the separated parts of the whole. Luckily, both countries agreed to offer the places I needed for my work, giving the project a chance of success.

Arriving back home with my findings documented, I was blessed to have my daughter Ajra Miska by my side at that time to assist me in planning my projects. She was just about to develop her methods of spiritual healing through communication with her spiritual master Christopher Tragius. He agreed to help us while we worked on the project that we were seeking to create in Ireland. Connecting with the devas, who are spirit guardians of the soul of the Derry/Donegal landscape, the master could obtain information about the role that each place played within the landscape temple, how it was originally conceived by the Neolithic culture, and the later transformations which all the localities underwent during the succession of cultures inhabiting the country.

Luckily many Neolithic monuments are preserved in Donegal. So Christopher could use the stone structures still existing from the ancient culture of Tuatha de Danann—meaning 'The Children of the Goddess Danu'—as a model to explain the landscape temple's functioning.

First of all we learned that landscape temples did not originally exist on the surface of the Earth. The whole Earth is sacred and each tiny cell of it too. The Earth herself does not need symbols of her sacredness to be exposed upon her surface. It was the highly advanced Stone Age culture that first recognized the soul level of the landscape and offered it a form in which to manifest. For this purpose it developed the language of standing stones, stone circles, the so-called 'chambered graves', earth works, etc. Through this kind of cooperation between human creativity and the soul power of places, a new geomantic layer of landscape was created. We call it the layer of landscape temples, embodying the qualities and powers of the invisible soul that permeate a particular landscape.

Secondly we were taught that, as a living, breathing organism, a landscape temple is composed of three basic phases, featuring:

- the inbreath;
- distribution of the soul powers throughout the relevant landscape;
- and the outbreath.

The function of the center of inbreath is to draw the cosmic powers of the soul into the organism of the given landscape. The second phase is carried out by the centers of Wholeness, Creation and Transformation which are responsible for injecting the inhaled soul qualities into all aspects of the life evolving within that landscape, be they on the level of nature or culture. The purpose of the final phase, the phase of outbreath, is to draw together the knowledge gathered from all the places through which the breath of the world soul has been moving and send it back to the universe as an information source from which other worlds can grow[3].

Christopher Tragius also informed us of the distinct role that the male or yang impulse plays within a landscape temple. Its presence also has three phases. It is born out of the center of the Virgin and directed towards the center of Creation where it has an important function as the partner of the place's yin-powers. It is only the interaction between the feminine and masculine powers that makes possible the life-fostering role of the Creative center. There the incoming streams of abundance are constantly being mated, to be poured out into the landscape to give further scope to the manifold character of life's expressions.

Christopher relates that when the Neolithic culture flourished in Ireland, great ceremonies were held yearly at a specific point on Inch Island, which represents, as I have mentioned, the Virgin Goddess aspect. The rituals took place where nowadays the ruins of Inch Castle stand. Their purpose was to invoke the birth of the masculine power out of the holistic structure of Inch Island's power-fields.

They directed it to the top of Grianan Mountain, still marked by a Celtic sanctuary in the shape of an amphitheater. There, the

3 For a more detailed description of the Derry/Donegal landscape temple, see my book *Die Landschaft der Göttin*.

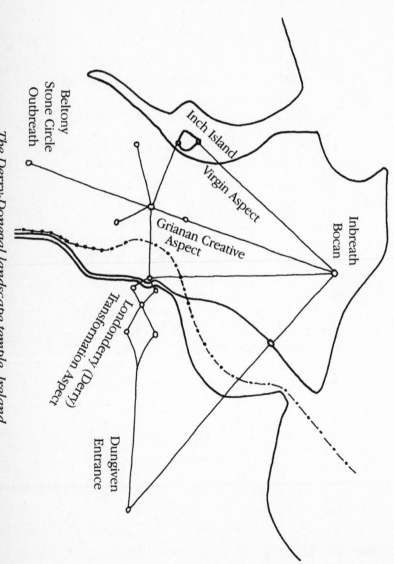

The Derry-Donegal landscape temple, Ireland.

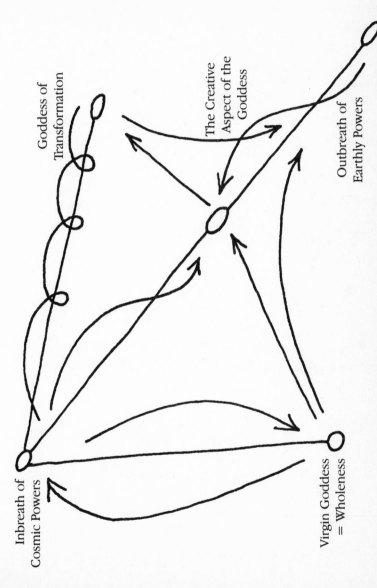

Goddess of Transformation

The Creative Aspect of the Goddess

Outbreath of Earthly Powers

Inbreath of Cosmic Powers

Virgin Goddess = Wholeness

General layout of a landscape temple.

Creative powers of the Goddess are focused and rituals of sacred marriage took place. After the male impulse had played out its fertilizing role, it was carried in ritual fashion to Derry and the Black Goddess' island on the river Foyle where it entered the dark space of the underworld for regeneration. Then, through the rituals of the following year held on Inch Island, it was again called into existence and creative action.

The work of carving 17 lithopuncture columns of Irish granite and positioning them in the landscape took until July 1992. On each of them my wife Marika and I carved a special cosmogram.[4] Parallel with this project, another very interesting process was going on at home. My country Slovenia was splitting away from Yugoslavia and becoming an independent state. Because we had been under German rule for more than a thousand years, we had no appropriate symbols of identity as a nation, such as a national flag and coat of arms. They had to be created from scratch, and a public competition was advertised to receive proposals. I felt inspired to take part.[5]

My idea was to explore the territory nowadays covered by Slovenia and to fuse the results with the knowledge of landscape temples that I had so far gained. From this synthesis I thought it possible to create a cosmogram that could act as the official symbol of the country's identity. With the help of Ajra and the support of her spiritual master we studied the country bit by bit. Partly we traveled, partly we worked from a distance using maps. It turned out that even though the country is composed of many different landscapes, it still presents the mega-structure of the usual landscape temple, itself composed of many lesser landscape temple structures.

Its center of cosmic inbreath is located in the Julian Alps, occupying the north-western corner of the country. It is centered on Slovenia's highest mountain called Triglav—a name denoting a

4 Concerning the holistic language of cosmograms, see my book *Earth Changes, Human Destiny,* Chapter 5, Findhorn Press 2000.

5 Slovenia is situated on the southern side of the Alps and represents the northern part of the former Yugoslavia.

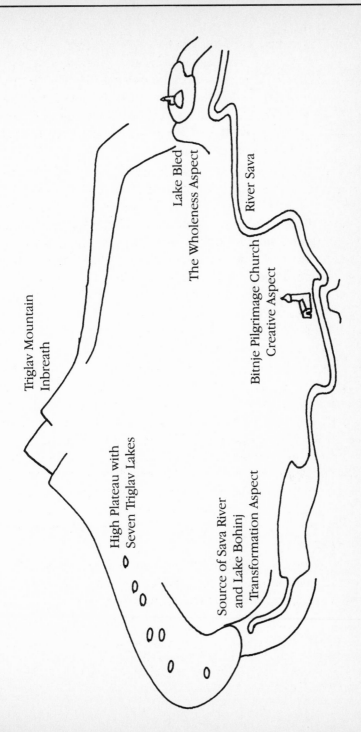

Triglav Mountain
Inbreath

Lake Bled
The Wholeness Aspect

River Sava

Bitnje Pilgrimage Church
Creative Aspect

High Plateau with
Seven Triglav Lakes

Source of Sava River
and Lake Bohinj
Transformation Aspect

The Triglav landscape temple: the landscape temple of inbreath for Slovenia.

mountain with three peaks (2863 m). Its three aspects are located at the foot of the mountain chain. Lake Bled, which I mentioned in the last Chapter, represents the Wholeness aspect. The lake is renowned for the church built on its island, which is a pilgrimage center for the Virgin, and for a castle which dominates the lake from a vertical rock formation. The other two aspects, Creation and Transformation, are embodied in two other pilgrimage centers, Bitnje and Lake Bohinj.

The landscape temple of inbreath centered in the Triglav mountain chain is the origin of the three spiritual axes that unite the soul of the country that is embodied within the variety of landscapes composing Slovenia. I call them the *white* axis of Wholeness, the *red* axis of Creation and the *black* axis of Transformation. There are three landscapes that embody the Goddess' three aspects for Slovenia and they are centered along these three axes. The landscape of the Kras, extending close to the Italian border, embodies the principle of Wholeness; the landscape of the Ljubljana Basin stands for the principle of Creation; and the principle of Transformation is represented by the landscape of Slovenian Carinthia, extending along the border with Austria.

What was new to me, as regards the usual structure of a landscape temple, was the fact that Slovenia has no common center of outbreath. Each of the three axes terminates in its own landscape temple of outbreath; the *white* axis in the heart of Istria, the *red* in Bela Krajina—the 'White Land' already mentioned—on the border with Croatia, and the *black* one in Prekmurje, extending along the border with Hungary.

After getting to know the basic features of Slovenia's macro-landscape temple, I depicted them in the form that was to become the new country's coat of arms. Its upper portion displays a triangle composed of three stars, to represent the opening through which the country inhales the stream of cosmic power and information. This inbreath is carried into the organism of the country by means of the above-mentioned three axes, which are represented on the coat of arms by the three peaks of the Triglav mountain. Two wavy lines at the base of the coat represent water and the outbreath function, which in the case of

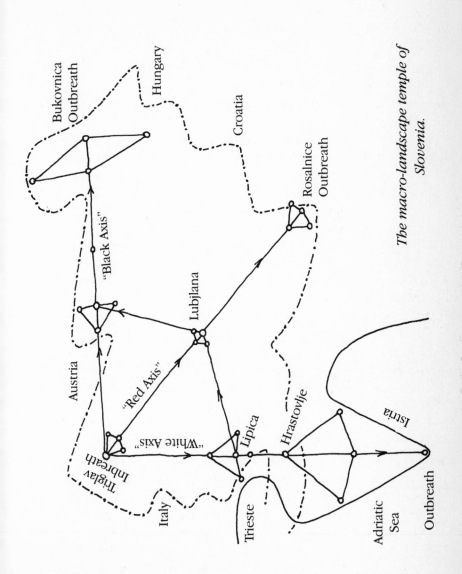

The macro-landscape temple of Slovenia.

the landscape temple of Slovenia is closely connected with the quality of water.

Only a few days before the start of the short war for Slovenia's independence on June 27, 1991, the country's parliament declared my proposal to be the official coat of arms of the new-born Republic and also decided to use it to embellish the national flag.

Working with the macro-landscape temple of Slovenia showed me how indispensable for proper understanding of the landscape is the principle of the endless tripartite division of the Goddess, as I demonstrated above with the example of Aphrodite and her three basic sub-aspects. Only if one imagines a landscape temple extending over a vast country being subdivided into the landscape temples of particular landscapes, which in turn are subdivided into landscape temples of the different places that compose those landscapes, can one understand how the vastness of a country can be touched by the powers of its soul through to the last inch of its territory.

Having finished my work on the landscape temples in North Ireland and Slovenia, I was now convinced that I possessed the key to unlock the soul organism of any place or country. My enthusiasm faded away in the second half of 1991. I realized that the visitations from the Goddess and my communication with her different facets, which were my main source of teaching, had ceased, and I was left somewhat alone with my questions and speculations. Ajra had plunged herself fully into her duties with her young family and the newly opened healing studio and didn't have much time to support my investigations. In the end I began to doubt and worry.

After plumbing the depths of disappointment, I had a dream telling me why communication had broken down. In the dream I was standing in a crowded bus with a bag in one hand and a handful of caramels in the other. To keep my balance in the jolting bus, I had to get one hand free so I could hang onto something. In my moment of need I saw a round, motherly woman standing

close by, someone who seemed known to me. She had a little pocket over her opulent breasts and I decided—without asking— to store my caramels there so as to have a hand free. After a little while, feeling no shame at all though the other travelers were all around me, I stretched out my hand and took one of the sweets out of her tiny pocket to suck it and make the time pass more quickly. Later on, I felt a longing for a second caramel. Again I stretched my hand towards her breasts. But this time I felt ashamed and did not dare to touch them for a second time. Instead I started to apologize to everyone around.

The message was clear. I was being urged to consider how the rhythms of human evolution have changed since the days when people recognized the presence of the Goddess *all around them* and the paths of initiation were held open to her presence. In the meantime, both as a culture and as personalities, we have gone through a process of extreme individuation. We are becoming autonomous individuals who are unable to relate to any aspect of reality if we do not experience it first as a part of our own personal microcosm.

In the far past we did indeed experience our soul as a fractal of the universal Goddess ensouling us 'from outside'. To put it in the language of the dream, the 'sweetest' aspect of our identity was stored at the 'Goddess' breasts'. Through an appropriate ritual we could reach in there whenever we 'longed for another caramel'.

Significantly, while reaching for a caramel for a second time—the 'second time' symbolizing the present epoch—I felt too ashamed to touch a strange woman's breasts. Times have changed, and to get in touch with my soul dimension I must search within the emotional, energetic, mental and spiritual layers of my own body, and not somewhere outside.

To experience the soul of a landscape in a way that corresponds to our present epoch, I should like to propose the following exercise, which is one I use myself. I should be pleased if you would try it.

Exercise for experiencing the soul of a landscape

- *Lie down, let yourself feel at peace and stretch out your body. Try to locate the center of your being. Where is it located at this moment within your organism? When you are clear that you have located it, stay centered in it for a while, visualizing the center as a bright point.*

- *Ask an animal to lie down under your feet so that you can feel its fur. It can be your power-animal or one that responds to your present call. Its role is to keep you connected to the soul level. Remember that animals are symbols of the elemental soul.*

- *While remaining focused in your center, open yourself to the features of the landscape around you. Touch its hills or mountains with your awareness, be aware of its plains or rivers.*

- *Now forget all about these links and imagine that the ground is no longer holding you. Stretched out as you are, let yourself fall down without losing foot contact with your animal. The animal should represent the axis around which you are circling in slow motion while falling into the void behind your back. Make a full 360 degree circle till you arrive back in the position in which your physical body rests.*

- *Now you are in the dimension of the soul. Do not hesitate, but go with your awareness into the ambience and experience the soul dimension of the countryside around you. You may lose the proper resonance after a while, but you are free to repeat the process as often as needed to get the idea of the landscape temple involved.*

- *Finally give thanks and document your findings so that you can compare them with possible future explorations of the same place. Remember that a place or a landscape is new and slightly different in each moment.*

A few years passed before I was able to detach myself from relying too much on the model of the ancient landscape temple and recognize that the soul of a landscape has different possible modes of expression. In this, I was greatly helped by discovering

landscape temples composed in unusual and unconventional ways. Let me give some examples: first of all the landscape temple of the Berlin area in Germany.

Berlin was founded in a flatland where lakes, marshes and rivers are the only marks of identity. To balance the extremely yin-loaded landscape, the structure of its landscape temple goes to the other extreme, forming a straight geometric composition of three triangles that encompass one another, the biggest one representing the framework within which lies the large cityscape with all its suburbs.

During my communion with the soul of the Berlin cityscape, I was inspired to look first of all at Berlin's coat of arms, which portrays the colors characteristic of the Goddess: a *black* bear with an outstretched *red* tongue displayed on a *white* field. The three colors are in tune with the three qualities embodied by the bear as a power-animal: Love, Benevolence and Courage. In regard to the landscape itself, these three qualities are represented by three Elements that constitute the dynamics of the landscape temple of Berlin.

The outer triangle is governed by the powers of the Water Element and the principle of the Virgin. At its south-west corner, embodied in the city of Potsdam with its exquisite parks, the triangle inhales the cosmic powers of the Water Element, while at the opposite corner in the south-east, centered in the river Spree, the triangle is supplied with the earthly quality of the same Element. Within the power-field of the Berlin landscape temple the incoming streams of watery quality undergo a process of fusion. They are finally distributed to universal space through the third corner of the triangle, focused at Oranienburg in the north.

The second triangle of the landscape temple is much smaller and governed by the powers of the Air Element. The source of its qualities is located above the district of Alt Tempelhof where the Templars had their seat during the Middle Ages. There, high in the atmosphere, I can perceive an etheric 'temple' that concentrates the cosmic qualities of the above-mentioned Bear. On the other side of the city, the area of the Rehberge national

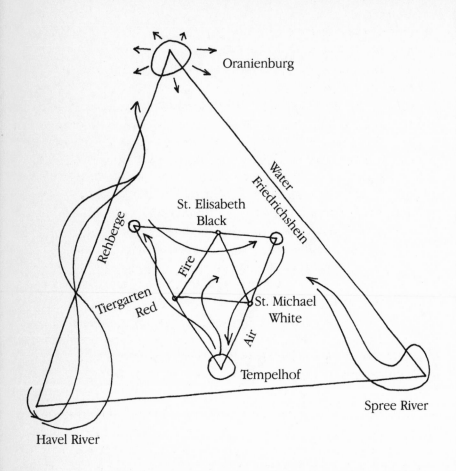

The landscape temple of Berlin, Germany,
relates to the Elements of Water, Air and Fire.

park inhales those qualities and uses them to impregnate Berlin's underground space. The final corner of the second triangle, the one focused in the Friedrichshein Park, serves as the center of outbreath and distributes those qualities into the outer space of the Berlin cityscape.

The third, even smaller, triangle is dedicated to the powers of the Fire Element and its purpose is to 'translate' the three qualities of the cosmic Bear—anchored above Tempelhof—into the threefold qualities of Berlin's soul body. Its corners are focused at three distinct places in the city center The ruins of the majestic church of St. Michael stand for its Virgin aspect, the Victory Column with the surrounding Tierpark for its Creative aspect and the neglected graveyard of St. Elisabeth—once intersected by the Berlin Wall—for its powers of Transformation.

For years I have been working with Ajra on Great Britain's landscape temple of inbreath, which occupies the central area of Scotland. It is focused around the primordial landscape of the Grampian mountains, where the British Isles take their breath from the breadth of the cosmos. Around the central inbreath area a spiral-like composition of landscape temples follow each other from Aberdeen, across Elgin, Forres, and Loch Ness. Finally the ceremonial chain of landscape temples reaches the island of Iona. The archaeological evidence confirms that the whole chain was created in the Neolithic era.

The tiny island of Iona was most sacred to the ancient cultures and also played a decisive role in the era of Christian conversion. I perceive a flower-like chalice positioned high above the island. A special source of spiritual knowledge is anchored there that, transmuted and transformed through the whole chain of the above-mentioned landscape temples, adds its impulse to the inbreath center embodied by the Grampian Mountains. Only through the spiritual and practical efforts involved in creating the chain of landscape temples did it become possible for the exquisite qualities concentrated above Iona to become involved in this inbreath stream and initiate a special quality in Britain's soul body. I can feel that special quality each time I approach the British Isles from the Continent. Somewhere about the middle of

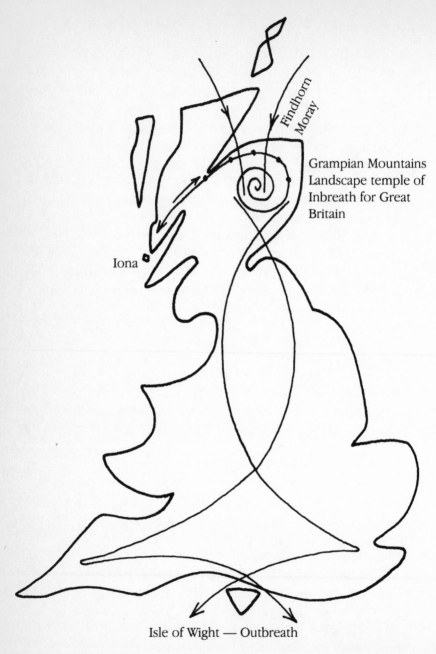

Findhorn
Moray

Grampian Mountains
Landscape temple of
Inbreath for Great
Britain

Iona

Isle of Wight — Outbreath

The breathing system of the landscape temple of Great Britain.
Note the path of impulse-exchange between Iona and the Grampian
Mountains that runs via the chain of landscape temples in Moray.

the Channel I get lifted onto a higher level of being, which corresponds to the level at which Britain's soul body is vibrating.

During our work in Scotland our main interest was devoted to a particular unit in the above-mentioned chain of landscape temples, one where the grounds of the Findhorn Foundation play an important part. That particular landscape temple has its inhalation center situated in the east, in Burghead, on a steep rocky promontory reaching far into the North Sea. On the other side of the area, in the west, one can find its exhalation point, focused in the waters of the Findhorn River at Sluie.

As usually happens, one finds the tripartite form of the landscape temple in the middle between these two centers. The Virgin aspect is represented by Pluscarden Abbey and by the almond-shaped valley within which the monastery resides. The Transformation aspect is focused on the desert-like dunes of the Moray Firth behind the village of Findhorn. There, in ancient times, people were coming 'to the desert' to experience their inner transformations in solitude. And there, in the early '60s of the last century, Eileen and Peter Caddy, together with Dorothy Maclean and Ogilvie Crombie, founded a community and a spiritual center that plays an important role in the cultural transformation of the present day. Many people who have lived there or visited the place—including myself—have gone through critical transmutation processes, while still enjoying its unique atmosphere. It is a typical center of Transformation.

Between the two, behind the town of Forres, lies the center of Creation, embodied by the seven rounded hills that make up the feature called Cluny Hill, which also has a deep Hollow at its center called Hell's Hole. Remember that the name 'Hell', signifying 'the Shining One', is one of the names of the Goddess. Each of the hills has at its top a focus to attract the power of one of the seven classical planets—Saturn, Jupiter, Venus, Mars, Mercury, Moon and Sun. After their impulses have touched the top of their corresponding hills, they wind around them, following their invisible spiral paths to flow down into the cauldron of Hell's Hole. There the sacred marriage takes place between the feminine power of the Earth and the masculine power of the impulses from the planets. The 'child' of the union

is the quality of life's abundance that, if the landscape temple were fully awake, would constantly pour from the Hollow into the surrounding countryside.

To stimulate its awakening, in June, 1999, Ajra and I worked with an international workshop group to attune the Cluny Hill landscape temple to the present moment in the evolution of the planet. We split into seven small groups, each going to one of the seven hills to simultaneously perform a ritual that we had prepared in advance.[6] The results demonstrate that a landscape temple is not a static formation but a living soul body that reacts to impulses at the relevant moment.

My observations, both during the ritual and afterwards, confirm that the landscape temple first of all reacted to our work by initiating a short but intensive phase of self-cleansing. This manifested in the form of a mighty pillar of cosmic power, invoked to pour its cleansing and rejuvenating powers into Hell's Hole. The moment its activity reached the vast underground area of the Hollow, the incoming power-flow separated into seven strands, each of them ascending through the 'chimneys' of the seven hills out to the cosmic heights. The last image showed the final result of the cleansing process looking like clouds of smoke issuing out of the seven power-points at the top of each of the hills.

After a while the direction of the energy flow reversed itself and changed to its usual direction. The power-points on the seven hills again acted to attract the cosmic impulses bearing the mark of the seven planets. But this time the flow of the impulses spiraling down towards the etheric space below the Hollow was much more vivid than before. Also, the interaction with the essence arising from the core of the Earth, which takes place within the alchemical retort below Hell's Hole, was more intense. The power brewing there was now a radiant green color, characteristic of the presence of the heart quality. Only now did the phase of dispersion into the surrounding landscape become

6 For the ritual to attune a place to the present moment marked by the earth
 changes which are taking place, see my book *Earth Changes, Human Destiny*,
 Chapter 9, Findhorn Press 2000.

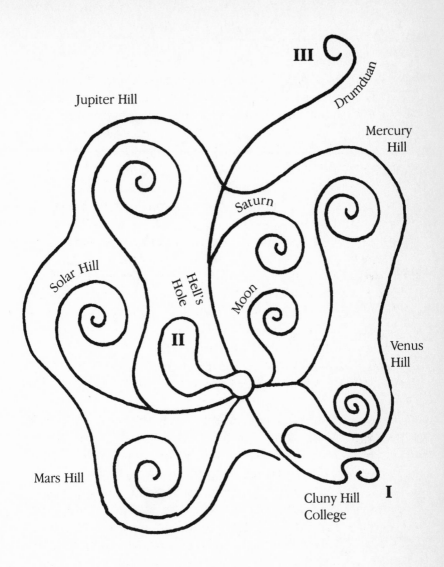

The landscape temple of Cluny Hill at Forres, Scotland,
relates to the seven Planets.
Numerals I, II, and III denote the place's three Goddess aspects.

properly consolidated. First, the ascending powers formed a green colored cupola above the Hollow. From its margins the newly brewed quality then began to disperse into the environment to enhance the processes of life and the growth of culture.

My travels to other continents also helped undo my fixed ideas about temple models and instead recognize the amazing variability that can be manifested by the Goddess' landscape temples. A good example came to me through the earth healing work I have been doing in Brazil in the last five years, during which I have got to know the subtle dimensions of the country quite well. And yet, as long as I tried to project the models that I had experienced in Europe on the countryside there, I couldn't find the key to the structure of its landscape temples. However, during my stay in Rio de Janeiro in November 1999, I was given an insight that revealed a landscape temple composition that I hadn't ever met before.

With my friend and collaborator Franklin we visited the former Royal Chapel, built on a mighty rock that once stuck directly out of the ocean. Unfortunately the shore was later artificially drained to build the city throughway. The place is called Gloria, and the church there is dedicated to the Virgin. I was amazed at the height and depth of the chapel's power-field. My inner vision showed a fantastic flower with petals extending into different portions of Brazil.

Feeling I was thus connected to the whole country, my intuition suggested that I identify simultaneously with the various sacred places in Brazil that I know well, like Aguas Emendadas close to Brasilia, Colegio Hill in Sao Paulo, Uoro Preto, Pedra da Gavea in Rio, etc. In that moment the Goddess unexpectedly pierced the thick layer of my ignorance and appeared in front of me nude, emerging out of the ground up to the level of her hips. I nearly forgot to breathe, so deeply touched was I by her power and beauty.

Then I realized that the reason for her showing herself in part identical with the ground must be because she is basically connected with the whole country whose soul she represents. So

I started to spread my inner vision across the country, beginning with the direction of Sao Paulo where I had given a lecture and workshop the day before. As soon as my attention reached the spiritual center of Sao Paulo called Colegio, there emerged from the ground an identical Goddess figure, but black. I let my attention traverse the country like a light beam and the same thing happened when it reached the water sanctuary of Aguas Emendadas, except that the Goddess figure appearing there was colored blue. Continuing to link in this way with other sacred places, in each case I witnessed the emerging of the 'same' Goddess body out of the ground. Soon I realized that the reason why all the figures were revealing a nearly identical form was to tell me that I am seeing a system through which one and the same soul presence is distributed throughout the whole country.

The system of the Brazilian landscape temple is composed as a radial network. From each of the major Goddess centers, eight beams go out to lesser, related centers. From each of the lesser centers another eight beams radiate to smaller focal points, etc. In this manner the soul presence can be embodied within each inch of the land, just as I had discovered in the case of the infinite tripartite division of the Neolithic landscape temples in Europe. Yet the landscape temple of Brazil shows an indigenous structure, having its origin in the creativity and Goddess devotion of an ancient pre-Columbian culture unknown to me. It may be supposed that the white colonizers of Brazil did not care to continue maintaining the ancient landscape temple network, and yet were inspired to construct their earliest church buildings on the places of its major focus. The finest examples of this kind of continuity are the Sanctuary of Gloria itself, and also Colegio in Sao Paulo, Saint Francis in Uoro Preto, the old town of Porto Seguro, etc.

It would get boring if I were to describe many more of the different forms of landscape temple. The knowledge of their presence is much more vivid if experienced personally, as related to the place where one is presently living. To facilitate such contact, I wish to propose another exercise that is based upon my experience in Gloria.

*The Goddess ensouling the landscape of Brazil
as she revealed herself at Gloria, Rio de Janeiro.
She designated the focuses of Brazil's landscape temple
through fractals of her presence.*

Exercise for perceiving the soul organism of a place

- *Attune to your inner center, taking care to be well grounded; rest there peacefully for a while.*

- *Direct your attention to the various places in the landscape which you think should be explored in order to support it, either for its power-field or consciousness, or because it is sacred to the soul level of the landscape. Swiftly go to each place and bring it back with you into your body until your body feels packed full of the various power points and places. Hold them all within the sphere of your body.*

- *Then release them all in an instant and start to feel and perceive immediately, because right now you are in touch with the soul of the place. Do not hesitate, the reality lasts only for a moment.*

My insights into the process of the Earth Changes that started late in 1997 indicate that the transformation of the different dimensions of the earth's body has also had profound effects on the structure of landscape temples. As an example, I can instance the changes that I perceived after March 2000 within the macro-landscape temple of Slovenia, described above.

First of all I noticed that below the country's surface a majestic power-field is building. Little by little its archetypal powers are starting to break out through the soul membrane of the central landscape temple of Slovenia, the one in the Ljubljana region. As a result the three above-mentioned landscape temple axes that permeate the country have become highly energized and have started to rotate. The process carries with it the general feeling that the powers of the soul are about to awaken in their full potential.

What interests me most is the emergence of a new kind of power-axis that I have detected not only inside the landscape temple of Slovenia but also in several other places and landscapes that I have visited during the past year. The axis resembles a scepter composed of a power center at both extremes and a third one in the middle. Since the axis resembles a broad power path, it would be more appropriate to speak of a scepter-like channel.

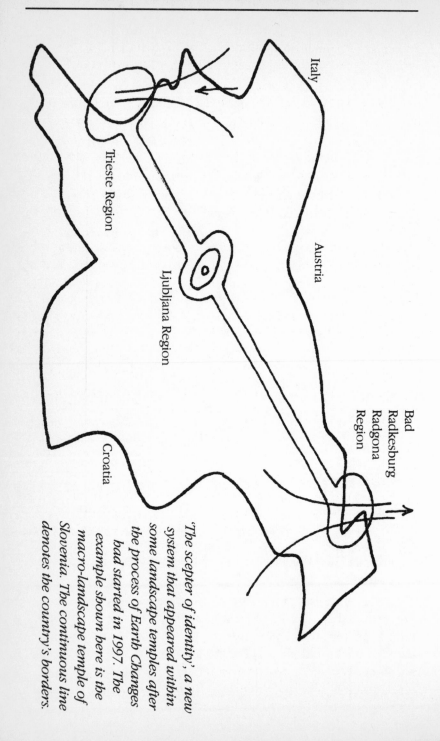

Italy

Trieste Region

Ljubljana Region

Austria

Bad
Radkesburg
Radgona
Region

Croatia

'The scepter of identity', a new system that appeared within some landscape temples after the process of Earth Changes had started in 1997. The example shown here is the macro-landscape temple of Slovenia. The continuous line denotes the country's borders.

The centers positioned at either end of the channel connect, one with the cosmic realms and the other with the earth's depths.

In the Chapter dedicated to the personal soul, I wrote of perceiving such a 'scepter' newly manifesting as the emblem of the human being's new identity. It connects the throat area with the base of our belly and is centered within our heart center. In the case of Slovenia's macro-landscape temple the throat area corresponds to the Bay of Trieste, together with its coastal regions that belong partly to Slovenia and partly to Italy. There, as broad as the bay area, I perceive a light pillar entering deep into the earth.

Moving to the opposite end of the 'scepter', we find that the landscape centered around Bad Radkesburg on the Austrian, and Gornja Radgona on the Slovenian, side of the border corresponds to the base of our belly, i.e. the chalice of the hips. There, a similar light pillar deriving from the earth's depths reaches up towards the cosmic heights.

The role of the central point within the scepter-like channel (which in the case of the human being is focused in the heart) is to balance the two polarized centers at its extremities. Simultaneously, it serves as the source of dispersion, so that the soul powers fused from the elements supplied by the other two centers can spill out through the whole width of the corresponding landscape temple. In the case of the macro-landscape temple of Slovenia, the role of central focus is performed by the exquisite landscape temple of Ljubljana, which is Slovenia's capital city.[7] There, both the traditional and the newborn landscape temple network intertwine to enhance each other's strength and beauty.

7 For details on the landscape temple of Ljubljana, see my book *Earth Changes, Human Destiny,* page 215, Findhorn Press 2000.

The Son of the Virgin, Her Consort, and Her Uncles

Now that we are starting on the last quarter of our writing-and-reading game, it is time for some brief retrospection.

The last four Chapters were dedicated to those spheres of creation where the Goddess principle presides most vividly, manifesting as the guiding impulse of life's organism. Our first challenge was to become aware of the feminine dimension of culture and focus on the timeless pulse of an alternative history. This is not one subordinated to the masculine sense of linearity, leading from a dwindling past towards a vague future, but instead recognizes the autonomy of the present moment and the simultaneity of life's network which comprises all that was and ever will be.

Of course, it is undeniable that changes occur; cultures rise and disappear. But this doesn't necessarily mean that we have to submit to the mind-constructed pattern of a linear type history. To put it in the language of the Goddess, evolution has phases that rhythmically exchange their dominant position in time and space. The phase of seeding a new cultural development is succeeded by a phase of expansion, and the phase of expansion sooner or later becomes a phase of decay. There follows an intermediate epoch during which the center of evolution ascends to the next level of the cosmic spiral to ensure that the new cultural cycle does not become a mere repetition of what we already know and what we already are.

In the next Chapter, the Fourth, we addressed the personal identity of the human being. We recognized the impulse of the Divine Feminine working through our soul level. Mediating

between the lofty levels of the spiritual world and the dense strata of the physical world, her impulse enables us as angelic spirits to live and create in the conditions of manifested matter without having to lose our identity. It is the soul-facet of our being that secures the continuity of our personal evolution while we move from life to life towards experiencing the totality of our essence.

In the Fifth Chapter I tried to present to modern consciousness a new way of viewing that most exquisite phase of evolution that abides under the immediate protection of the Goddess, the animal kingdom. The vast palette of all the possible life forms that comprise the animal world is an excellent ground for the experimentation that enables the Virgin to develop the instrument of the soul, first of all in its simple will aspect, then in its emotional aspect, aiming always towards the point of soul individuation that is governed by the mental aspect. To make this last step possible, human evolution has entered the process, helping to push the evolutionary stream towards even greater dimensions of spiritual autonomy.

The last chapter relates to the sacred dimension of the Earth and the ways in which the Goddess, as the soul of places, landscapes and continents, speaks through the physical body of the planet. We came to understand the different compositions of landscape temples as being different forms of the language used by the landscape's soul to communicate with the indwelling human culture.

The function of the two chapters at the beginning of the book was to instill the concept and inspiration of the Goddess into the framework of modern consciousness, which is in the habit of looking on life in terms of the male God-principle. Primarily, my efforts aim at having the Goddess recognized as an autonomous cosmic principle that is not a mere bit player in a God-centered universe. She represents a different and perhaps more complex and more organic way of understanding the cosmic wholeness, and of finding one's place within its organism.

Secondly I tried to show that the Goddess principle is not a religious pattern related to the past. On the contrary, if we would ready ourselves to listen to her impulse NOW, the voice of the

Feminine Divinity could bring into our lives a powerful alternative to the mess of contemporary civilization with its social injustice and ecological aggression.

Finally, the present chapter intends to integrate 'the other side'. How could one speak of the holistic nature of the Goddess impulse if the masculine facet of life were to be excluded? No way! But to think of Goddess and God as partners, together ruling the vastness of the universe, could also be prone to error. That implicitly conveys the patriarchal concept of Divinity, with the masculine as supreme ruler representing the gilded summit of the hierarchical pyramid. There is little difference between thinking of God as a dictator or as consenting to share the power-position with a consort. In both cases we are dealing with humanly created imagery and not with a reality of life.

Instead of engaging in a discussion of the different possible ways in which the cosmos is organized, let us stay loyal to the path of immediate experience, the path that the Virgin is teaching. Our guiding star until now has been a heartfelt dedication to the feminine way of viewing life. Why neglect it at the very moment when we are starting to focus on the masculine principle?

First, we should understand that the masculine quality that desires conceptual clarity in respect of what is going on within and around itself is a virtue and not something to be ashamed of. What threatens the integrity of life today is not that, but the disproportionate extension of mental attitudes that tend to suffocate the subtle essence of life's reality.

Adorning the presbytery of the Chapel of the Virgin of Guadeloupe in Santa Fe, New Mexico, USA, there is a most surprising vision of how the feminine and masculine principles can co-exist together in an inspiring manner. My daughter Ana and I gave a speech on Earth Healing there in November 2000. Amazed at its subtle message, I was able to use the ancient painting as a model to explain my world view.

After the Spaniards had colonized the territory of New Mexico, they built the Chapel of the Virgin of Guadeloupe at the end of the Royal Road in Santa Fe and brought the huge painting that Jose de Alzibar had created in 1783 there on mule-back. The

central portion of this baroque painting shows the vision of the Virgin as she revealed herself to a member of the Aztec nation, which at that time was suffering under the pressures of a forced conversion to Christianity. The story goes that the Aztecs recognized the Virgin who appeared as Tonanzin, an aspect of the eternal Goddess principle that they knew from within their own cultural context. Obviously, the Virgin appeared to comfort the Indians and offer a spiritual framework to which both the broken nation and its tormentors could relate.

At its center the painting presents the shining image of the Virgin of Guadeloupe in the form that she left imprinted on the mantle of the Aztec seer. Surprisingly, above her are painted the figures of three identical young men. Believe it or not, this is a threefold repetition of the portrait of Jesus the Christ[1]. All the three identical Jesus figures have a scepter in one of their hands, holding it at one of the precise three dominant points to which I referred while discussing the new phenomenon within the landscape temple organism: this is the newly appearing landscape temple axis, of which one end relates to the cosmic and the other to the earthly pole of the landscape's body, while the central point between them holds the balance between the two extremes, serving as the center for distribution. What pours out from there is the abundance of multidimensional life.

To experience the quality of this new dimension of the landscape temple—i.e. the quality of the scepter-like channel that is being demonstrated by the tripartite Christ figure—I suggest the following exercise. The scepter's two ends are to be identified with the Greek letters Alpha and Omega. Traditionally, the first one denotes the beginning and the last one the ending of the time span of our universe. The central nexus of the 'scepter', being identical with our heart center, represents the eternal NOW.

1 In the tradition of Middle Ages art in Europe, there exists a representation of the Holy Trinity composed of three identical Father God portraits shown as old, bearded kings who rule the universe. But that is another story.

The Virgin of Guadeloupe appearing below the threefold repetition of the portrait of Jesus the Christ, 18th century painting, Santa Fe, New Mexico, USA.

Alpha and Omega exercise

- *Maintain an inner silence for a moment. Then direct your awareness to your throat center and say: I AM ALPHA. Rest quietly for a moment, letting the words vibrate within you.*
- *Direct your awareness straight down to the bottom of your belly and say: I AM OMEGA. Rest quietly for a moment, letting the words vibrate within you.*
- *Let your awareness ascend to your heart center and say: I AM NOW. Rest quietly for a moment and let the words radiate through you and beyond.*
- *If necessary, repeat the procedure a few times.*

With their free hand the three Jesus figures are making a set of gestures that suggest the repetition of a cycle. The left-hand figure is making the gesture of turning within, the central one an outgoing gesture, and the third one again the gesture of turning within. In other words one can say that the gesture of introspection alternates with the gesture of blessings sent out into the world. The rhythm of the three gestures is similar to that of breathing and is related to the cycles of moon, on which the Virgin in the center of the painting is standing. One may say that the threefold sequence of gestures reveals the yin or feminine principle inherent within the Holy Trinity, which is what I believe the three men at the top of the painting to represent. Instead of the usual masculine aspect of the Trinity governed by the figure of the Father, we are confronted by its feminine facet, which is usually hidden.

When I test the power-field of the tripartite representation of the Christ, it displays a yin quality. But testing for the quality of the power-field of the figure of the Virgin, I have to admit that, quite surprisingly, it shows a yang or masculine characteristic. It is true that she is making a very sweet and feminine gesture of devotion. But the testimony telling of her appearance in 1531 to the already Christianized Aztec Juan Diego states that the Virgin did not possess such a pale skin as is shown on this painting. Hers was the deeply dark skin of an Indian woman when she revealed herself. Hence, she is called by many 'La Virgen Morena', the Dark Virgin.

This corresponds to the yin-yang sign, whose 'white' field of femininity is endowed with a 'black' spot of yang quality.

I was familiar with the inspiration imparted by this kind of intertwining of the feminine and masculine aspects of Divinity. I had previously experienced it personally while visiting one of the places in Mexico where, according to tradition, the Virgin of Guadeloupe has appeared. This is the reason why I reacted so enthusiastically, recognizing the same quality in the ancient painting.

Only three years before I found this painting in Santa Fe, my daughter Ana and I were leading an Earth Healing workshop in the state of Morelos, south of Mexico City. As part of the program of the Idriart Festival[2], in which we were collaborating, I had been asked to prepare a workshop on the local landscape temples. My Mexican friends had recommended Tlayacapan as the best possible place for the purpose, it being traditionally known as a sacred landscape.

For me, the circumstances already rang with symbolism, for I was arriving there on the *last day* of 1997 to prepare for the workshop that would take place on the *first day* of 1998. But when I looked upon the landscape at Tlayacapan, I nearly fell to my knees for, even physically, it reveals its sacredness. Right in the middle stands the majestic rock formation where the Dark Virgin appeared. My Mexican guides asserted that the rock is called Tonanzin, which is the pre-Christian name for the Dark Virgin.

Stretching all around in the distance, one can admire a grand circle of impressive mountains sculpted by nature out of the deep volcanic strata. Each has a different form and embodies a different spiritual quality, which it was possible for me to detect through inner vision. Among them I recognized a mountain that appeared black on the inside, obviously dedicated to the powers of transmutation. Another one showed an inner world with a gigantic platter full of the finest fruit, symbolizing the quality of abundance. There is also a mountain with a wreath of fairy

2 The Idriart Foundation was founded by my brother Miha Pogačnik and fosters worldwide cooperation in art and different forms of civilization, with special emphasis on the economy.

dancers around it, a mountain filled to the brim with the white milk of the essence of life, a 'green mountain', a table mountain representing the Fire Element, etc.

Attuning to the above-mentioned central rock formation of the Tlayacapan sacred landscape, I saw in its interior a womb-like cave framed by something that I recognized as vocal cords. Then I saw a sheaf of white crystal light descending from cosmic heights and passing through the 'vocal cords'. Tonanzin, the Dark Virgin, was revealed to me as the 'Virgin who gives birth to the Creative Word'. All around I saw sphere upon sphere of spiritual beings. Again I was confronted by the illogical intertwining of the feminine and masculine elements of Divinity, the feminine quality of giving birth correlated with the Word, which is the creative language revealed by her Son.

But the situation wasn't at all romantic for me. On the day I visited Tlayacapan I became terribly ill with a sore throat and the following day, when I was leading the workshop group to experience Tonanzin, I could hardly speak. It felt as if my throat had been cut through and the vocal cords destroyed. As a result, the mental-masculine role of the head felt totally separated from the feminine-intuitive powers of the heart. I found myself caught in the schism of the modern world, whose powers and institutions are asserting the exact opposite of the Dark Virgin's revelation: *the basic interconnectedness of heart and mind*.

When the human mind is separated from the heart, it cannot hear the intuitions or perceive the love vibrations emanating from the heart level. When we habitually decide about world affairs from a point of mental solitude and one-sidedness, we are pushing the planet and its life expressions to the brink of suicide.

While the festival group sat in the dust of Tonanzin's central cave, sheltered from the intruding rays of the sun, I tried in my rough and dwindling voice to explain this dramatic contrast as clearly as possible. This was the first time that I spoke publicly about the Earth Changes that were showing their first indications then, in late 1997. Among the innovations important to our theme, the Changes are fostering a new proportion between the feminine and masculine aspects of our being.

To find a language in which we can continue to explore this new yin-yang proportion, I propose to return to the Birth Scene in Bethlehem. Even though there may be lacking historic evidence that Jesus the Christ ever lived or that the Virgin ever gave birth to him, it is undeniable that a revelation happened in Palestine at the beginning of our age, one that brought forth the most powerful images. Soon afterwards they started to change the human world quite radically.

The patriarchally oriented culture of the time reacted with a load of doubts and fears and violently tried to suppress the revelation of the Virgin and the Christ, or at least make it conform to the old and outworn patterns of human thought. Fortunately the first form of opposition didn't succeed, but unfortunately the second one did. And yet the echo of their revelation has persistently re-appeared during the last two millennia—the Virgin of Guadeloupe's appearance being only one example—in a continuing attempt to free the message of the Virgin and the Earth-born Christ from the repeated distortions projected onto it by the human mind.

The mythic scene of the Christ's birth, which we discussed in detail before, belongs to those images that preserve the original spirit of the revelation. In our previous chapter on animal soul relationships, we focused only on the subsidiary elements that accompanied the Birth scene, such as the Straw on which the Child lay, the Ox and Donkey figures and the procession of the Three Magi. This time we are interested in the role of the Son-of-the-Goddess impulse that was born out of the wholeness of the Virgin at the beginning of our age.

Attuning to the Child itself, around whom the Birth scene is arranged, I propose to imagine it as representing the birth of the Divine Self of the human being into the core of the earthly reality. Once it floated above the incarnated individual as her or his higher self. Now it is anchored right in the center of our heart, pulsating there and hoping to be discovered by the mind-attached consciousness.

The process of 'embodying' the Divine Self, which as a race we are only starting to experience, can hardly be described in a

logical manner. For this reason, I make reference to various images that are capable of revealing more of the Birth's dimensions. But the ultimate quality of this unique initiation within which humanity is presently walking can only be felt individually, expressed through one's own inner language, the language of experience. Let me propose an exercise that can facilitate it.

Breathing exercise to focus in the heart

- *Lay the book to one side and start to breathe deeply and consciously.*
- *While inhaling, imagine that you are taking your breath from the depths of the earth and guiding it up to the level of your heart.*
- *A short pause follows, during which you stay gently and firmly concentrated in your heart center.*
- *While exhaling, guide your breath up towards the cosmos as high as you can.*
- *Immediately the next inhale starts, imagine you are taking your breath from the cosmic heights and guide it into your heart center. Pause there again for a moment.*
- *While exhaling, guide the breath down, deep into the earth.*
- *Start again from the beginning, taking your breath from the depths of the earth and repeat the whole process a few times.*
- *During one of the pauses, stay centered in your heart while continuing to breathe normally. Hold the moment of your presence in the heart for as long as possible. Know that you are reproducing within yourself the secret of the Child's birth and try to feel its quality and intuit its dimensions. Give thanks.*

The Virgin as the Soul of Life, the cosmic power that traditionally is called the Goddess, opened the way for the Divine Self of the human being to come down and become present *within* the incarnated individual. Speaking in symbolic language, the Virgin gave birth to a Son. Even though continuing to partake in eternity, since then the Divine Self is, in a logically

incomprehensible way, related to the space-and-time dimension of the human being—provided one is ready to recognize its presence and to cultivate it. No automatism exists on this level!

The fantastic act that brought the Divine Self down into the immediate physical presence in turn created the impulse that demands that the microcosm of our being rearrange itself in a new, spherical way, focused *around* the Child in the center.

As a first consequence, the old patriarchal world structure that is based on the principle of the hierarchical pyramid started to tremble and dissolve. Secondly, all the different facets of the human being—by which I mean the elemental Self, the organic base of our Body, the three aspects of the Soul—were gathered up to become renewed and initiated into a new non-hierarchical relationship to the divine core.

It is right for the outer Self to also play a new role within the renewed constitution of the human being. I am speaking of the field of consciousness that is the masculine counterpart of the soul. The change particularly refers to the conscious aspect of the human consciousness that I usually call the 'outer self' but is often called 'the ego' (see the drawing of the constellation of the human self in Chapter Five). Relating to the Birth scene in Bethlehem, the so-called ego appears in the figure of the Father, the masculine counterpart of the Virgin. Seen historically, this is Joseph the carpenter, coming to Bethlehem with his wife to answer the call of the Roman authorities to inscribe his name in the register of citizens.

What symbolism is contained there! The ego, walking the path of its worldly duties, was unexpectedly confronted in Bethlehem by the birth of its divine counterpart. There, the outer Self was challenged to renounce its ruling position within the incarnated human totality, yielding to that which is in fact itself— its own face seen in the mirror of Divinity. The last two thousand years present a picture of the confusion that resulted when the hierarchical pyramid that had held the ego in its proper place—in relationship to the Divine Self at the top of the old hierarchy— started to dissolve. The egocentricity that followed is a tragic misunderstanding of the new order of the universe, which is of a

spherical nature, but *of course is not* centered in the self-pride of the outer Self.

I love a fresco preserved from the Middle Ages in the pilgrimage church of Crngrob, close to my native town of Kranj, Slovenia. While the epochal Birth scene is taking place, Joseph, representing the outer Self of the human being, is sitting in the nearby kitchen baking pancakes.

I know that consideration of the subtle changes now surfacing within the inner constitution of the human being may be confusing to the mind. How does the Child born in Bethlehem relate to the human ego? Does the Son of the Virgin represent the masculine counterpart of the Goddess principle?…My answers to these questions may not be the best ones. But to be honest, one of my aims is to confuse the mind by building complex images in the hope of clearing out worn-out thought patterns and making way for new insights. In our case, I believe that only by obtaining immediate experience of the Child in its all-embracing totality can we save ourselves from wrong interpretations. The following is the way in which I propose to approach right communication:

Exercise to experience the Child within

- *Lie down, stretch out your feet and breathe consciously for a while.*

- *Imagine that your torso represents the straw on which the newborn Child lay in Bethlehem.*

- *Imagine the ox and the donkey standing over your feet, but not above the level of your knees.*

- *The Three Magi are kneeling, one at your head, one at your belly, and one on the opposite side of your body at your buttocks. The light channel of your spine represents the guiding power of the Star of the Magi.*

- *Then imagine that a shaft of crystal white light is entering your head and continuing through the throat towards the heart center, representing the Virgin's birthing channel.*

- *Now look at the newborn Child lying on the straw of your body and feel who he is and what does that represent within the totality of your being.*

I discovered a surprising set of revealing images related to the masculine counterpart of the feminine Divinity on the fringe of the 'White Land', the Slovenian country-side called Bela Krajina, which I have mentioned twice before. They are housed within three almost identical Gothic churches built one beside the other close to Metlika, not far from the banks of the river Kolpa that forms the border between Croatia and Slovenia. It is an ancient place of pilgrimage dedicated to the Virgin and her Son. Its name is 'Rosalnice'.

Three churches of the Holy Mary in Rosalnice, Slovenia

According to Ajra's spiritual master Christopher Tragius, in the prehistoric epoch there existed on that site a sanctuary dedicated to three mighty nixies that are called 'Rusalke' in Slovenian—hence the place's name. They embodied the threefold Goddess, the tradition that was later taken over by the 'Christian Goddess' Mary. She appears in each of the three churches clothed in one of her three aspects, as the Virgin, as the Mother of God and finally as the Lady of Sorrow. The tripartite role ascribed to Holy Mary reestablished the original quality of the sacred place. The ancient tradition found a new expression through medieval imagery.

Of the three churches, the right-hand one is dedicated to the Virgin and her Son, which is the theme that we have already discussed above. Let us rather enter the left-hand church which represents the Transformation aspect. Enthroned on the main altar, the Virgin sits with seven swords thrust into her heart and

the Son's dead body in her lap. The image of the Lady of Sorrow mourning over the dead body of the Son is complementary to the birth scene of the Christ. Whereas in the birth scene we get to know the secret of the Divine Self anchoring its presence within the totality of the human being, the Virgin's mourning scene directs our attention to the not less mysterious descent of the Christ into the underworld and his 'incarnation' within the earth's essence and within nature. It is exactly the opposite of what is usually meant by the label 'death'.

In this sense, the mourning Virgin-Mother is identical with Demeter mourning for her daughter Persephone, who each autumn has to leave the surface of life's organism to be drowned in its underworld. Translated into present-day language, the underworld means the subconscious level of the Earth where are stored the archetypes of all living beings—including the archetypes of plants, animals, landscapes and of each human being who ever walked upon the planet. Only on the threshold of the following spring is Persephone allowed to re-appear as Kore, clothed in the beauty of reawakening nature. Do you remember her story from our third chapter?

What did the Son of the Virgin do after slipping across the threshold of death into the realm of archetypes? Medieval pictures often show him during the three-day intermediate period between his death and resurrection, walking among the souls of dead personalities like the Biblical prophets who died long before he was born.

From that point on, the Church Fathers and the later theologians were interested only in the process of Christ's resurrection. The risen Christ of course reveals an important message that should not be overlooked. But little attention has been given to the Son of the Virgin's descent into the archetypal world of the earth and nature. One exception is St. Francis of Assisi who intuited the presence of Christ within Nature, the Earth, the Sun and the Moon. And of course there is a powerful saying of the Christ himself, preserved in the Gospel according to Thomas: "Split a piece of wood, and I am there. Lift up the stone, and you will find Me there."

Indeed, my experience shows that the Son of the Virgin, after his decease from the visible side of reality, has not been working only within the human archetypal world, but also within that of the earth and nature, or more precisely within its 'underworld'. By this, I mean the sub-elemental space of the Earth where the archetypes of all nature's creatures are stored. It is from this treasury of Earth that elemental beings and nature's spirits derive the knowledge that they need as the architects and guides of the earthly creation[3].

Referring to my experiences of the workings of the Christ within the archetypal level of earth and nature, I would like to elaborate on the vision I had on May 27, 2000, in a forest in Saarland, Germany, which I reported in the Appendix to my book *Earth Changes, Human Destiny*. It was one of the most powerful visions that I have ever had in my life. I saw appearing in front of me the tall figure of a Pan, the ancient God of Nature. As he raised his hands, I could clearly see the stigmata—the wounds of the Christ—on his hands, feet and in his side. And as I became aware of the signs of the Christ that Pan was showing me, silvery beams flashed from each of them to the corresponding points on my body. I was deeply moved in my innermost being.

I well know the usual presence of a Pan, and have described it in my book *Nature Spirits & Elemental Beings* as being a focus of the consciousness of nature, holding within his sphere the complete knowledge of any living being of nature that resides in the area entrusted to his attention. His role is to hold the family of living beings united in the common purpose. I have also discovered that each place or landscape has its own Pan focus, which is a fractal of the Earth's Pan. Finally, Pan has an all-connecting role within the consciousness of nature, which is not at all difficult to understand if, of course, one accepts the assumption that nature is primarily a vast consciousness.

But this time, the meeting with the Pan in the Saarland forest was a fundamentally different experience. His presence felt as if it were representing a medial form between Christ and Pan.

3 For more information on the sub-elemental level of space, see my book *Healing the Heart of the Earth*, page 111, Findhorn Press 1998.

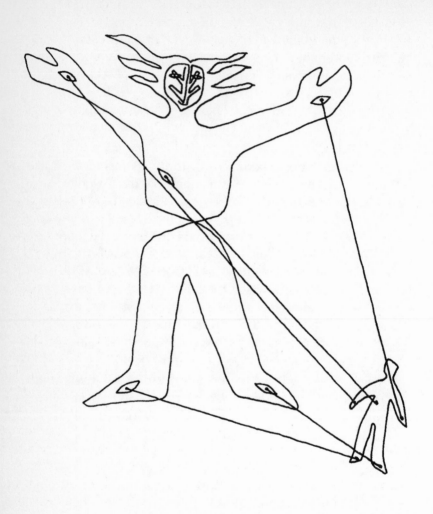

*The Pan as God of Nature
showing me his stigmata,
my vision in the Saarland, Germany, May 2000.*

He embodied a quality vibrating beyond the usual figure of a Pan, with the obvious intent to deliver a specific message. Translated into words, he came to orient me towards where the presence and spiritual activity of the Son of the Virgin should be looked for nowadays: it is within the world of nature and the Earth sphere.

To get a feeling for this surprising gift of our epoch, rest in silence for a moment and ponder over the sentence:

> *The Son of the Virgin has died to the human world to re-appear through nature.*

However, I do not mean nature in a romantic, 19th century, sense. I mean nature as it is nowadays, mirroring the condition of human beings in their state of separation, self-denial and alienation. Think of Mad Cow's Disease as mirroring our degraded relationship with our own elemental soul. Look on the massive felling of virgin forests as mirroring the deterioration of our relationship with the life-forces of our body. Consider the shameless plundering of natural resources, carried out with the intent of increasing power and status, that mirrors our ignorance of the essence of Divinity that vibrates within each living being, and within each one of us as well. Remember the plants crippled through genetic engineering; they mirror our distorted relationship with our own identity.

Only later did I realize that, in the sense of our degradation and alienation, there is a symbolic meaning in the image of the Pan showing me the wounds of the tormented Christ. Nature is indeed undergoing a severe process of change and transformation that merits the symbol of crucifixion. Yet there was no trace of blame in the eyes of Pan, appearing as if the tortured Christ were dwelling within his body. When he raised his hands to show me the stigmata and when the silvery beams flashed towards the corresponding points on my own body, I felt rather that he was proclaiming a joyous invitation. It was an invitation to the human race to recognize our own Christhood—i.e., to recognize the high tide of the renewed identity within the multidimensionality of our own being—and to join nature in the process of change and transmutation which it is right now going through.

To say this symbolically, one could expect that the Child born in Bethlehem at the beginning of our age to be nowadays an adult woman or man ready to love and care for life with full responsibility and joy in beingness. Unfortunately, the reality is slightly different—as you well know.

Returning to the three pilgrimage churches dedicated to the feminine Divinity in Rosalnice, Slovenia, this brings us to the theme of the central one. In accordance with the tripartite division of the Divine Feminine, the right-hand church represents her Virgin aspect and the left-hand one—which we have just visited—the aspect of Change and Transformation. It follows that the third church, the central one, should be dedicated to the Creative facet of the Goddess. Indeed, its central figure is a strange baroque sculpture in which Mary and Jesus appear to be partners. Yet, strangely enough, the Christ has his eyes closed as if he were not alive, but were representing a dead body. The contrast between the vivid radiance of the Virgin and the dwindling presence of the Christ is even more striking because they are dressed in appropriate clothing that is changed for special occasions.

We asked Ajra's spiritual master what was the meaning of this sculpture. He confirmed that it was intended to represent the Creative phase of the Goddess, but the artist was not free to clearly express the role of the Christ as the cosmic consort of Sophia, the Feminine Divinity. Indeed, images of the partnership between Christ and the Holy Mary—standing for the cosmic Sophia—are very rare. I know of one featuring Mary-Sophia and Christ sharing the heavenly throne, showing the Christ crowning her with a crown identical to the one he is wearing. Such recognition of the equal status of the feminine and the masculine facets of Divinity is, according to the theological point of view, possible only in heaven. And this is so in the case of the image to which I refer: the scene of the crowning takes place in the spiritual world after the ascension of the Holy Mary.

Yet, on the other hand, our incarnated reality presents a much duller picture. Instead of the revelation in Palestine renewing the relationship between the feminine and masculine facets of Divinity and serving as an archetype for a healthy and

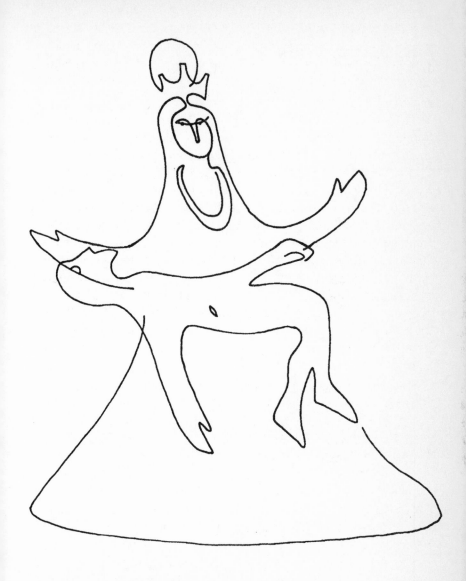

Holy Mary, ceremonially dressed for the 'sacred marriage',
and her lifeless partner, the Christ.
Baroque votive sculpture from
the central church at Rosalnice, Slovenia.

The true image of the partnership between the Christ and the Holy Mary, who is representing the cosmic Sophia. Fresco from the Middle Ages in the church of Udine Castle, Italy.

uplifting relationship between women and men, our culture has throughout the ages overwhelmed us with a multitude of shadow images. By these I mean the images of shame, guilt and isolation projected upon our womanhood and our manhood. Typical of these images are, respectively, Adam's supposed sinfulness after making love to Eve in Paradise, and Eve's humiliation. Another is the Christ's death on the cross and his Mother's impotence to help him—although one should imagine that she represents the Divine Feminine.

In Helsinki, while traveling through the soul-level of my body as described above, I had an experience that shows what harm is caused by these false images imprinted into the soul memory of the human race. While moving around my body and exploring the masculine facet of the soul organism, I became interested in something resembling a stiff horizontal beam in the area of my shoulder. I thought that it might represent the masculine counterpart of the labyrinth to which the feminine aspect of the soul relates. After concentrating on the rather undefined phenomenon behind my back, I realized that I was confronting the image of the suffering Christ carrying the cross on his shoulders. Feelings of shame and suffering overtook me, the awful projection of a guilt that the alienated Christian doctrine has imprinted in my soul. I knew that to become free as a man, I had to get rid of the false attitude that refuses to understand the spiritual meaning of the transmutation process, but instead searches for an object on which to project its blame.

So I called my fish-like friend Faronika back to help me. You should have seen with what vigor she crashed into the cross at my back. While she was tearing it to pieces it turned out that it had no substance. Composed of layers and layers of sheets of newspaper, it stood for mental preconceptions and suppressive patterns derived from alienated religious beliefs and imprinted into the soul memory.

But then, to my horror, the fish started to dig deeper into my back, dragging out square plates of iron and steel into the daylight. I realized that the plates related to the warrior-like discipline that had been beaten into the masculine soul memory during life after life. They symbolize that well-known rigid and

merciless attitude that insists it must make a stand, no matter whether it is standing for the good or the bad. This military kind of routine was used to torture the souls of men during the long millennia of patriarchal rule, and they finally lost the sensitivity to love and to be.

On the other hand I have had insights to confirm that in the meanwhile it is possible to birth the creative partnership between the feminine and masculine facets within us. I am referring to a succession of insights leading to a moment of revelation that was bestowed on me during my previously mentioned retreat in September 2000, only a few days after I had been inspired to write this book. It started with a funny little event. Early one morning I was seated in meditation in the solitude of an olive grove. I do not remember why I chose the slogan 'natural intelligence instead of the artificial one' as the theme for my meditation. Perhaps I hoped to get a deeper insight into the language of cosmograms[4]. It was not a fortunate choice, seen from the perspective of my recent inspiration to work on the revelation of the Divine Feminine.

That was when a cat must have appeared behind my back because I heard its mew. I thought that something as banal as the mew of a cat couldn't be carrying a message for me, so I continued to concentrate on the theme of my meditation. The cat's second call held such appeal that I couldn't resist going within and opening up my consciousness through the back of my head. Only then did I realize that, hidden within the mew of the cat, was an invitation to attune to the heavenly sphere.

I did so and was surprised to feel, high up above me, the presence of Sophia, the Divine Feminine. As already mentioned, in the realm of Christian mythology Sophia represents the universal Goddess principle that eventually incarnated in the individuality of Holy Mary, analogous to the Christ spirit embodied within the personality of Jesus of Nazareth. You will be aware that at times we speak in different symbolic languages, and

4 If you are interested in the theme of the language of cosmograms, see my books *Healing the Heart of the Earth,* page 202, and *Earth Changes, Human Destiny,* page 98, Findhorn Press 1998 and 2000 respectively

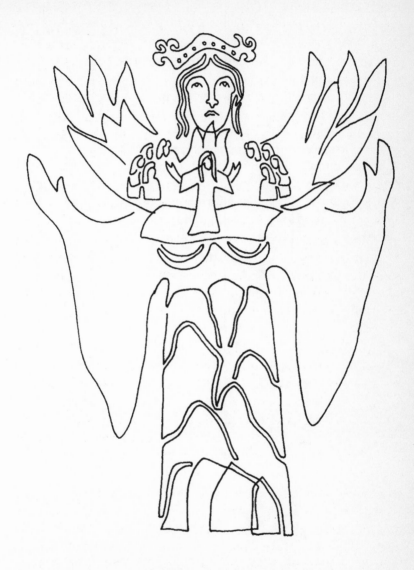

*Vision of the cosmic Sophia emerging from a rocky mountain,
witnessed by the 12th Century Abbess
Hildegard of Bingen, Germany.
Note the smallness of the figure of Mary, and the multitude of
human souls emerging out of the heart space of Sophia.*

that it is our duty, when working on translating the different names into the principles inherent in them, to hold open the doors to all possible approaches to the truth.

While I was totally immersed in the vast presence of the Virgin distributed throughout the universe above, I suddenly realized that there, only few steps in front of me, another presence was vibrating. I couldn't mistake its identity, it was the Christ presence. I was amazed how firmly it stood upon the ground. To confirm my observation, the Christ image identified for a moment with a clump of reeds growing nearby. At the same time his voice sounded within me, saying: "Call me the Spirit of the Earth, the Christ by another name." My intuition added the complementary part that related to the appearance in the sky: "Be aware of the Goddess of the Universe, Sophia by another name."

Once again I was confronted with a situation where the water flowed uphill! The feminine principle deriving from the belly of the mother Earth should be the one anchored within the reeds and in the ground, and not the Christ, who ought to be representing a cosmic power floating above. Yet the revelation asserted that exactly the opposite was true.

The way to be conclusively certain about the 'new constitution of the universe' was to see how it felt within. Indeed, the moment I attuned to the Christ presence, I discovered it within my heart, pulsating simultaneously with the heart of the Earth. The Goddess Sophia, on the contrary, appeared distributed all around me. To experience the relationship between the two partners who constitute Divinity in its Creative phase, I was in that same instant shown the following exercise:

Spirit of the Earth and the Goddess of the Universe exercise

- *While inhaling, guide your breath from the breadth of the universe in through your back into your heart. Say silently: "THE SPIRIT OF THE EARTH IS WITHIN MY HEART," and while pronouncing "Spirit of the Earth" think of the Christ, or of God, of the Masculine Divinity, or any synonym you like that is of a masculine nature.*

- *While exhaling, distribute your breath throughout the universe while silently saying: "THE GODDESS OF THE UNIVERSE IS ALL AROUND ME." While pronouncing "Goddess of the Universe" think of Sophia, of the Divine Feminine, of the Soul of Life, or the Goddess, or any synonym you like.*
- *Continue breathing in this manner. After a while, forget about the words and concentrate on the intertwining of the two cosmic principles within you and without.*

After doing the exercise a sense of clarity surfaced within me, telling of the three 'generations' of Goddess present simultaneously within the human being and within the multidimensionality of the environment:

1. Wherever I go, I walk within the Mother Earth. She can also be called Gaia, the tripartite Mother of the Ocean, the Earth and the Sky. She is the Soul of the planet and the ensouling principle within the nature kingdoms, of which the human being is a part;

2. The threefold Goddess principle in its three phases as Virgin, Creation and Transformation manifests as the guiding soul principle within the fully individualized human being, within the animal world, and within the landscape. The Son of the Virgin represents its male complement and partner, manifesting at those moments when a polarity field is needed to enhance the life process;

3. The Goddess of the Universe (Sophia) and the Spirit of the Earth (Christ) are both simultaneously present within me and without. They together represent the fantastic, multi-dimensional, and loving quality of the new phase in the evolution of the human being and the earth. They exist only to the degree that a human being is willing to manifest this new quality within his or her own life and consciousness.

But do not imagine that the principle of the Mother Earth belongs only to the Paleolithic era in the past, when the human race knew only the natural way of life! Nor is there any way that the threefold Goddess principle can refer only to the Neolithic

era, when people recognized the Goddess-centered character of the universe and the earth. Nor should you consider our Sophia-Christ 'generation' to be more advanced than the other two. At each phase of our evolution there was something new to be learned and embodied, which is also the case now.

All three generations of the Divine Feminine represent different levels of existence and different aspects of our identity. In consequence, all three are equally important for us to get to know ourselves and the life of the planet in its wholeness.

After I had succeeded in formulating a kind of comprehensive order of the universe, conceived from the feminine point of view, I felt happy and greatly relieved. The only cloud was a severe pain in my left ankle. The pain was increasing from moment to moment without any evident reason.

Since I couldn't get around it, I started to investigate the cause of the problem. I asked one of my helpers, the giant fish Faronika, to guide me. She appeared under my feet and started to raise my body upwards. As I was taken higher and higher, I noticed that my ascent was following the line of a naked body of huge and athletic-looking stature. It was such a giant! When I reached the level of its eyes and looked into their depths, I knew that I was confronting one of the Brothers of the Goddess. I had forgotten to include them in the above listing of the Goddess' threefold constitution of the universe. The pain in my left ankle had manifested to remind me.

Indeed, when dealing with the second and the third generations of the Goddess, I had been sensitive enough to recognize the role of her male counterpart. I had not done so in the case of the first, Mother Earth, generation. You will remember I spoke about the three sisters governing the powers of the Earth cosmos: the Goddess of the Ocean, the Goddess of the Earth, and the Goddess of the Sky. They were mentioned in the second chapter in reference to one of their images preserved by the Greek culture: the three sister Gorgons; the powerful Steino, Euriale and Medusa.

When referring to the body of the planet, I usually call them Mother of the Sky, Mother of the Ocean and Mother of the Earth.

In the story I know, they have four brothers who appear as giants representing the Four Elements: Water, Fire, Earth and Air. Because the Four Elements represent the tools of creation, so the intelligences governing their powers can be considered to be the Brothers of the Mother Goddess. This accords with the pattern of ancient matrifocal societies where the role of the father was less important than the role of the brothers of one's mother. Usually one does not know who one's father is, but one knows one's uncles very well, as being the male presence in the community.

Consequent on the new experience, the first point in the above schema has to be revised to include the male aspect too:

1. Wherever I go, I walk within the Mother Earth. She can also be called Gaia, the tripartite Mother of the Ocean, the Earth and the Sky. She is the Soul of the planet and the ensouling principle within the nature kingdoms, of which the human being is a part. *Mother Earth has four Brothers, masters of the Four Elements, Water, Fire, Earth and Air.*

One can theoretically understand the kind of creative tools that are represented by the Four Elements. The Water Element, for example, stands for biological processes and the emotional quality permeating creation. One can imagine the Fire Element as the tool of change and the medium through which spiritual impulses can manifest. The Earth Element governs the processes of materialization and the birth of form. The Air Element represents the medium through which consciousness can express itself. As embodiments of these kinds of ever-present tools of creation, the Brothers of Gaia must have appeared to the ancient people like giants or Greek Titans. But what do they represent to the modern non-mythic consciousness?

I had to wait for a month to get the answer. It reached me in September 2000, while I was working in Sweden. I have already mentioned my Scandinavian tour and the experiences that I had in Norway, Sweden and Finland that were key to my personal transformation process. Each country gave me a gift so that the threefold experience could be complete. Yet before I left Sweden,

another kind of experience was inserted into the threefold structure. I met trolls.

In Scandinavian tradition trolls are beings of nature who are invisible and gifted with giant stature and natural good humor. People who remain in contact with them say that they are hypersensitive, which is the reason they withdrew from Central Europe to find their last retreat in the nature-imbued countries of the far north. According to my view of the Earth consciousness, they are not another species of elemental beings but rather represent the archetypal forces of its subconscious.

The night before I left Sweden to fly to Helsinki, I was awoken by the piercing call of an unknown animal. After the third call reached me, I realized that it could be a message so I opened my consciousness to the phenomenon. I instantly perceived myself within a gigantic and extremely subtle sphere that was encircling *and* permeating me at the same time. The bright focus of the being's consciousness was located at the top of the sphere, like a ring bearing a precious stone.

The quality I perceived was closely related to the angelic presence, as I know it permeating each atom of the universe. But this time it had the definitive mark of an elemental substance that is part of the Earth cosmos. Speaking in my own language, I often use the expression 'archetypal powers of the Earth' that manifest as the mythical beings described in the first chapter of my book *Nature Spirits & Elemental Beings*. Was this the right trail to follow?

To get a feel for whether my ideas were at all sensible, I called on one of these archetypal powers, the giant fish Faronika, and asked it to show me its relationship to the newly discovered trolls. Instantly the fish became as broad as the cosmos, so that I found myself within it. As a result I understood that there is a clear distinction between the archetypal consciousness of the Earth and the 'trolls'. The latter refer rather to the soul level of the planet, and not to its consciousness as do the archetypal powers. In consequence, it feels right to label the Lords of the Elements as Brothers of the Goddess and to consider their re-appearance in our modern epoch as part of the new revelation of the Divine Feminine.

My vision of trolls, 'the uncles of the Virgin'.

Later on, I had some further contacts with 'trolls'. They are beings of freedom, goodwill and humor. Their all-permeating presence can shatter every barrier that we people build within ourselves and in the environment around us. Once, when I was caught up in my traumatic fears, I called on them for help. They appeared as soft, gigantic bears woven from dark and subtle light. Bouncing through me in a funny and joyful way, they brought about an instant healing. The exercise that I was taught to use while contacting them goes as follows:

Exercise to experience the presence of 'trolls'

- *Center yourself and be at peace. Ask to communicate with the Uncles of the Virgin.*

- *Focus your attention simultaneously on the end of your 'tail' (if you would like to have one) and slightly above your crown chakra.*

- *Enter into the field of experience. After the communication has been rounded off, give thanks.*

Liberatress:
The Feminine Redeemer
is About to Manifest

One of the inspirations that came to me while preparing for the current book was a sentence clear as a crystal, which I awoke to a few days before I started to write in mid-December 2000. It stated simply and without any comment: "Saskia—a figure of the Feminine Redeemer."

One might wonder, who is Saskia? She was the much-loved wife of Rembrandt, the famous 17th century Dutch painter. She often figured as a model for his paintings but died quite young and left the painter in grief and solitude. After her death she appeared once again as a mysterious image in one of the master's well-known paintings, the grand-format canvas called the "Night Watch." She can be identified as a young woman of childish figure, moving quasi-invisibly among the soldiers. The canvas was painted in 1642, the year of Saskia's death. Constantly surrounded by crowds of visitors, today it adorns one of the walls of the Rijks Museum in Amsterdam.

I knew without a doubt that the inspiration referred to the "Night Watch" and Saskia's puzzling appearance as a bright being of light moving among the grave-looking soldiers of Amsterdam's night watch company. They had ordered a group portrait to be painted by the grieving master. But when the painting was finished they refused to pay for it, because they asserted that it showed some figures that had nothing to do with their profession and the membership of the group.

Rembrandt's disappointed customers had mainly in mind three strange images arranged in a triangle around the center of

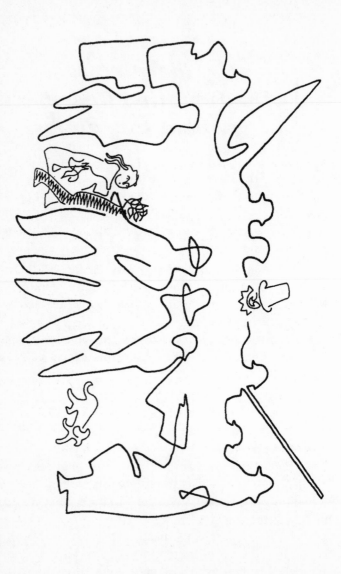

Rembrandt's Night Watch with the little figure of Saskia led by the Black Dwarf. The figure of the dog below and the man with the tall hat above complete 'the triangle of the human self'.

the painting. At the bottom right, a dog is sneaking among the soldiers' feet. Opposite, there appears the childish figure of Saskia, glowing with an extremely radiant golden light and gliding graciously among the soldiers who obviously do not see her. The third image to which they objected marks the top of the triangle. It shows the round face of a man with a tall hat on his head.

When I was exploring Amsterdam in 1998 to prepare my second Earth Healing workshop for the city, I felt attracted to the Rijks Museum. I did not know which painting was calling me, but I knew from experience that there exist some rare works of art through which the soul of a given place finds a window for expression. I had encountered some paintings of this kind in Venice and had used them to decode the essence of this unique water city[1]. Amsterdam is also a water city, where canals provide the main pattern for its structure. Because the constitution of the two cities was complementary, I supposed that in Amsterdam too I could find art works that spoke the hidden hologrammic language, telling stories of which we are unaware.

So I decided that I would first walk through the famous Museum without looking at the paintings—which has to be esteemed a sacrifice because I was going there for the first time and would have enjoyed seeing its treasures. Instead, I stepped into the center of each display room, closed my eyes and tried to feel whether a piece of art was displayed there that attracted my inner attention. You may be interested in the kind of exercise I use in order to perceive the inner light of paintings:

Exercise for perceiving the invisible aspect of a phenomenon

- *Find your inner center and focus there for a moment.*
- *Then imagine that you turn a somersault backwards and in the next instant find yourself on your feet again. In this way your consciousness slips through the archetypal space of your back to attune to the invisible side of reality.*

1 For details, see my books *The Hidden Pathway through Venice* and *Geheimnis Venedig* (The Secret of Venice).

- *After you have landed on your feet again, your eyes are closed (or perhaps open) and you watch inwardly. The exercise can also be used to perceive elemental beings or geomantic phenomena.*

Of the Museum's paintings, Rembrandt's Night Watch revealed the strongest light impulse. Observing it, I noticed that the commander, depicted in the very front of the group of soldiers, is dressed in the traditional colors of the Goddess—white, red and black—which are also the colors of Amsterdam's coat of arms. Drawing myself into the inner atmosphere of the painting, I could recognize in it the archetypal patterns of Amsterdam and the message of the city's neglected soul. But a year later, while I was preparing the follow-up workshop for Amsterdam, I felt that the painting was again calling me, as if an even deeper layer of its message was awaiting, one which I had overlooked the previous year. This time I felt inspired to take the whole workshop group with me to the Rijks Museum, rather than going alone.

After I had explained the Night Watch to the group, showing it to be a surprisingly exact representation of the city's geomantic organism, I suggested they take a little time to personally experience the atmosphere of the painting. During the few minutes' span devoted to individual investigation, a few members of the group approached me to ask the meaning of the dark, almost black, 'dwarf' figure with a wreath of laurel round his helmet, who seems intertwined with the bright presence of Saskia.

I felt deeply embarrassed. I hadn't even noticed the dark figure that obviously belongs to the triangle representing the archetypal dimension of the painting. The 'dwarf' is as tall as little Saskia and seems to be holding her hand as if he were her guide. In contrast to Saskia, he is looking away from the spectator and is almost completely hidden behind the dominant figure of the commander adorned with the colors of the Goddess.

On the other hand, I was relieved by the discovery of this new riddle because that night I had dreamt of the Goddess, but had been unable to recognize her. I knew therefore that there

must be a blind spot in my consciousness that was causing my insufficient perception. Now I was offered an opportunity to enlighten it.

In the dream, I entered my parents' dining room and saw a slim woman seated at the table in the place where as a child I had always sat during meals. Because she was sitting in front of a window lit by bright sunlight, she appeared completely dark to me and I couldn't recognize who she was. So I approached her and reached out my hand in greeting. She stood up to come closer to me, but still remained unrecognizable because the bright light at her back was becoming even more intense. What made her known to me as infallibly representing the Black Virgin was a dark kind of inner light that glowed within her.

When I looked again at Rembrandt's painting, I could recognize in the half-hidden figure of the 'dwarf' some surprising similarities to the Black Lady of my dream. Because the 'dwarf' is positioned in front of the bright presence of Saskia, he appears almost completely dark, just like the Goddess in my dream. With his mysterious dwarf-like size and face hidden to mortal gaze, he may represent the powers of the Goddess of Transformation leading Saskia into the world of deceased.

Yet other details suggest a deeper layer in the painting's hologrammic message. Whereas the 'dwarf's' helmet is adorned with a green laurel wreath, a dead dove and a bunch of dried flowers are hanging from Saskia's belt. It would be too easy to say that they denote Saskia as being a person who is currently dead. Why then should the black figure of the 'dwarf' who is leading her into the underworld be wearing a wreath of vividly green plants?

Do you remember how tangled were the roles of Sophia and Christ, about which I wrote in the previous Chapter? Is there not a striking similarity between that and the bright presence of Saskia wearing the symbols of death and the dark 'dwarf' wearing the symbol of life? The dance of Saskia and the Black Dwarf on Rembrandt's canvas has the same quality of accelerated spin that happens when space turns over, and what was once above finds itself below and what was once outside finds itself currently inside.

What then is the prophetic message that the painter-in-despair wove into the grandeur of the Night Watch? There must be some such message. Otherwise an unknown man would not have lost his reason a few years ago when in front of the canvas, attacking the painting and cutting it to pieces with his knife. Nor would I have felt so deeply embarrassed when I dismissed the role of the 'dwarf', blind to its presence at Saskia's side. Even the soldiers of the Amsterdam night watch company who commissioned the painting recognized that it reveals something else, which is not their group portrait.

Let us imagine that the soldiers who figure on the canvas with their armor and guns and their long lines of spears represent the consciousness of the modern human being, endowed with mentality and almost totally controlled by the mind. It must indeed be threatening to that mental overlay for Saskia to unexpectedly appear below its surface and begin dancing with the Black Dwarf. It transmits the feeling that there is a multidimensional vortex suppressed under the surface of one's mind, a vortex that might suddenly rise up from within and reveal its tremendous dance of death and life, which humans are not ready to accept. *It is the power of one's Soul coupled with the powers of the Black Virgin,* which causes one to be inspired and scared at the same time.

As I have mentioned already, Saskia appears on the Night Watch canvas as part of a triangle, opposite to a dog that represents the elemental aspect of the human being—the one that connects us to the powers of nature—and at its top, the funny face of the man with the tall hat who represents the outer Self, the Ego. If the triangular configuration represents the constitution of the rounded-off human being, then the bright figure of Saskia stands for one's multidimensional Soul. What makes the appearance of Saskia threatening and inspiring at the same time is her way of embodying a kind of accelerated movement that comes into being through the interaction of the individual Soul with the transpersonal (cosmic) power of the 'Black Dwarf', representing the all-transforming impulse of the Black Virgin. Saskia does not merely represent the human soul imprisoned below the surface of the dominant consciousness, but

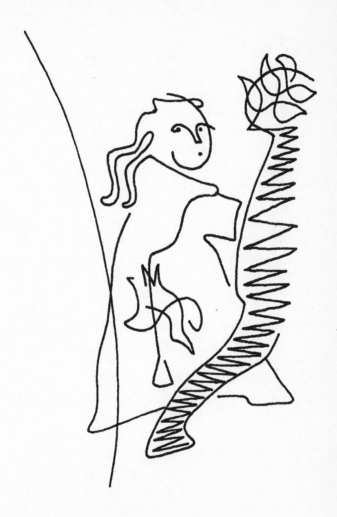

Saskia and the Black Dwarf, representing the human soul guided by the impulse of the Black Virgin. Detail from Rembrandt's Night Watch.

also conveys a message that is highly relevant to this epoch of our evolution.

The details of the painting suggest that Saskia and the 'Black Virgin' are holding hands while dancing swiftly among the soldiers, together going in the same direction, away from the spectator. But in the moment of revelation, Saskia turns her head to look in the opposite direction, staring directly into the spectator's eyes, and the features of her face give an impression of concern and the sense of a warning. Remembering the story of the decapitation of the Gorgon Medusa, you may know what this concern and warning is about.

She was telling us that in the near future—which is nowadays our present—the powers of one's Soul, awakened by the touch of the Black Virgin, will arise in all its cosmic strength from within the individual human being, and from within the human race as well. They will blow the lid off the governing mind structures and set free the suppressed wholeness. Nobody will be able to hold back the revelation of the Feminine Redeemer, because it will arise in innumerable individuals like a high tide out of the elemental Soul's sub-conscious space. If a hundred emerging channels were to be filled in by the panicking mind or by threatened institutions, another thousand would appear as unexpected situations came cropping up, both within people's personal lives and in the midst of the public arena.

Concentrating on the canvas of the Night Watch and keeping in mind all that we have discussed and experienced together throughout this book, we are about to discover a layer of planetary transformation that is basically different from the process of Earth Changes as we have known them up till now. It is the feminine counterpart of the geomantic process of transformation, which has been transmuting the Earth's fundamental constitution during the past three years.

According to my geomantic observations, the process of Earth Changes started in February 1998 with a surprising mutation of the planet's ground radiation. Beforehand, its quality was marked by the dominance of the Element Earth. Step by step, the ruling position was taken over by the Element Air. In the

following Autumn-Winter period powerful archetypal forces were introduced to my awareness. They originally belonged to the depths of the Earth, yet now are manifesting on the planet's surface. The overwhelming 'dragon forces', which know no separation and are heralds of the universal connectedness, started to influence geomantic systems and life processes, cleansing and changing them. After the solar eclipse of August 11, 1999, the light body of the Earth, its landscapes and places, started to transform, strengthening the all-connecting bonds of the planetary wholeness. Elemental beings, representatives of the Earth's consciousness, started to experience an initiation into a level of freedom that was previously unknown to them.

Next, those realms of invisible reality that had long been excluded from human awareness began to move closer to us, seeking to interact with human consciousness again. These are the voices of the ancestors and other beings from the invisible realms, all of which are picking up volume within the human psyche. Many individuals are about to learn to cautiously integrate the powers of darkness—understanding them as their own shadow—into their daily lives, so that the danger of destructive conflicts (including wars) shall be overcome in the future.

In consequence, human beings have started to change and transform on all levels of their existence—mainly subconsciously. The process that has been triggered includes a fundamental change in world-view and in the way we relate to nature, as well as changes in our manner of understanding who we are and what is the purpose of life[2].

By the end of April 2000 it seemed to me that planetary transformation was well under way, even if the ongoing process was still mainly unnoticed by the public. Indeed, the only link in the chain that seemed almost totally missing was the moment of the human race's awakening to its co-responsibility for the course of events. During its initial phases the transformation proceeds mainly on the invisible levels, so the population, who have never

2 In my book *Earth Changes, Human Destiny*, page 147, Findhorn Press 2000, I compare the phases of the present planetary transformation to the process of the breaking of the Seven Seals described in the Revelation of St. John.

been trained to perceive the world of the invisible, do not notice its accelerated activity. The situation is becoming dangerous. Before the wave of changes approaches the densest level of reality and becomes obvious to the superficial mind, the transformation may already have progressed so far that people will no longer be able to adjust to the frequencies of the renewed planet...What then? We could lose our planetary home. I began to ask myself if it was even possible to accomplish the gigantic task of awakening human awareness to the fact of the changing reality.

Nevertheless I continued to talk publicly about the actual Earth Changes, trying to teach people how to attune to them and how to release the bonds that are tying places and elemental beings to the disintegrating world structure, not allowing them to flow with the changes. I spared no effort. But on the other hand, I became slightly but persistently sick, so that I became weak and vulnerable. Through the hologrammic language of several strange events and dreams, I was finally made aware that the present Earth Changes are not just progressing in the linear fashion of successive phases, as I had got to know them in the period between autumn 1997 and spring 2000. There must also be another kind of dynamic going on, which my consciousness couldn't yet grasp.

A characteristic dream from April 14th, 2000, featured me driving a car. Suddenly, coming round a curve, I found myself facing a traffic sign telling me that the road was closed. I glimpsed a free side road and instantly took that direction. But the road soon ended in a sleepy private courtyard. Reluctantly, I stepped out of the car to ponder on my dead-end situation and was surprised to see that my wife—or was she the feminine counterpart of myself?—who was riding in another shiny, white car, had already found the right road and was disappearing in the distance.

As the present book is witness, an astonishing turn-around in my understanding of the Earth Changes did indeed start to surface in the middle of the year 2000. The linear flow of the Changes seemed to be interrupted unexpectedly and their main direction changed. Gradually I became sensitive to another level

of the Earth's Self-Healing Process, which before was submerged in my subconscious. Instead of feeling myself lost in my struggle to detect the Earth Changes' next step on the threshold of the third millennium, I should have been realizing that in the meanwhile they were appearing on a previously incomprehensible plane that bears the hallmark of the rebirth of the Goddess. The Changes' newly introduced guideline could be defined as the reawakening of the Divine Feminine within the individual microcosm of each living being that ensouls the Earth, and within the totality of its all-embracing cosmos.

To get in tune with the feminine layer of the Earth Changes and to understand how its organism functions, I first of all had to submit myself to a sophisticated process of personal cleansing and changing. Only then did I start to understand that the task of awakening human beings to our responsibility for the present moment in our individual evolution and recognition of the present upsurge in the Earth's transformation, which seems insoluble if approached from the outside in the masculine way of acting, could 'easily' be accomplished via the feminine way. By 'feminine way', I mean the high tide of transformative powers arising from within each individual's soul[3].

Even if impossible to observe exteriorly, millions of people are already caught up in the high tide of the Black Virgin's impulse. Rising through the soul level of a multitude of individuals and expressing through each person's particularity, it eliminates the need for any unifying outside pressures, any coordinated activity or single-pointed faith. Everybody is free to become who she or he is, and yet a sense of common purpose, mutual understanding and an all-permeating love bond is surfacing. Just watch what is going on within you and within the circle of your friends! We cannot ignore the effects of the soft, smooth, supple impulse of the Feminine Redeemer working within the alienated human world.

3 Compare this insight with the results of the extensive exploration of public opinion carried out in the USA by Paul Ray and Sherry Ruth Anderson. It is shown that about 25% of the population (an estimated 50 million people) are already walking the path of change. See their book *The Cultural Creatives*, Harmony Books, New York 2000.

While preparing for my workshop in Berlin, which was to take place March 9–11, 2001, I asked my inner guidance what kind of meditation I should propose to those interested in supporting the spread of the Black Virgin's impulse around the planet. There was an immediate response, telling me that the Berlin area is the ideal place to approach the Earth's 'inner self' and be able to interact with it. The subtle, watery landscape of Berlin represents a kind of door for entry into the soul level of the planet. For those who know Berlin, I mean specifically the south-west corner of the Tiergarten Park, opposite the Zoological Gardens. The place is full of little lakes and islands.

But afterwards, I had the feeling that my proposal would not really be complete if I were to concentrate on the Berlin area only. Instead, my attention was led to Africa, or more precisely to Mauritania in the south-west corner of the Sahara desert. This landscape is all bare and dry, totally the opposite of Berlin's. Focusing on this area of Africa, I realized that it represents a place for the outflow of the powers of the planetary Soul. It looks like a chimney from which the 'white smoke' of the Soul's vibration is ascending into the high atmosphere of the planet, there to spread out to form a white 'coat of protection' around the planetary sphere. I realized that both aspects, the entrance to the depths of the planet in Berlin and the outflow from the Sahara, had to be included in the meditation.

For purposes of the meditation one can use the pair Berlin-Mauritania, or simply enter the planet from one side and imagine the 'chimney' located on the other.

Meditation to support the Black Virgin's impulse

* *Enter the place of inner peace and feel connected to the universal whole.*

* *Direct your awareness to the area where you intuit there is a suitable door through which to enter the soul space of the Earth.*

* *Glide from there into the depths of the Earth and imagine that there is a beautiful white ball representing the Soul of the planet at its core.*

- *Watch as rainbow-colored rings of vibration expand from the white ball towards the surface of the Earth. They transcend the surface and start to embrace the planet, ascending high into its atmosphere.*

- *After a while direct your attention to the area of outflow. See the concentrated stream of perfectly white light issuing out of the depths of the Earth. On reaching the surface of the planet, it ascends high into its atmosphere. There it spreads around the Earth to form a protective sphere that extends around the planet.*

- *For a while, watch the rainbow-colored rings of soul vibration expanding and contracting freely between the white ball at the Earth's core and the embracing protective sphere.*

- *Rejoice, and feel the presence of the Earth's soul touching your heart as well as the hearts of your fellow human beings.*

With the aid of Saskia and her astonishing appearance among the men of Rembrandt's Night Watch we have come to understand the purpose of the present revelation of the Feminine Divinity. Yet the insights presented in the previous chapter affirm that there can issue forth no Goddess impulse that is truly in tune with the present moment if its masculine dimension is not included, along with its feminine. It is of the utmost importance to realize that it is not enough just to allow the high tide of the Black Virgin's solvent powers to arise within one's soul. The Black Dwarf, intertwining with Saskia as they dance among the soldiers' legs, warns us not to ignore the complementary role of the active side of the Virgin's present revelation.

And yet I would have dismissed this point as I went about decoding the practical dimensions of the present Rebirth of the Divine Feminine if, while writing this chapter and arriving at the place where you are now, I had not, right out of the blue, had an accident. While leading a workshop on perceiving the invisible layers of nature, I fell on the rocks at Duino castle in Italy so badly that I could use neither my left hand nor my right foot. In a very effective way, I was forced to lean back and ponder the hologrammic language of the event.

A week later I had the help of a vivid dream. I was traveling on a grand ocean liner and sitting on one of its decks, deep in discussion with one of my best friends. Suddenly, for no apparent reason, he was wiped off the deck and fell deep down into the rough sea. Very upset, I ran around shouting, "Man overboard, man overboard!"

The crew of the ship reacted promptly, stopping the liner and turning it around to go back and search for the lost passenger. But while turning the ship around, the crew did not keep a good watch and the vessel came too close to the cliffs on the shore. Only by the greatest efforts did they succeed in getting out of danger.

That last image refers to the difficulties that I had brought on myself—remember my painful fall on the rocks—by being insufficiently sensitive to the contradictory nature of the Feminine Redeemer's revelation. I believe that it also symbolizes a chain of dramatic events, such as might cause human beings worldwide to pay attention to the unexpected turn-around in their own and the Earth's evolution.

The dream helped me to finally grasp that, through the new, feminine qualities introduced into the Earth's Self-healing Process, a revolutionary inversion in the course of the present Earth Changes has been taking place since the mid-point of the year 2000. To put it in storybook form, one could say that three years after the transformation process began and while it was well under way, the divine supervisors, the Patronesses and Protectors of Mercy, realized that human beings would be unable to go along with the Earth Changes and were in fact stuck in a subconscious fear of change. They found us to be almost hypnotized by the power of the planet's re-emerging beauty and strength. It was not by chance that in my dream the tragedy of my drowning friend took place on a stormy sea, signifying that the upcoming problem has quite definitely to do with the emotional upheaval that roars in the subconscious psychic space of the innumerable individuals who inhabit the planet at this moment of its resurrection.

In answer to the call for help—I am still following the story of my dream—the divine Mercy decreed that the forward-striving

momentum of planetary change stop for a moment, and the ship be turned around to help the lost human race. Within the eternal space of that decisive moment, the feminine facet of Divinity must have decided to manifest as a silent helper, to be what I call the Feminine Redeemer. To 'embody herself' might be too material an expression to use in this case. But as my experiences of the last nine months have shown, the manifestation of the Liberatress takes on very distinctive forms. Even if they do not immediately touch the physical level but express mainly through the emotional and soul dimensions, one cannot overlook their active intervention if one listens carefully to the sounds of the Earth Cosmos NOW.

As I told you at the very beginning of this book, its basic inspiration came to me through a Russian icon representing the Black Virgin with her Son. There, to my great surprise, I discovered that a new impulse must have been born in the powerfield of the breath that connects the Virgin with her Son, who in this case represents the human race. I have never before felt the kind of sweetness and power—the simultaneous presence of the two contradictory qualities intertwined and permeating each other—as was then revealing itself in the exchange of breath.

At first I believed that the icon was a special one because it had the ability to convey the immediate experience of the breath that flows between the Virgin and her Son. I got this idea because, even when testing that flow on one of the icon's countless reproductions, I could not dismiss its intensity. But now, at the very end of the companionship of our writing and reading, I have to admit that the icon's reproduction was obviously meant to be a demonstration piece, to attract my attention to the intimate relationship between the Virgin and the human race, newly reborn within the self-healing and transforming process of the Earth.

To deepen my understanding of how the newly born relationship is about to be 'embodied', another set of revealing experiences and images have surfaced now, a few days before I have to deliver this manuscript to the publisher. During the first days of March 2001, I was leading a workshop in Great Britain entitled "The Daughter of Gaia—Rebirth of the Earth Cosmos" as

a guest of the Ruskin Mill Further Education Center based in Nailsworth, England. I found the country in great distress because it was during that exact week that an epidemic of highly infectious foot-and-mouth disease surfaced in Great Britain, forcing the countryside into a state of quarantine. The people were upset, and more than 50,000 domestic animals were slaughtered and burned on that particular weekend to prevent the spread of the plague. It was the second animal-related catastrophe to strike Great Britain after Mad Cow Disease (Bovine Spongifom Enteritis, or BSE) surfaced there not long ago.

In my talk I wrote on the blackboard the English word for 'ANIMAL', but without the ending 'L', so that another word appeared, ANIMA, the Latin word for 'soul'. After summarizing the contents of Chapter Five of the present book—"Lady of the Beasts, Mistress of the Animal Souls"—I was able to show that our modern human relationship with the animal kingdom and the consequent emerging problems are the mirror of human ignorance of our own personal soul dimension (which in turn I identify with the Goddess' presence within).

I also asserted that within the geomantic organism of Europe, Britain has the role of Messenger. In the chapter on landscape temples I mentioned the country's somewhat elevated powerfield, which represents the podium from which each actual message is spread worldwide. During the last decade, the population of the whole planet often held its breath when looking at the exquisite images of the different crop circles appearing year after year in the fields of Britain. They bear witness to the awakening of Gaia, the Earth, as a cosmic being whom I call the Daughter of Gaia, and represent her way of opening to universal space and her attempt to talk, through the language of cosmograms[4], to all people and all beings populating the planet's surface.

Now, on the threshold of the third millennium, the message that is sounding from 'the podium of Britain' has taken on the form of the animals' tragedy. It can be understood as a call to the

4 For more details on my perception of crop circles, see Chapter 3 of my book *Christ Power and the Earth Goddess,* Findhorn Press 1999.

human beings of the present civilization to renounce a kind of suppression that is directed against our own soul essence. If we do so, the animal kingdom will be free to follow its own path of evolution instead of being ruthlessly forced to suffer in a role that mirrors our ignorance of the feminine dimension of Divinity within ourselves. Like all beings of the Earth, animals right now need all their powers to be able to follow their transformations within the flow of the present Earth Changes. These Changes will bring them closer to what they in their essence are.

As a practical exercise, I proposed that the workshop group go to the nearby forest and there perform a ritual to console the country's suffering animal population and support its effort to sound the message of the Feminine Redeemer, even at the cost of the self-destruction of some of its species. During the past few years I have developed a ritual for "Comforting the Animal Kingdom" to support their sister evolution. I have mentioned it already in Chapter Five, but this time I was inspired to expand on the way of attuning to the animal soul level and spreading the message across the relevant country.

Ritual for comforting the animal kingdom

- *Select a place for the ritual. It can be your home. When working with a group, I prefer a place that is dear to animals, one where they choose to gather, or come regularly to drink water.*

- *The participants choose their places within the ambience, close their eyes and each, for him or herself separately, attunes to the animal kingdom. I propose that you focus your attention on the end of your imaginary tail while simultaneously opening the 'door' at the back of your head. It is the door to the soul level.*

- *Each participant should then fold their hands together in their lap so that the middle fingers touch each other to form a kind of seat. Each one should then silently invite an animal to jump into this seat without defining which animal it should be. Rather you should watch what kind of animal comes to you, so that after the ritual you can share your experience with the other participants.*

- *While holding the animal souls in their laps, the group should sing harmoniously, and thus create a channel for the flow of universal love to caress the animal kingdom.*

- *Imagine that the vibration of the singing is forming a spiral that rotates slowly clockwise, rising high up and spreading the quality it has created throughout the country to comfort the animal kingdom.*

- *When the singing is over, everyone opens their hands wide so that the animals can jump back into the ethers.*

While the group was performing this ritual in a hazelnut forest above Horstley Valley, a strange animal soul approached me and jumped into my lap. At first I thought it was a calf, but then I realized that its long legs and slim body rather marked it as a fawn, a young deer. What made it very special was a little crown on the sweet, tiny head. While the royal fawn was sitting in my lap, I could feel the enormous power of its presence and I realized that it was as unknowably old as it seemed to be young.

The comparison that came to mind was that of the Lamb of God representing the Christ as the Redeemer. He incarnated to show human beings a possible way of liberating themselves from the bonds of the overdeveloped mental, emotional and cultural patterns that prevent humanity completing the step towards freedom, to become who we in our essence are. The meek power of love is His tool of liberation. Accordingly, the Redeemer's impulse is usually depicted as a lamb with a nimbus, who holds a cross in its hoof. The image comes to us from the Gospel according to John, in the words that John the Baptist spoke when he saw Jesus coming towards him: "Look, there is the lamb of God who takes away the sin of the world!" (John 1:29)

My intuition suggested that the crowned fawn represents the cosmic figure of the Liberatress, the feminine counterpart of the Redeemer. Consequently I speak of the 'Feminine Redeemer' even though the Redeemer is usually depicted as a man. On the very day that I returned home from England I had a welcome confirmation that I was not alone in fantasizing about the figure of the Feminine Redeemer. Looking in my library for images that I could transform into drawings for the present book, I found a

forgotten volume entitled *Sophia—Maria* by Thomas Schipflinger, which an intuitive woman had sent me years ago after reading my book on the Landscape of the Goddess.

There I discovered a set of medieval miniatures depicting the visions of Sophia witnessed by the Abbess Hildegard from Bingen (1098–1179). She is one of the most remarkable feminine figures of the Middle Ages, a founder of monasteries, advisor to popes, a writer and a healer. Her vision, which surprisingly connects us with the present revelation of the Divine Feminine, is entitled "Sophia-Maria and the God's Lamb." It shows the dark red, winged figure of Sophia as she is usually depicted in the icons of the Orthodox Church. She stands on the earthly green body of the old Gaia who is wrapped around by a snake. Yes, I shouted, Hildegard foresaw the appearance of the Daughter of Gaia! There is an obvious similarity between this image and the figure of Mary standing on the moon that has the old crone's face, about which I wrote in the first chapter.

But Hildegard's vision differs decisively from the usual Middle Ages depictions of the Virgin with her Son. The Christ does not appear here as a baby but as Sophia's equal counterpart. In fact, above Her head there is another head bearing the features of her consort, the Christ. Both the faces of her head are separate but at the same time connected by a golden ring vibrating between them. To make clear that we are here seeing two equal principles united within one presence, the Christ shows His own wings marked with two of the symbols usually ascribed to the Gospels, the eagle of St. John and the human face signifying the Gospel according to Matthew.

What is most remarkable in Hildegard's vision—besides the fact that the face of Christ is shown complementing the body of Sophia—is that instead of holding the baby Son, She is caressing a tiny lamb against her heart, which sets Her in the cosmic role of Liberatress that She is about to manifest in the not too distant future. Almost nine hundred years later I recognized its emerging presence in the tiny, crowned fawn that jumped into my lap during the ritual in England honoring the animals. I shall never forget the loving feeling that pervaded me when the fawn leaned its crowned head against my heart.

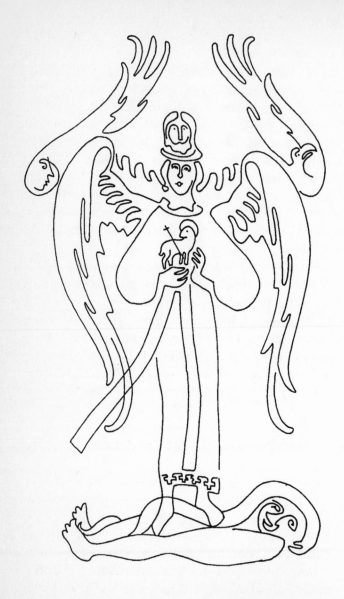

*Vision of Sophia by Hildegard of Bingen, 12th century.
Note that Sophia and Christ are one being, and how they relate
to the old Gaia who is wrapped around by a snake. The lamb
in Sophia's hands signifies her role as the Feminine Redeemer.*

Let us say that my intuition, backed by the set of experiences here described, is correct, and that the impulse of the Feminine Redeemer is right now finding ways to manifest among people, seeking to inspire innumerable individuals to accelerate their own personal transformation and in so doing support the Self-Healing Process of the Earth. What can one do to answer the call? The masculine way of deciding on appropriate action does not feel in tune with the feminine essence of the impulse, which seeks to arise from within the soul core of every individual, similar to the incoming high tide when it starts to submerge the shores of ocean. But also, it does not feel appropriate to lean back and let the impulse do its work, now that we have recognized that the feminine and masculine aspects of the impulse represent an indivisible unity.

As a practical proposal, my inspiration suggested that I should summarize my experiences of the last nine months while I tune in again and again to the re-born impulse of the Divine Feminine, and so create a list of nine imperatives to be followed, or goals to be nurtured, while we seek to interact with the newly promulgated initiative of the Feminine Redeemer[5]. I am writing these texts while imagining I am holding her representative, the royal fawn, in my lap and looking deep into its eyes.

Nine imperatives

Imperative one: No guilt! Accept the perfectedness of your being!

The idea that the human being is a sinful being is a most repulsive concept, completely contrary to the message of Divinity as sounded anew by its feminine facet. The human being is a being of freedom and can grow and develop only by absorbing one experience after another. The experiences which have a negative character come into being in order to further the positive attitudes of the individuals involved, or else to demonstrate that their consciousness is leading them astray pretending that the

5 They are complementary to the Seven Letters from the Revelation of St. John, which I decoded as being seven imperatives issued by the Christ for the present epoch of Change. See my book *Earth Changes, Human Destiny,* Chapter Six, Findhorn Press 2000.

The 'royal fawn' appearing in my lap during the "Ritual for comforting the animal kingdom," performed in England during March 2001.

path is safe at the point where the common wisdom would foresee an abyss. Whatever happens within the totality of one's life has a deep meaning for one's experience and one's growth.

Accept the authority of the Virgin within you! She represents the original beauty and perfectedness of a being ensouling the universe. The authority of the Virgin within the human being stands for the ultimate faith that should never be lost. It asserts that, born out of the wholeness of the universe, we all are on the path of development and no catastrophe can strike us unless it is needed to further our growth and deepen our sense of the inner wisdom. By the ultimate faith, I mean that positive attitude towards one's life that one should nurture under whatever conditions may emerge.

By inwardly holding fast to this kind of non-sectarian and non-ideological yet all-embracing trust one helps to dissolve the outgrown mental patterns of guilt and doubt that block and overpower those human potentials that right now are desperately needed.

Imperative two: Restore your emotional sensitivity!

The mental crust that modern consciousness projects onto the multidimensional organism of the environment not only prevents human beings from perceiving the subtle nature of life around us, but also drastically diminishes our own emotional sensitivity. We are becoming operational units of the mind machine, which we are about to make more and more perfect.

There is no way out of this self-constructed mental prison other than the conscious act of detaching oneself from the dominance of the all-controlling mind. But one cannot succeed even by repeatedly and perpetually detaching oneself if one does not do parallel work on re-awakening one's emotional sensitivity towards the subtle dimensions of life. A successful change does not mean that one's conscious control will be overpowered by an upsurge of emotions, but rather balanced out and finally diluted by a regained capacity to resonate intimately with the pulse of life within and without.

The nature kingdom all around us has never lost its ability to communicate in a holistic manner, one that we would call

emotional in character. Now is the time to recognize the helping hand of nature's beings, be they visible or invisible, who can lead us out of the mental 'labyrinth' that is about to become our grave. Talk to them, try repeatedly to feel their presence and establish well-grounded paths of communication with trees, lakes, cows or elemental beings.

Imperative three: Honor the cyclic nature of your path!

The linearity of our projection of time and space deprives us of the ability to perceive the cyclic essence of life's every-day processes, and of the universal ones also. The result reflects in humanity's massive pressure on the resources of nature, expressing itself in a one-sided struggle for stability, security, success and continuous good health.

The universal dynamics of each particle of life are composed of three phases. The phase of Wholeness is followed by the Creative Phase, which in turn is inevitably followed by the phase of Change. The drive of civilization is to pump up to the very roof the importance of the Creative Phase, while ignoring almost completely the sense of Wholeness and totally suppressing the need for Change. The powers of Transformation even tend to be perverted into the role of negative energies, or labeled as the opposing 'Powers of darkness'.

We should seek consciously and yet sensitively to pay attention to the fearsome dimensions of Wholeness and Transformation. Trust in the wisdom of the cosmic wheel. Intuit those moments when there is need to attune to the universal wholeness, and find a way to act accordingly, no matter what the circumstances. Honor the moments of change and transformation no matter how painful they appear, and be ready to reorganize your life accordingly, even if it draws unprecedented circumstances down upon you.

Imperative four: Cultivate the freedom of your soul!

The modern way of life is based on a concept that claims consciousness as the source of spiritual and material growth. Others, in the name of ancient traditions, claim that the soul

alone is the origin of life's abundance, the earth's fertility and the human creative imagination. Which is right?

If the rejuvenating, transforming, and emotionally potent powers of the soul do not pervade the sphere of consciousness, the mind tends to become the sharp tool of ignorance and controlled destruction. It is also true that without the structuring and organizing knowledge that consciousness can bring to bear, the soul lacks the ability to influence the flow of life in any very creative or innovative way.

Cultivate the freedom of your soul. Do not try to eliminate its permanent pulsations from beyond the sphere of your consciousness. Do not attempt to stifle its emotional eruptions when they surface to sound a warning, which is perhaps also a call for change or a new initiative. Listen to the goal towards which the impulse of the soul is leading you.

Cultivate your relationship with your soul by learning step by step to understand its hologrammic language. Make the effort to translate the voice of the soul into those concepts that can serve your consciousness as guidelines, how you can think on a given matter in a loving and holistic way and how to behave or act accordingly.

Imperative five: Recognize the gift of your body!

Stop using your body as if it were a machine that is obliged to create for you in every moment what you want from life! Wake up to the truth that your body is a multidimensional being of nature, a living vehicle of evolution through which, first of all, nature is exploring the further steps of its growth and the expansion of its consciousness. Of course, it is also true that this marvelous creation is offered to us as our means of traveling through our life experiences, while still being our tool of manifestation.

But neither of the two purposes is more important than the other. In fact, they are mutually dependent on each other, because:

It is only by ensouling the body with its elemental essence and attracting to it the service of an elemental being that nature has given the body the qualities it needs to become the temporary home of the human spirit.

It is only because human souls, plus their consciousness with their crazily creative ideas, are ready to incarnate within the body thus prepared that it becomes possible for nature to experience a refinement of its creation.

Now it is time to take the cooperation between the two parties involved a step further, in the sense of increasing their awareness and loving care for each other. If we ignore the challenge and continue to neglect its voice in the old fashion, the body may refuse to serve us. Recently, following the Earth Changes, it has achieved the cosmic right and freedom to purposely rebel.

Imperative six: Bury your corpses!

For long ages past the human body, and the natural environment too, were used to experiment with the outcomes of those of our thoughts and feelings that became imprinted into the tissue of physical reality. For example, some thoughts that deviated from the path of a divine principle, after we had cherished them for a long time, caused the deterioration of the corresponding aspects of our body, or of the environment that resonated with that principle. As a result, our consciousness was able to recognize the mistake and become ready to acknowledge that the path it had taken was leading it towards self-destruction and misery.

This kind of limited application of the personal and Earth body, using them as a mere physical mirror for the condition of our mental and emotional power-fields, is no longer an appropriate way to engage the fantastic potentials of the multilayered planetary body and its fractal, the personal vehicle. We are invited to discover the body as the perfect instrument of our soul, capable of communicating with the human self and ready to serve as a tool of perception and creation on all levels of existence.

To enable it to serve on the new level, the body has to be freed from traumatic blockages related to the unresolved past when it was being used to teach our consciousness certain difficult lessons. The intelligence of the body will find ways to make you aware of such a need when it surfaces. Instead of being scared of the memory, know that the time has come 'to bury old corpses'.

Imperative seven: Ask for what you need!

In our present condition, when the alignment between Divinity and the human self is being renewed, it is nonsensical to rely always and exclusively on our human powers and capabilities to manifest what we need, as the present civilization is trying to do. On the other hand, it is no longer appropriate for us to behave like the child who forever asks the Father or Mother for what it needs. That belongs to our past. We find ourselves jumping back and forth between these two ways of getting what we are striving for, though neither of them corresponds to the present status of the human being nor to the essence of the new epoch of our evolution.

The renewed flow of breath between human beings and the Divine demands that proper paths of communication be opened through which the new relationship can grow in power and credibility. Inwardly communicate with the Divinity within. Tell it repeatedly what you need, ask that it be given you, do your part in manifesting it and observe how it comes into being to appear in the here and now. And give thanks all the time.

This is the essence of the new partnership between humanity and the Divine Cosmos. It is based on perfect trust, mutual communication and loving communion. Asking for what one needs in the sense of inwardly expressing one's visions and expectations means one abandons both of the outgrown paths of manifestation and sets a pointer towards the new dawn.

Imperative eight: Follow the impulse of your heart!

There are often so many voices speaking and screaming within one's interior that confusion is the inevitable result. Know that among them there is only one whose message can never be confused and whose call can never destroy the peace of your soul. It is the voice of your heart.

If a decision is needed, open directly to the presence of your heart sphere and feel its impulse. Ask for angelic guidance only after you have contacted the presence of your heart. Only after you have well grounded yourself in the wisdom of your heart, only then ask your conscious mind for its ideas about how to understand the message. Only after touching upon the

knowledge of your heart does the conscious mind have a sense of how to consult your elemental being, talk to your invisible masters and guides, or ask for the opinion of your ego.

Do not cheat yourself by asserting that it is difficult to understand the message of the heart. The impulse of the heart needs only to be trusted for it to be felt, and one only needs to attune to its sound. Everything else can easily be accomplished by using the multitude of human facets and helping beings. To open up access to the core around which one's action evolves and around which one's peace can center, that is the real need.

Follow nobody else, be they human or divine, follow the impulse of your heart.

Imperative Nine: Reconnect!

Your mind and your sensual experience may try to convince you that no essential changes are happening in or around you, just isolated catastrophes of a greater or lesser sort in haphazard sequence. You should not rush to such assumptions until you have learned to connect yourself to the emerging earth cosmos and feel its pulsations. These will help you get a proper perspective on the threads of development in and around you.

To connect with the emerging earth cosmos, you first of all need to look into the eyes of your inner child. It stands for the infinity within you and for your eternal presence. Imagine the child squatting head-down within your belly. Then see it rising, head upright, from the waters of the subconscious to stand in your lap fully awake and radiant. Hold it in your arms, be that child with your eyes looking through its eyes and your heart beating through its heart.

Once you have connected with your divine core, proceed to establish a link with your soul, with the Goddess within. Do you remember the first drawing and initial exercise in the present book? Become aware of your soul dimension as it unfolds around the divine child. As you gradually come to embody your soul dimension, you become ready to identify with your conscious mind without fear of falling under its one-sided control. Now you can be who you truly are, and do what needs to be done.

List of Exercises
included in the text

Chapter 5 Lady of the Beasts, Mistress of the Animal Soul

Chapter 6 Behold: Landscape Temples Worldwide!

Chapter 7 The Son of the Virgin, Her Consort, and Her Uncles

Chapter 8 Liberatress: The Feminine Redeemer is About to Manifest